PORTRAITS *of* CANADA

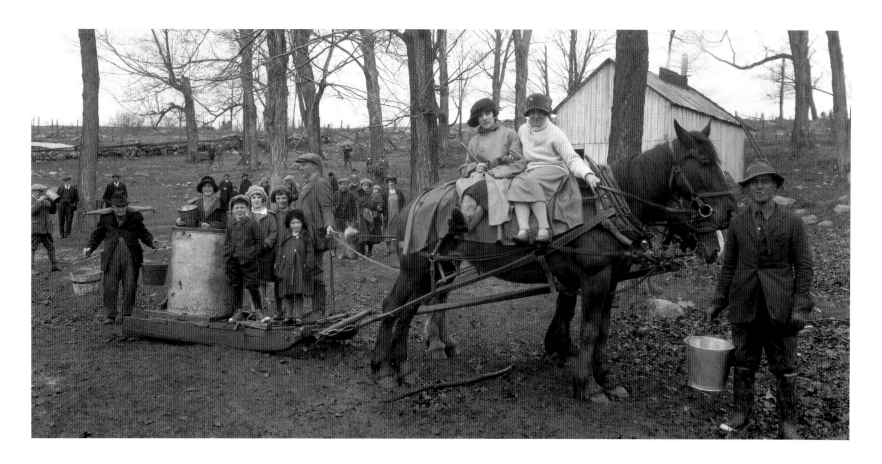

The practice of boiling maple sap into maple syrup is a centuries-long tradition beginning with First Nations peoples. There is no surer sign of spring in Quebec than when the sap starts to run, as this April 1928 photograph taken at the farm of Alexandra Lavigne at St-Placide, Quebec, confirms. The familiar sugar shack *(cabane à sucre)* and horse-drawn sleigh complete the setting. In Quebec, "sugaring off" is not only an important aspect of the culture, it is a significant industry that supplies more than 50 per cent of the world's maple syrup.

Anonymous, NS.16580

PORTRAITS *of* CANADA

PHOTOGRAPHIC TREASURES OF THE CPR

Jonathan Hanna

Robert C. Kennell

Carol Lacourte

FIFTH
HOUSE

Cover and interior design by John Luckhurst
Cover and interior images by CPR Archives
Edited by Lesley Reynolds
Proofread by Rennay Craats
Scans by David Hancock / CPR Archives

A Note on the Type:
The type in this book is set in Adobe Garamond.

The publisher gratefully acknowledges the support of The Canada Council for the Arts and the Department of Canadian Heritage.

THE CANADA COUNCIL | LE CONSEIL DES ARTS
FOR THE ARTS | DU CANADA
SINCE 1957 | DEPUIS 1957

We acknowledge the financial support of the Government of Canada through the Book Publishing Industry Development Program (BPIDP) for our publishing activities.

Printed in Canada by Friesens

10 09 08 07 06 / 5 4 3 2 1

First published in the United States in 2007 by
Fitzhenry & Whiteside
121 Harvard Avenue, Suite 2
Allston, MA 02134

National Library of Canada Cataloguing in Publication Data
Hanna, Jonathan, 1954-
 Portraits of Canada : photographic treasures of the CPR / Jonathan Hanna,
 Robert C. Kennell, Carol Lacourte.

Includes index.
ISBN-13: 978-1-894856-77-5 ISBN-10: 1-894856-77-5

1. Canada—History--1867- —Pictorial works. 2. Canada—Description and travel—Pictorial works.
3. Canadian Pacific Limited—Photograph collections. I. Kennell, Robert C., 1954- II. Lacourte, Carol III. Title.

FC174.H36 2006 971.05022'2 C2006-902919-9

Fifth House Ltd.
A Fitzhenry & Whiteside Company
1511, 1800-4 St. SW
Calgary, Alberta T2S 2S5

1-800-387-9776
www.fitzhenry.ca

Contents

Foreword *by Rex Murphy*

There is no saying better what these photographs—by their mesmeric, nostalgic, dramatic, and affecting force—say so vividly themselves.

Portraits of Canada is a graphic epitome, of quite exceptional professionalism, of a cardinal interval in our emergence as a nation. To see expressed in such rich and deeply conceived images a portion of what once we were, and how, in some sense, we came to be, makes a kind of civic call to us as Canadians. We come to this book with that sense of wonder about ourselves, and those who preceded us, that is inseparable from all peoples who have a fealty to their homeland.

There is nothing more natural for us than to be drawn to a collection of uniquely historical Canadian images. The past inevitably inflects the present, and we come to this book drawn by that common tug of curiosity about how those who preceded us, in one of the great signature undertakings of our origins as Canadians, have, in part, determined our present.

A selection from the vast photographic files of that foundational national enterprise, the Canadian Pacific Railway, *Portraits* houses images of iconic power from the very time that our country was acquiring its national character, images saturated with the deep evocative energy that all photographs that conjure yesteryear—days past and people gone—seem to so magically possess. It is a vivid compendium of singular moments, telling scenes, and personalities of our common past, captured by some of the finest photographers of that time.

Yet this book, as I think you, too, will find, does more.

Those who visit *Portraits of Canada* will be drawn to it as a compelling collection of scenes and people associated with a great enterprise and company, as a panorama of a hectic and heroic period so vital to our emergence as a nation. However, the impulse to view these scenes will not fully prepare for the richness of what is encountered. Some of these photographs quite simply have a poetic force, an unintended power as symbol or emblem that far transcends the day of their taking, their particular "Canadian" significance, or their plain duty as an album of the mighty works of the Canadian Pacific Railway.

By the wizardry of their composition, the artful isolation of figure or moment, by the brilliance of the eyes that framed and flashed each image you will find here, some of these photographs achieve an almost astonishing suggestibility.

There is a photograph of an engine driver in his cab (page 25), another of a "bulk" of five locomotives grimly turned toward the lens (page 153), and another of a "lamp

man" (page 193)—each of these strikes with the force and compression of a parable and achieves the evocative range of the most splendid metaphor.

The CPR photographers may have had their mandate. They were (I am tempted to say "merely" here, but there is nothing mere about their undertaking) keeping a record of the company's imperial enterprise. But there must have been something larger either than mandate or task—some fire caught either from the epic enterprise itself, or from a dawning intuition that they were acting as vital curators of a larger story (larger even than the railway or the country it was meant to bind)—which added a flare of genius to the execution of their craft.

Nothing is more particular, more hostage to the very second of the time and place of its taking, than a photograph. However, some of these pictures, even though steeped and alive in the very moment they are capturing, appear shorn of all time and place, escaped from all particularity. They have transcended the time of their taking and have become images of vast and general, homely and familiar themes. There is one of a captain and a cat that is waiting for its own short story (page 165). Another of a mountaineer and his companion—he is climbing a mountain and smoking a pipe—I don't know what the parable is here, but I know it's wonderful (page 17). There are others of war and its preparations that carry a menace that seems, alas, fearfully, contemporary (pages 58 and 60). And still others of the early Natives that convey an inexpressible mixture of nobility and sadness (pages 32-33). I'll stop. Of commentary on these pictures there is no easy end.

It is true, as you will read in the introductory chapter, that the CPR photographic collection is awesomely complete. Eight hundred thousand photographs speak of an amplitude that might embarrass even the legendary prodigality of the National Geographic files. To glean but 158 from that plenty must have been a work of excruciating diligence.

For the qualities that make the pictures in this book compelling and poetic, startling and charming, even in a few cases ominous and ripe with portent—this richness of appeal must have also been present in whole multitude that did not survive the terrible cut. I suspect there was a great stamina and a very singular fortitude that went to the editing of this collection.

Here it is then, a diary of a great enterprise; an album of a crucial, awesome interval in our history; and a gallery of faces, moments, landscapes, architecture, men, and machinery at work with the pressure of history at their back. Every scene gathered within *Portraits of Canada* is charged with the dynamic of an art that makes some of these images larger even than the calm, splendid, and terrible yesterdays they summon so well.

A Nation in Pictures

Canada, the dream, happened on 1 July 1867. Canada, the reality, happened on 7 November 1885, when the last spike was driven at Craigellachie, British Columbia. The Fathers of Confederation envisioned a nation, ocean-to-ocean, from Atlantic to Pacific, but it wasn't until the Canadian Pacific Railway (CPR) completed its transcontinental railway that Canada was a reality.

The railway was completed just four years and nine months after CPR's incorporation. Eight months later, passengers could travel from Montreal to the Pacific coast—4,700 kilometres by rail. In fact, Canada's first prime minister, Sir John A. Macdonald, and his wife, Lady Agnes Macdonald, did just that mere weeks after the first train crossed Canada.

By 1886, transcontinental train traffic was a reality for upper- and middle-class passengers who could now experience the diversity and beauty of the Canadian landscape, but although the railway had linked east and west, there were few settlements in between.

CPR took on a direct role in helping to establish about eight hundred Canadian municipalities, and it actively promoted immigration and the colonization of western Canada. It galvanized sidings into stations, stations into towns, and towns into cities. The company created commerce and developed tourism in the west, helping to sell Canada and its resources—all with the help of photography.

Almost from the beginning, CPR hired noted photographers, first on contract, then later in its own in-house photography and publicity department. Photographers worked in CPR's studio to record the expansion of the CPR and the making of the Canadian nation. Their images represent a visual journey across Canada in space and time.

Canadian Pacific Railway photographers were an adventuresome lot. Photographing the country meant you couldn't just stay in a studio. The early photographers lugged around all sorts of photographic paraphernalia, including a large-format, glass-plate negative view camera, a heavy wooden tripod, numerous negative plates, and the explosive flash-pan powder needed to light up a shadowy subject. CPR provided a few of its early photographers with a completely equipped photography car. Photographers sometimes had to set up a makeshift photo lab in their hotel rooms, just to get their

negatives developed, printed, and sent out to the press in a timely fashion. The photographers braved the elements, geography, and on one occasion, a grizzly bear attack, to get the picture.

By 1892, the company had set up a permanent studio and photography lab in its Windsor Station headquarters in Montreal. The department grew in size and stature to become the largest in-house industrial photography lab of any company in Canada. Company photographers produced images for advertising, claims, engineering, transportation, art and décor, marketing and sales, and human resources. The lab made custom prints and framed décor prints as well as high-volume press kits. For special events, such as the 1968 launch of the company's "multimark" logo, it produced thousands of photographs for media press kits. The central lab included a front-office order desk, image bank, photo studio, black-and-white and colour darkrooms, negative and slide processing rooms, a mounting and framing studio, negative files, and an enlarging room for wall-sized murals.

The photography department reached its apex in 1983, when no fewer than seventeen employees worked in the fourth-floor department in Windsor Station. In 1983, the department was still processing, printing, and filing the work of CPR special photographer Nicholas Morant, then seventy-three years old. In addition, there were a half-dozen freelance photographers contributing images to the department.

Later that decade and into the early 1990s, CPR started outsourcing many of its photographic activities and production. But, to this day, CPR maintains a heritage image bank of some eight hundred thousand black-and-white and colour negatives, prints, and transparencies in the CPR Archives in Windsor Station. The company also has an up-to-date photo/image/graphic studio with a ten-thousand-plus current negative, transparency, and digital image collection in its current headquarters in Calgary, Alberta. Graphic artists create, manage, and transform these images into the railway's internal, external, and marketing communications needs.

Although the technology has changed, the CPR photographic legacy remains. This book is a carefully made selection of 158 of the most thought-provoking, stunning, and interesting images that CPR photographers made of Canada through the railway's viewfinder. The old Chinese adage says that "a picture is worth a thousand words." Here you have 158,000 words' worth of images that show Canada's development into a coast-to-coast nation.

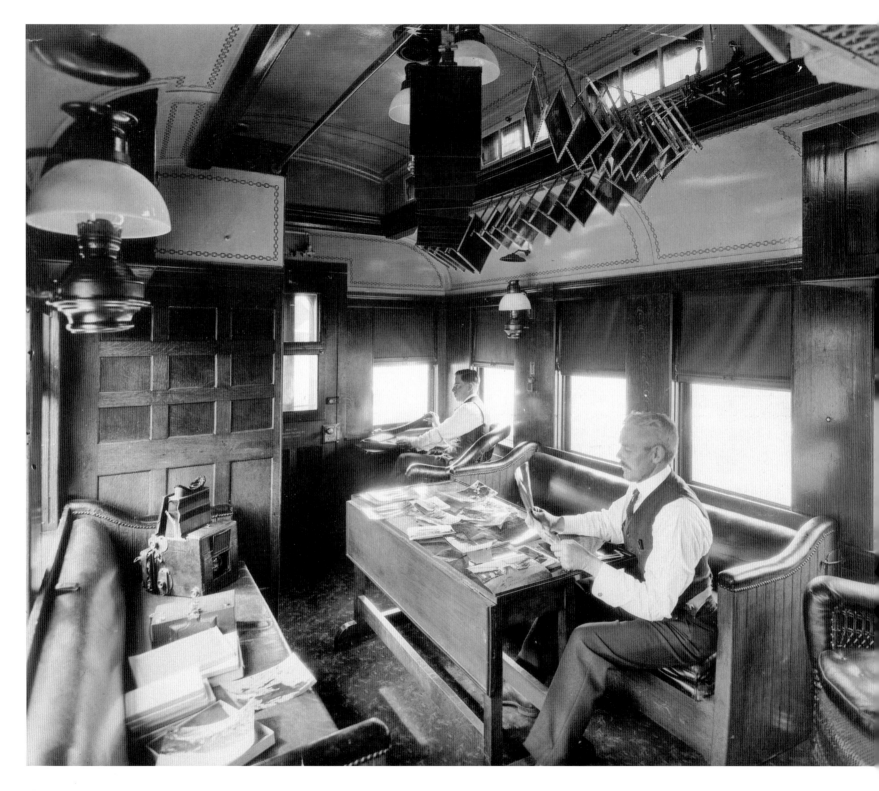

J. C. S. Bennett

J. C. S. Bennett first honed his photographic skills with the William Notman & Son photographic firm in Montreal and subsequently operated his own studio at several locations throughout the city. In 1884, at the request of CPR vice-president William Van Horne, he made the company's first lantern slides. Bennett's first big assignment came in 1891, when he covered the lying-in-state and funeral of Sir John A. Macdonald at Ottawa and Kingston for the *Montreal Star*.

Bennett joined CPR in 1902, and for the next thirty years photographed every aspect of the railway. In 1908, he even made a series of photographs along the Guatemala Railway, of which CPR's chairman at the time, Sir William Van Horne, was also chairman. As CPR's official photographer, he spent three months every year in the vast mountain territory that stretched from "The Gap," near Canmore, Alberta, to Kamloops, British Columbia. He often worked out of photograph car No. 35, which allowed him access to remote locations and onboard equipment to process, print, and catalogue his growing collection. Although Bennett photographed many dignitaries, possibly the highlight of his long career was accompanying the Prince of Wales' 1919 special train as it travelled from Saint John, New Brunswick, to the Pacific coast and back. During this trip he was credited with accomplishing the challenging task of taking pictures of the train in motion!

In 1928, two years before his retirement, Bennett built a house in Hudson Heights, Quebec, forty-five kilometres west of Montreal and within a stone's throw of CPR's Montreal-Ottawa line. He lived there until his death in October 1942. His obituary in the company's *Staff Bulletin* was headlined: "Veteran Photographer Covered Canada with Camera 30 Years"

Early in its history, CPR realized the value of photography as a means to promote itself and to popularize the diversity and beauty of Canada. Mobile darkrooms gave photographers access to otherwise inaccessible locations. Staff photographer J. C. S. Bennett, seated at right, and a youthful J. Armand Lafrenière work in the comfort of a specially fitted rail car. A hand-held camera sits on the couch, while recently developed, large-format negatives dry overhead.

J. C. S. Bennett, NS.159

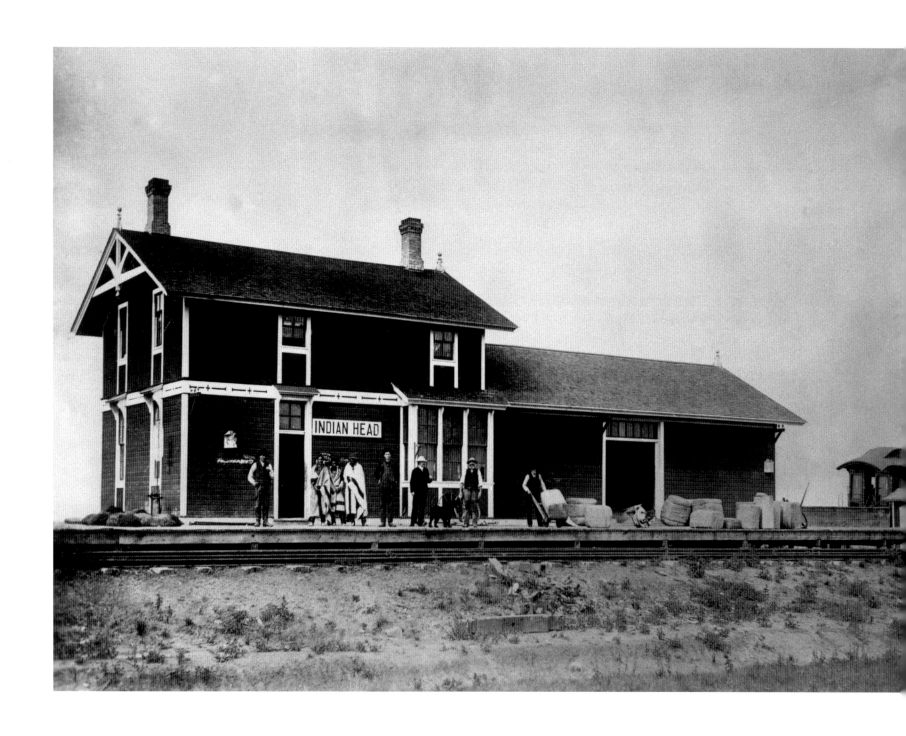

William Notman & Son

William Notman emigrated from Scotland to Montreal in 1856. He began to work in the wholesale dry-goods business, but soon decided to try his hand at photography. Montreal was ready for a skilled portraitist and his photography business prospered. In 1858, the Grand Trunk Railway hired Notman to photograph the work in progress on the Victoria Bridge across the St. Lawrence River at Montreal, sometimes referred to as the "Eighth Wonder of the World." His photographs of the imposing structure brought him fame, and his portraits and composite photographs became internationally recognized. The rapid growth of Notman's business also led him to hire and train many aspiring young photographers.

In 1884, CPR vice-president William Van Horne negotiated a deal with Notman, providing free transportation and a private car in exchange for photographs of the yet-unfinished rail line. That year, Notman's eldest son, William McFarlane Notman, made the first of many groundbreaking trips to the west for CPR. For William McFarlane Notman's 1887 and 1889 excursions, CPR provided a specially equipped private car with a bedroom, parlour, kitchen, and darkroom. This allowed the photographer the most direct, unfettered access to otherwise inaccessible locations. The relationship between William McFarlane Notman and CPR endured with additional trips to the west in 1897, 1901, 1902, 1904, and 1909.

In 1935, Notman Studios, including its vast negative collection, was sold to Associated Screen News (ASN), then a subsidiary of CPR. With both film and still photography studios, ASN created a wide range of material promoting and advertising CPR's broad transportation interests. In 1954, when the railway sold its controlling interest in the company to a Toronto group, the historic Notman collection was dispersed separately. It now resides in Montreal's McCord Museum of Canadian History.

This small group of First Nations people wrapped in distinctive Hudson's Bay Company blankets at the CPR station at Indian Head, Saskatchewan, was photographed in 1884, probably by William McFarlane Notman. The railway's official car to the right of the station undoubtedly acted as his temporary home and portable darkroom. Cumbersome equipment and the challenging processing methods of the time made this car an invaluable resource.

Notman & Son Studio, NS.5239

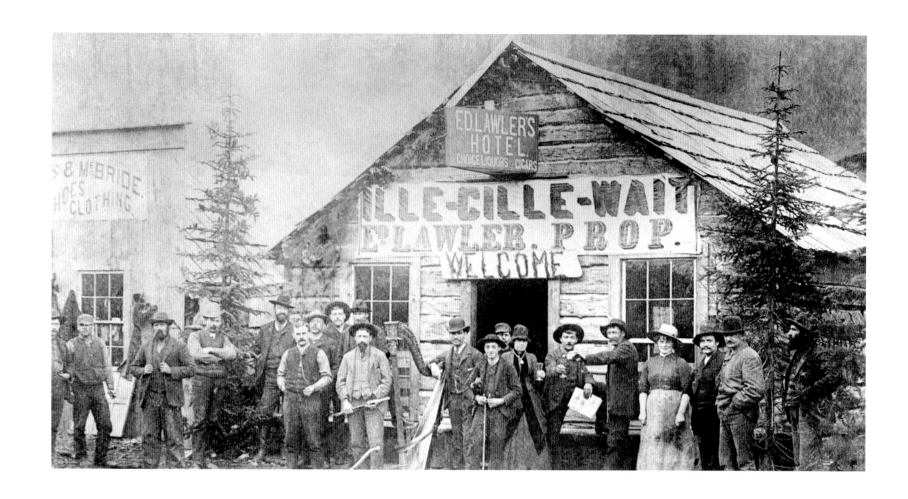

An irreverent group of railway navvies and merchants gather in front of Ed Lawler's hotel in about 1884 for what appears to be a celebration. Glasses are poured and musicians with harp, flute, and fiddle are at hand. The liquor- and cigar-serving hotel was located at Illecillewaet, (not spelled ILLE-CILLE-WAIT as on the hotel sign) British Columbia, about twenty-nine kilometres west of Rogers Pass, where CPR operated a temporary railway construction camp. It was here, on the treacherous descent of the Selkirk Mountains, that the railway built a grade-reducing figure 8, known as the Loops, which helped the railway to deal with the steep mountains more safely.

Anonymous, NS.4823

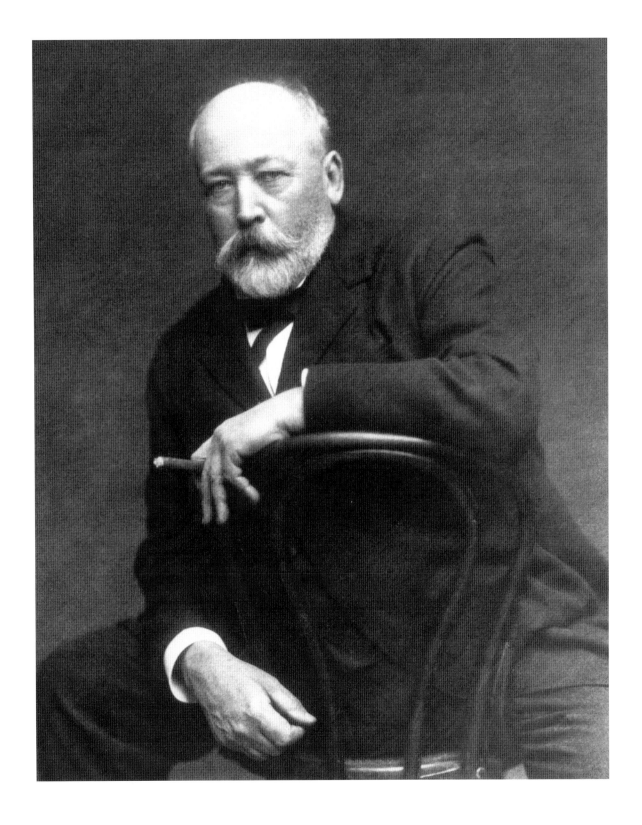

Entrepreneur, telegrapher, railway builder, art collector, cigar smoker, and poker player describe only a few of the many talents and traits of William Cornelius Van Horne, shown here in this photograph taken around 1905. "A human dynamo run by dynamite" was how a competitor once described him (D. B. Hanna, 1814). Van Horne was born in 1843 at Chelsea, Illinois. His father died when he was eleven, leaving insufficient funds to keep the family fed, so Van Horne soon left school to find work. Eventually, a job as a messenger led to his first railway position as a telegrapher. Van Horne ambitiously worked his way up in ever-increasing positions of authority at a number of railways, achieving general superintendent status at the St. Louis, Kansas City and Northern Railroad Company and becoming probably the youngest railway superintendent in the world at age twenty-nine. Van Horne's last railway job in the United States was to bring stability to the 3,500-kilometre Chicago, Milwaukee and St. Paul Railway Company. With a reputation as a skilled railroader, Van Horne was offered the position of general manager of the fledgling CPR at the end of 1881.

Anonymous, NS.25753

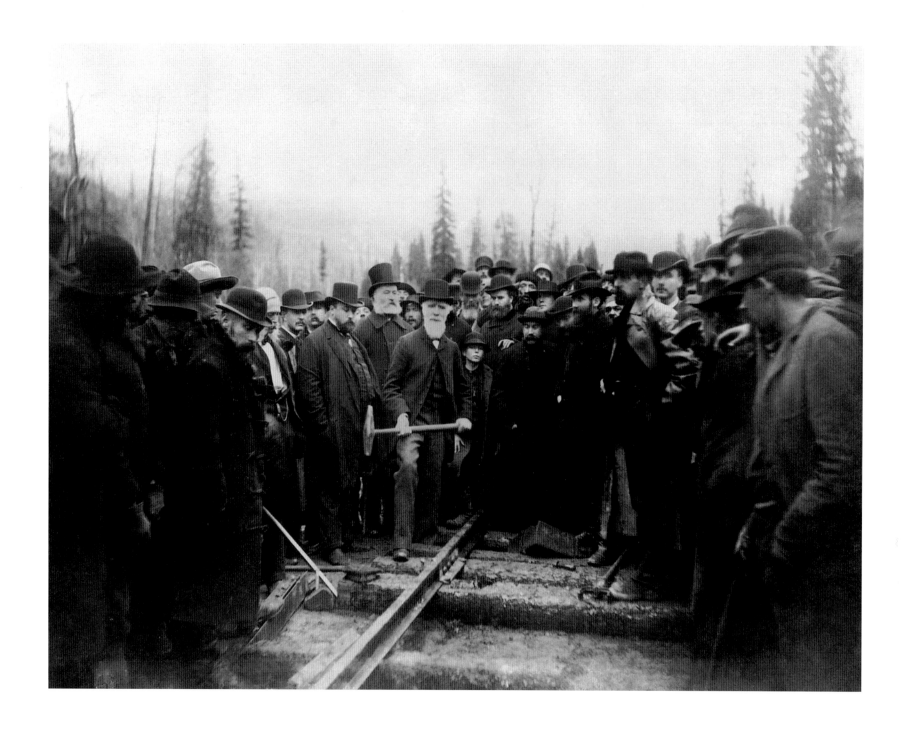

The Last Spike

At 9:22 a.m. Pacific time on 7 November 1885, with the repeated blows of his railway maul, Donald A. Smith, a member of the CPR syndicate and later Lord Strathcona and Mount Royal, drove the last spike to complete the Canadian Pacific Railway. Pierre Berton called Alexander Ross's photograph of the event "Canada's most famous photograph."

We have the famous last spike photo, but where's the famous last spike?

Some people think the last spike was a golden spike. A month before the November event, Canada's governor general was in British Columbia with a silver spike. He was supposed to drive CPR's last spike, but the railway wasn't quite finished. By the time it was, Lord Lansdowne was back in Ottawa with his silver spike.

The last spike, CPR vice-president William Van Horne decreed, would be a plain, ordinary iron one, just as good as any other on the line. So Donald Smith drove a plain, ordinary iron spike into a railway tie that cold November morning. Actually, there were two "last spikes." Smith bent the first one, so roadmaster Frank Brothers had to remove it and replace it with another one he kept at the ready, just in case. This time Smith carefully tapped home the official last spike.

After the ceremony, Smith collared Van Horne's assistant, Arthur Piers, who had pocketed the bent spike Frank Brothers had thrown to the side. Smith wanted the bent last spike in order to make souvenir scarf pins for the three spouses at the event and the many who couldn't attend. He had the souvenir scarf pins made into the shape of a spike, encrusted with a dozen precious and semi-precious stones, plus a slice from the bent last spike. He also had the words "Craigellachie, B.C. 7th November, 1885" engraved on the side of each scarf pin. The scarf pins were so popular that Smith had to commandeer an additional phony last spike to make more of them.

Roadmaster Frank Brothers removed the official last spike and replaced it with another so that no one would take it as a souvenir. Years later, Brothers presented it to Sir Edward Beatty—the man who ran CPR all through the Roaring Twenties and the Dirty Thirties. Beatty kept it on his desk in his palatial Windsor Station office in Montreal. It disappeared mysteriously one night, and has never been seen again.

Donald Smith drove the last spike on 7 November 1885.

Ross, Best & Co., NS.1960.A

Oliver B. Buell

Oliver B. Buell, an American, moved to Montreal in the early 1880s. By the mid-1880s, Buell was one of a few photographers to be commissioned by CPR to photograph the construction and later the newly completed line. He was also one of the few photographers to be provided with a specially fitted photography rail car for his expeditions. Buell adopted the title of "Professor" and used his photographs to illustrate magic lantern, or stereopticon, shows for his overseas lectures on tourism and immigration on behalf of both the Canadian government and CPR. His 1885 photographs of the North-West Rebellion troop preparations and of Louis Riel himself, during his courthouse address to the jury, are among his most recognized works.

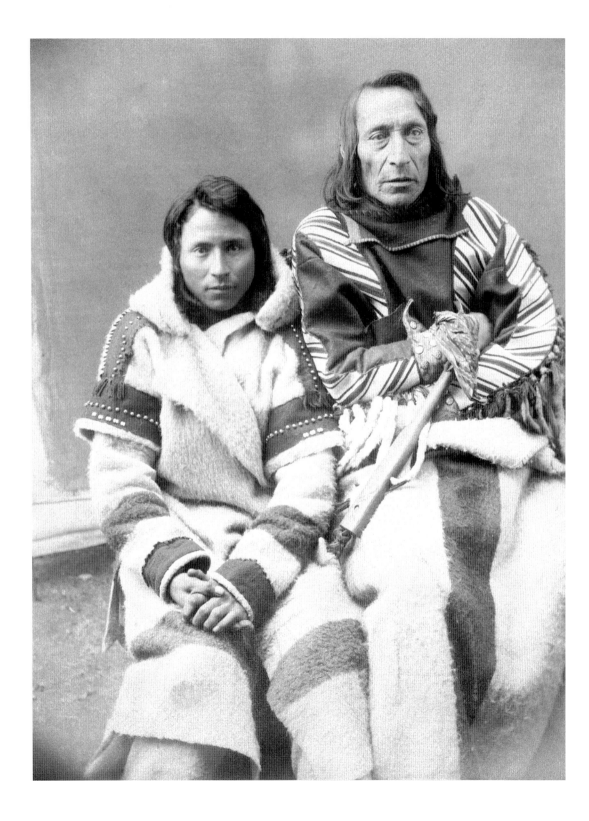

Chief Bobtail, also known as Kiskaquin, was photographed with his son, Asini Wachi, in about 1885. Chief Bobtail was an important Cree chief who signed Treaty Six in 1877 with the representatives of the Crown, in the hope of preserving the culture and spirit of the Cree Nation. At the time of the signing, Bobtail was probably the best known of the First Nations' chiefs. During the 1870s, seven treaties were signed on the prairies, allowing the Crown to open up territories for settlement and agricultural and resource development.

Oliver B. Buell, A.4260

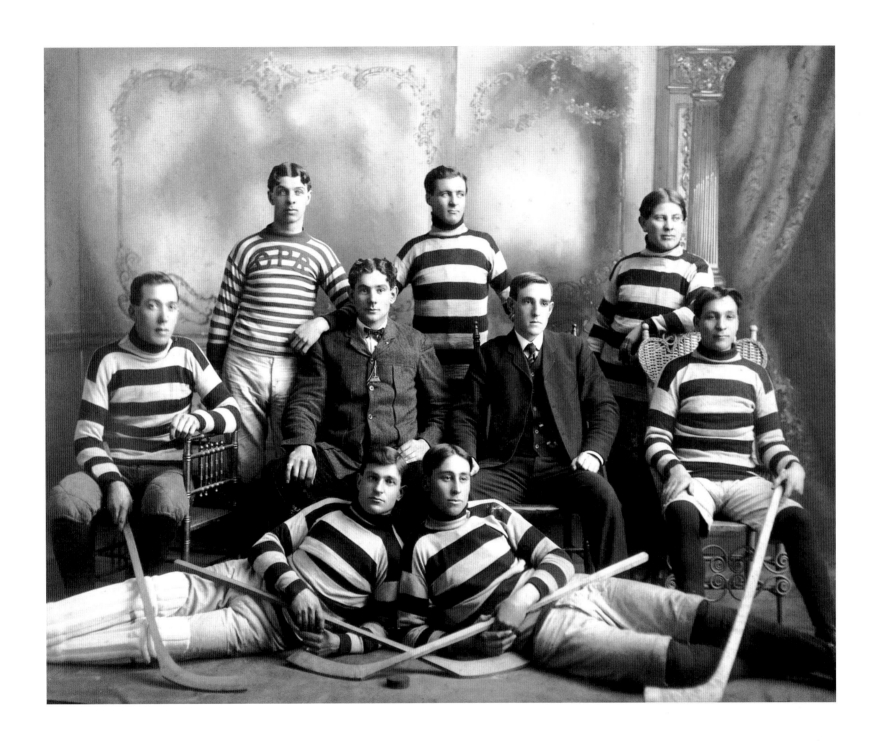

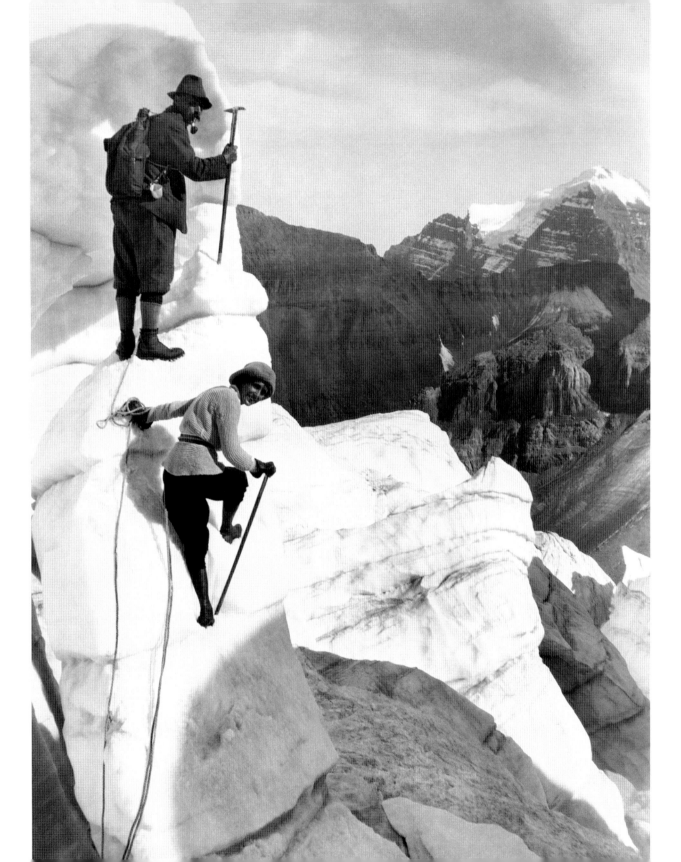

Opposite page: Hockey was fast becoming one of the nation's favourite pastimes when these employees from CPR's Moose Jaw division posed for this 1906 photo. That year, they were among seventy thousand CPR employees located in Canada—a number that represented about one-twentieth of the country's entire working population.

Anonymous, A.16789

"Fifty Switzerlands in One" was the slogan CPR adopted to promote the Canadian Rockies, home to its mountain hotels and bungalow camps. Soon tourists were flocking to enjoy the fabulous views, stay in the luxurious accommodations, and climb the unscaled mountain peaks. In 1896, an amateur alpinist fell to his death while climbing Mount Lefroy. This tragic accident convinced CPR executives to hire Swiss guides to safely guide tourists to the tops of the mountains, as shown in this photograph taken about 1925.

Anonymous, NS.6698

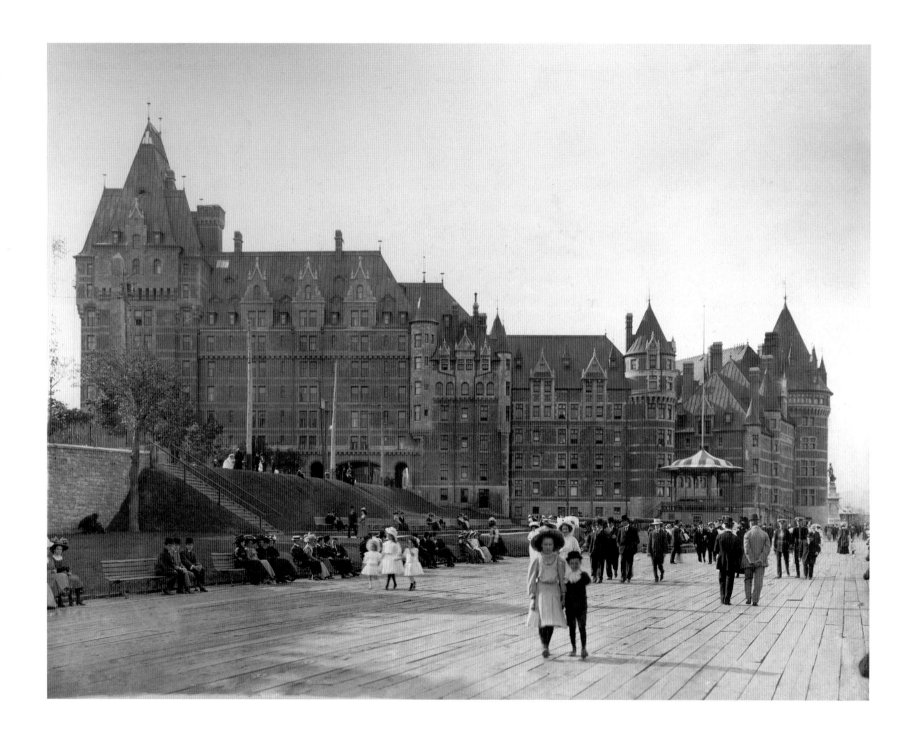

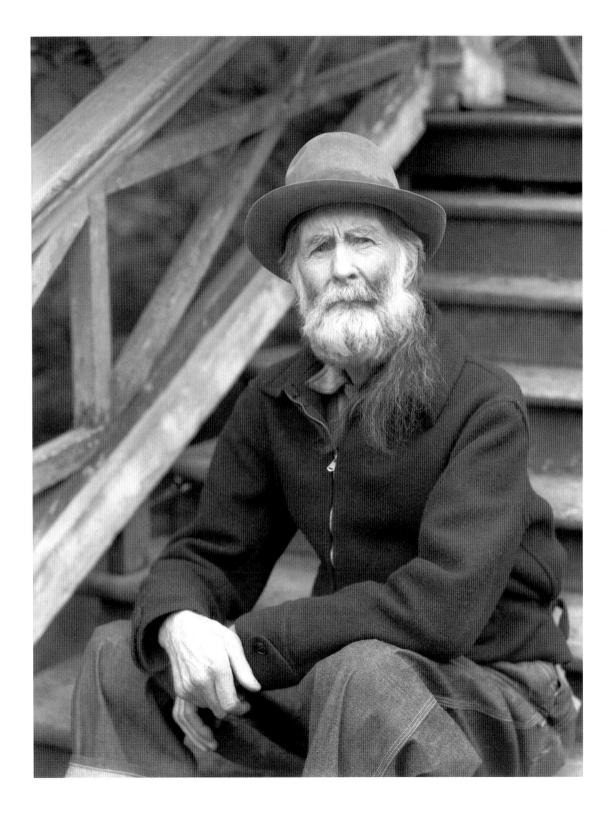

Opposite page: Dressed in their Sunday best, children and adults alike stroll along the Dufferin Terrace, fronting Quebec City's Château Frontenac. The imposing hotel first opened its doors on 18 December 1893. Bruce Price, the American architect who designed the structure, insisted on using blue limestone and Glenboig brick in keeping with the traditions of the old French city. The Château Frontenac soon proved to be a popular tourist destination and the Mont-Carmel wing, which features prominently in this photograph taken about 1920, was completed at a cost of $1.5 million in 1910.

Anonymous, H.O8.92

Little is known about Joe McKenzie or why Morant chose to make this handsome portrait of him around 1939. We do know that McKenzie lived in Yale, British Columbia, a town that attracted a diverse group of entrepreneurs and fortune seekers. It's believed that McKenzie was an old "sourdough," or experienced miner, who in his later days lived with ten golden-eyed black cats. Yale was first made famous when gold was discovered on a gravel bar in the Fraser River about three kilometres south of the town. The town then prospered as a transfer point for passengers and freight heading north for the Cariboo gold rush, and again when it became the headquarters for the construction of the CPR main line through the Fraser Canyon.

Nicholas Morant, M.501

Country music legend Wilf Carter was born in the Nova Scotia coastal town of Port Hilford, far from the mountains and wheat fields he sang about. Carter's musical career took off when John Murray Gibbon, CPR's head public relations man in the 1920s and 30s and secretary-treasurer of the Trail Riders of the Canadian Rockies, hired him to entertain tourists on the trail rides. Shown here in 1935, Carter was made "Official Trail Songster" in 1933. Acknowledged as Canada's first country music star, Carter wrote hundreds of songs and recorded more than forty long-playing records.

R. H. Palenske, NS.24871

Opposite page: During World War II, in addition to handling record volumes of traffic, CPR devoted a large portion of its repair facilities to the manufacture of military armaments. From 1941 to 1943, CPR's Angus Shops in Montreal produced 1,420 Valentine army tanks to assist the Russians in driving the German army from eastern Europe.

Anonymous, NS.3006

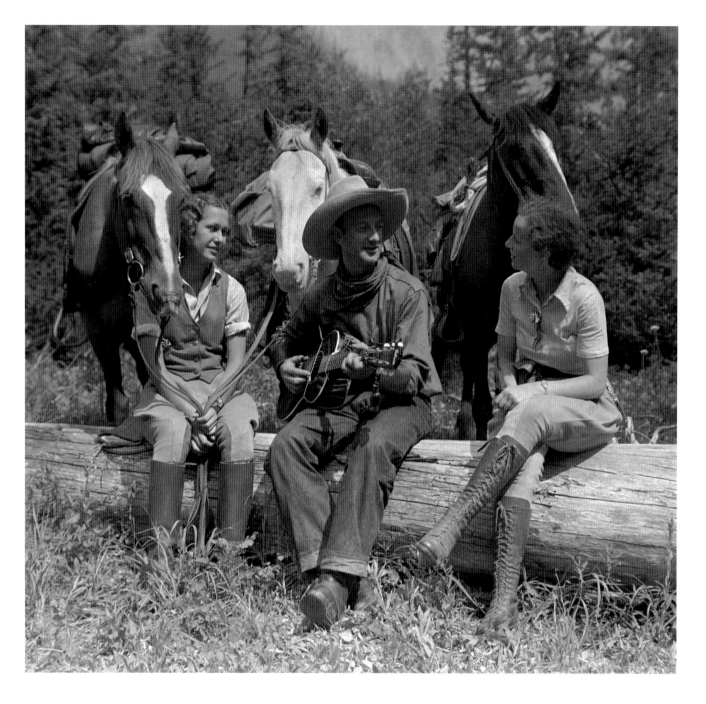

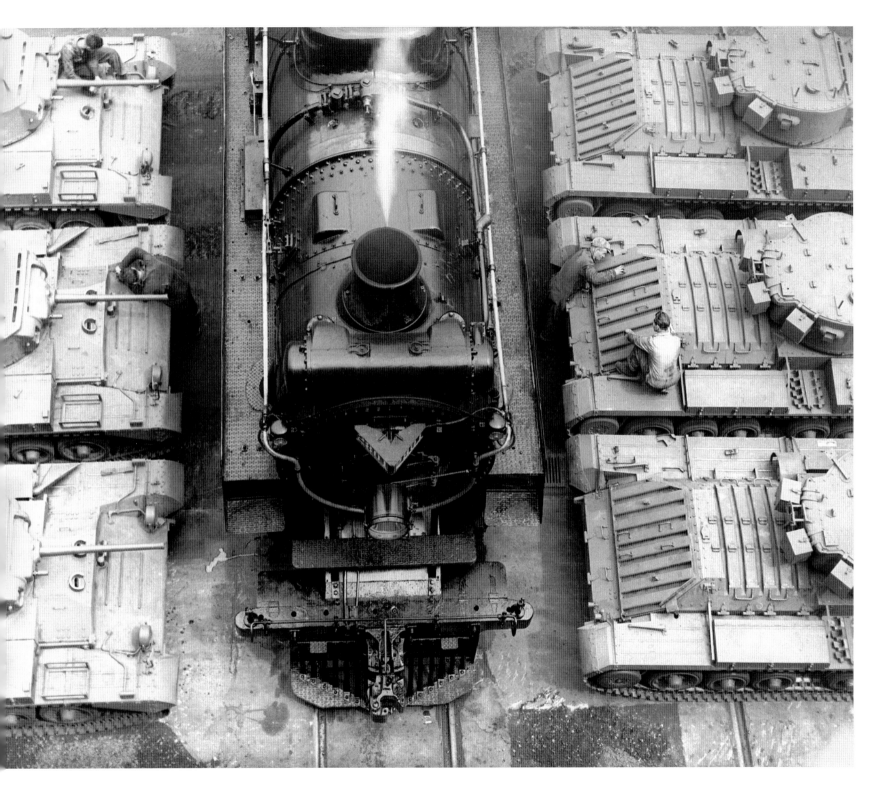

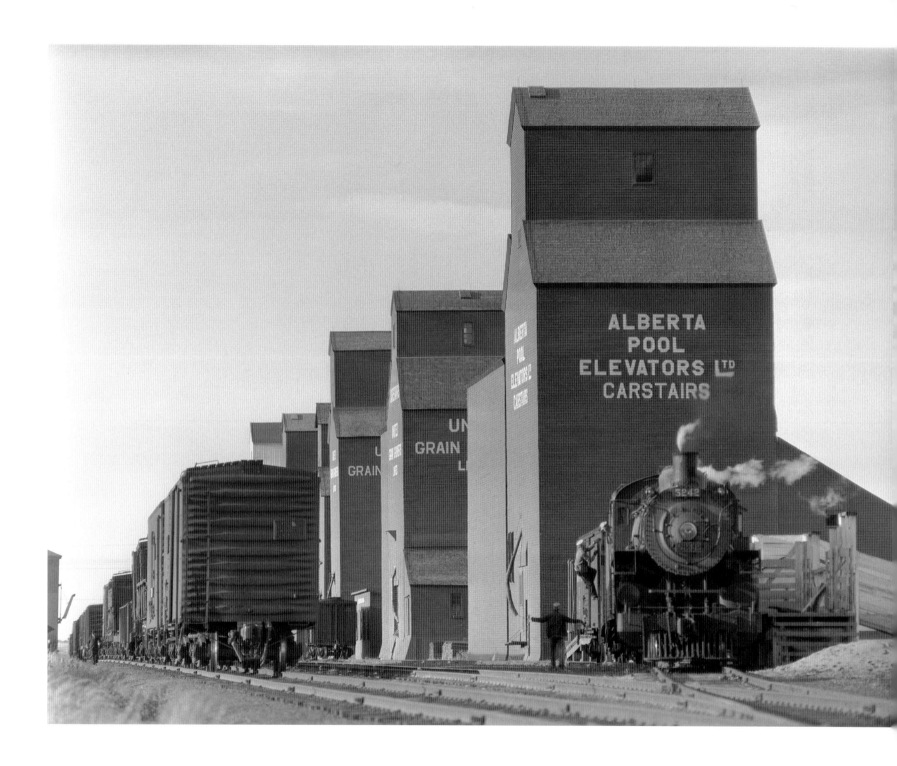

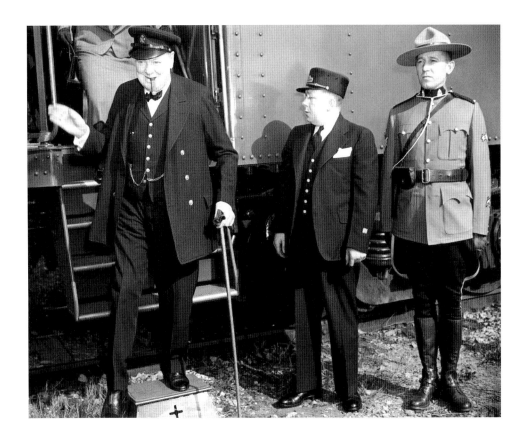

Under the watchful eye of a CPR steward,
British prime minister Winston Churchill
disembarks from his special train to attend
the 1944 Octagon Conference in
Quebec City. For the second time in
two years, the Château Frontenac was
appropriated by the Canadian government
to serve as the working headquarters for
World War II Allied strategy meetings
between Churchill and American
president Franklin Delano Roosevelt.

Anonymous, A.26375

This photograph of engineman Floyd Smith was one of a series that CPR staff photographer Donald Langford shot in 1945 for the *Staff Bulletin*, an employee publication. Langford was a skilled photographer and his photo essay on the Montreal to Ottawa wayfreight provides invaluable insight into the jobs of the engineman, fireman, conductor, and trainmen. The wayfreight, which was a six-morning-a-week intercity assignment, made numerous stops along the route over a period of eight to ten hours. The crew's job included loading and unloading hundreds of pounds of merchandise ranging from a box of soap to a farm tractor.

Donald Langford, B.554.1

Donald Langford

Twenty-one-year-old Donald Campbell Langford joined CPR's publicity department as an assistant photographer in 1941 and became a full-fledged photographer a year later. In October 1942, like hundreds of other duty-bound CPR employees, Langford was granted a leave of absence to join the military service. However, ill health forced him to leave the Royal Canadian Air Force and return to photograph for CPR. Langford's ambitions led him to resign from company service in 1947 to open a photography business. He employed about a half-dozen people in a studio located in Old Montreal and enjoyed commercial contracts with the likes of the Bell Telephone Company.

The National Dream

At the end of 2004, Canada lost a great Canadian when the famous author, journalist, and historian, Pierre Berton, passed away. The author of fifty books and a regular panellist on television's *Front Page Challenge*, Berton is probably most famous for his two-tome history of the CPR.

Berton awoke Canadians to their own history, making it lively and entertaining. Until he wrote *The National Dream* and *The Last Spike* in the early 1970s, only devoted rail fans and history buffs knew about the impact of CPR on Canada. Berton's two books on the Canadian railway company were so successful that CBC decided to film an eight-part series, called *The National Dream*, which aired for the first time in 1974.

When filming of the series took place in 1973, CPR contributed vintage equipment, suitable railway locations, and its corporate historian, Omer Lavallée, who provided vintage veracity. The company's public relations department assigned special photographer Nicholas Morant to cover the filming of the railway portion of the CBC documentary. He captured in still photography some memorable scenes of the railway's construction that are virtually indistinguishable from photographs taken in the 1880s.

Canadian Pacific Railway dedicated a little-used branch line in southern Alberta for the prairie construction scenes, ripping up the track leading off to the horizon so that it could be rebuilt by hand. The Brooks, Alberta, high school closed for a day so that its students, dressed in period costume, could rebuild the rail line on camera. The tracklaying was done just as it would have been ninety years before. The abandoned Kettle Valley line in southern British Columbia was also reopened. The trestles along the Myra Canyon section of this branch line, built between 1910 and 1915, looked very much like CPR's transcontinental main line wooden trestles from the 1880s. The vintage passenger train in *The National Dream* crossed the Myra Canyon trestles, which were still in place in 1973 even though the line had been closed a dozen years before. Converted to accommodate hiking and biking trails after the filming, many of these wooden trestles were destroyed by the forest fires that ravaged southern British Columbia in 2003.

The National Dream starred a number of accomplished Canadian actors, including William Hutt, John Colicos, Chris Wiggins, Tony Van Bridge, Gerard Parkes, and Ted Follows. There were some newcomers as well, like Joe Crowfoot, who played his venerable forefather Chief Crowfoot. Each one-hour segment featured Berton narrating the story of the conception and building of the transcontinental railway, with all its challenges, deaths, scandals, and eventual successes.

Pierre Berton, photographed in 1973 during the filming of *The National Dream*.

Nicholas Morant, M.8907

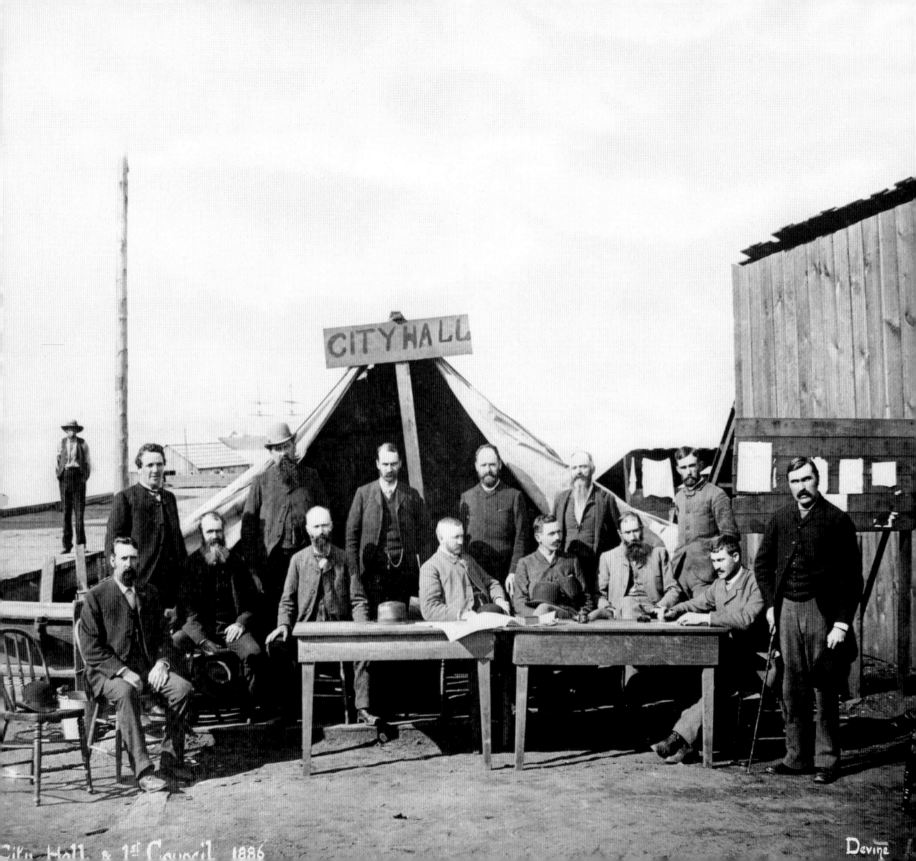

City Hall & 1st Council 1886

CITY HALL

Devine

Ask the Canadian Pacific about Canada

"No one who has not lived in the west since the Old Times can realize what is due to that road—that CPR."

—Pioneer Alberta missionary Father Albert Lacombe (1827–1916)

The early twentieth-century CPR logo featured a beaver and maple leaves and said it all: "Ask the Canadian Pacific about Canada." From its inception to the present day, CPR has used iconic elements of Canadian national identity in its logos and promotional material. However, the enduring relationship between the company and nation is based on more than just symbols. Much of Canadian history has played out along the CPR main line, giving the company unique opportunities to document Canada's journey to nationhood. Not only do the CPR photographs record momentous events in Canadian history, but also the social history of the late nineteenth to the mid-twentieth centuries in both the remote and the urban parts of the country. Not forgotten are the First Nations peoples, whose lives changed irrevocably as the railway made its way west.

Although CPR was definitely a profit-making venture, the company created a feeling of Canadian nationalism that went far beyond the mere pursuit of profits. William Cornelius Van Horne, an American, who was lured to Canada to build the railway, became more Canadian than many of his peers in federal politics. After giving up his American citizenship, he was knighted in 1894. Van Horne said that "to have built that road would have made a Canadian out of the German Emperor."

CPR brought settlers galore to the vast expanse of prairie grasslands previously occupied solely by First Nations and Métis peoples. Photographs promoted CPR's immigration and colonization schemes, recorded the first struggling new communities, and captured the likenesses of western Canada's pioneers.

The company's 1881 charter allowed CPR to branch out into land sales and settlement, port and shipping facilities, telegraph and express services, and even marketing the new communications technology invented just five years before—Alexander Graham Bell's telephone. Later, when airplanes were invented, CPR amended its charter to include the exploitation of that new transportation technology as well.

During two world wars, CPR came to the aid of Canada, at home and abroad, on land and at sea. The photographs of this time provide a fascinating glimpse at the challenges and personalities of war.

On 13 June 1886, three weeks before CPR's first scheduled transcontinental passenger train reached the west-coast city of Port Moody, British Columbia, a devastating fire tore through neighbouring Vancouver, reducing the city of about five hundred buildings to rubble. The determined, entrepreneurial spirit of the city is evident as the first city council meeting after the fire convened for a photograph outside a tent temporarily christened "City Hall." Mayor Maclean is seated in the middle, and CPR land commissioner Lauchlan Hamilton is seated at the end of the table on the right-hand side. One of the items on the agenda that day was the purchase of a fire engine.

Harry Torkington Devine, NS.24619

For centuries, the First Nations peoples of the plains hunted the plentiful herds of buffalo as a source of food, shelter, and clothing. With the completion of the railway and the dramatic increase in the numbers of settlers, the buffalo was hunted in ever-increasing numbers—almost to the point of extinction. For a time in the late nineteenth century, First Nations and Métis peoples collected buffalo bones at locations such as Gull Lake, in the future province of Saskatchewan, shown here in 1891, selling them by the ton to be shipped to manufacturing centres in the east where they were converted into phosphate for fertilizers.

Trueman & Caple, O. Lavallée Collection, A.7631

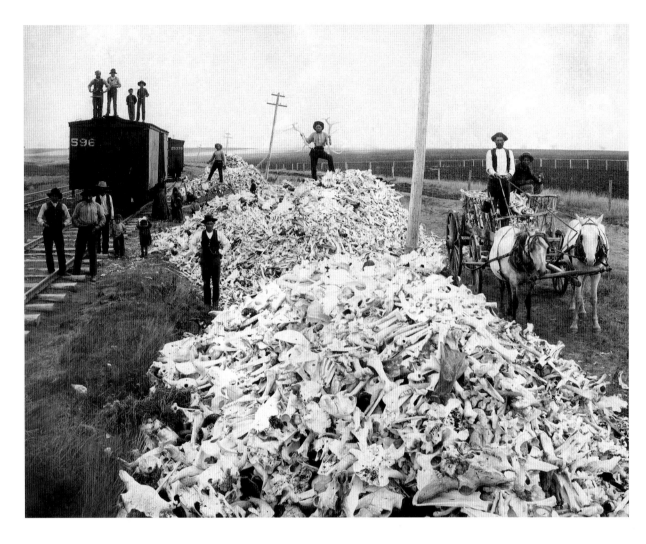

Alexander Henderson

Alexander Henderson, who was born into a wealthy Scottish family, immigrated to Canada in 1855 and became a merchant in Montreal. Henderson embraced the relatively recent invention of photography, specializing in landscapes. As an amateur photographer, he published a photographic album entitled *Canadian Views and Studies* in 1865. Soon after, he opened his photographic business at 10 Phillips Square. Long before CPR laid any rail, Henderson had recorded the operations of the Quebec, Montreal, Ottawa and Occidental Railway (later acquired by CPR) and the Intercolonial Railway. Henderson's success as a photographer coincided with CPR's hunger for the recorded image and he was appointed the first manager of the railway's photography department in 1892.

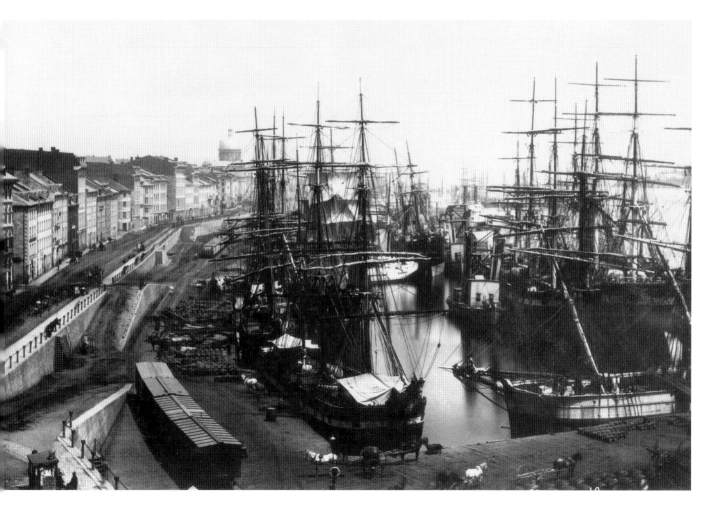

This view of Montreal's harbour, taken in the early 1870s from the old Custom House, is a fine example of Alexander Henderson's outstanding landscape photography. The location was frequently used by photographers to illustrate the burgeoning character of the city. During the 1870s especially, Henderson photographed extensively throughout Montreal, the province of Quebec, and parts of Ontario, gaining an international reputation.

Alexander Henderson, NS.709

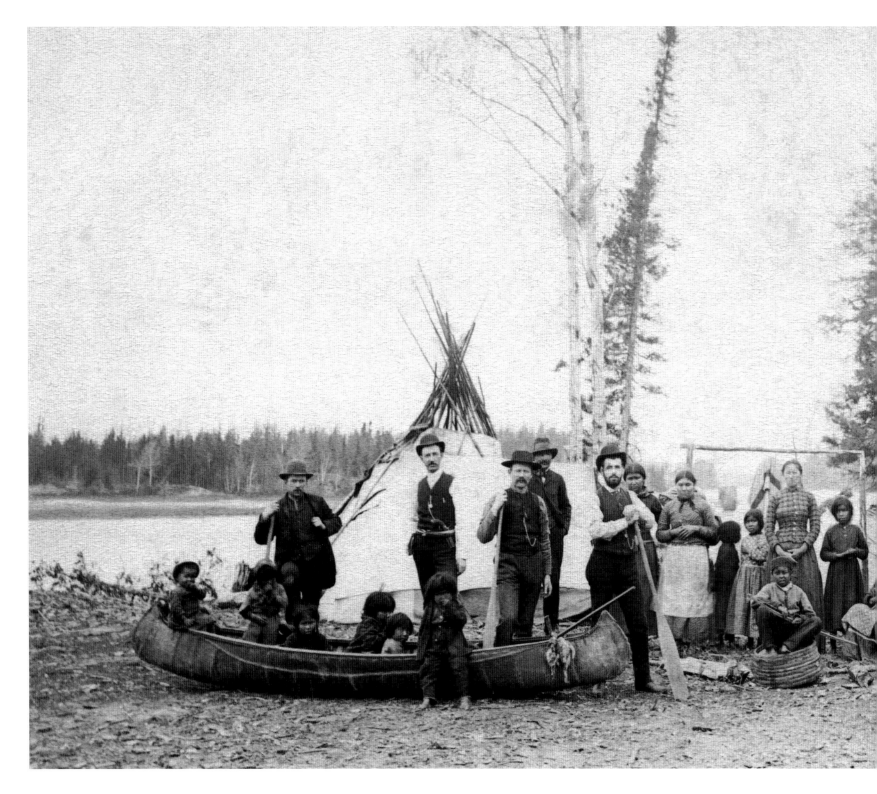

In 1884, a party of CPR surveyors and First Nations people gather at a Hudson's Bay Company post, possibly on Missinaibi Lake, about eighty kilometres north of the present site of Chapleau, Ontario. About one year later, rail was laid across the woods, rivers, creeks, and marshes of the Canadian Shield where Chapleau is located and where CPR established an important divisional point.

Anonymous, A.18090

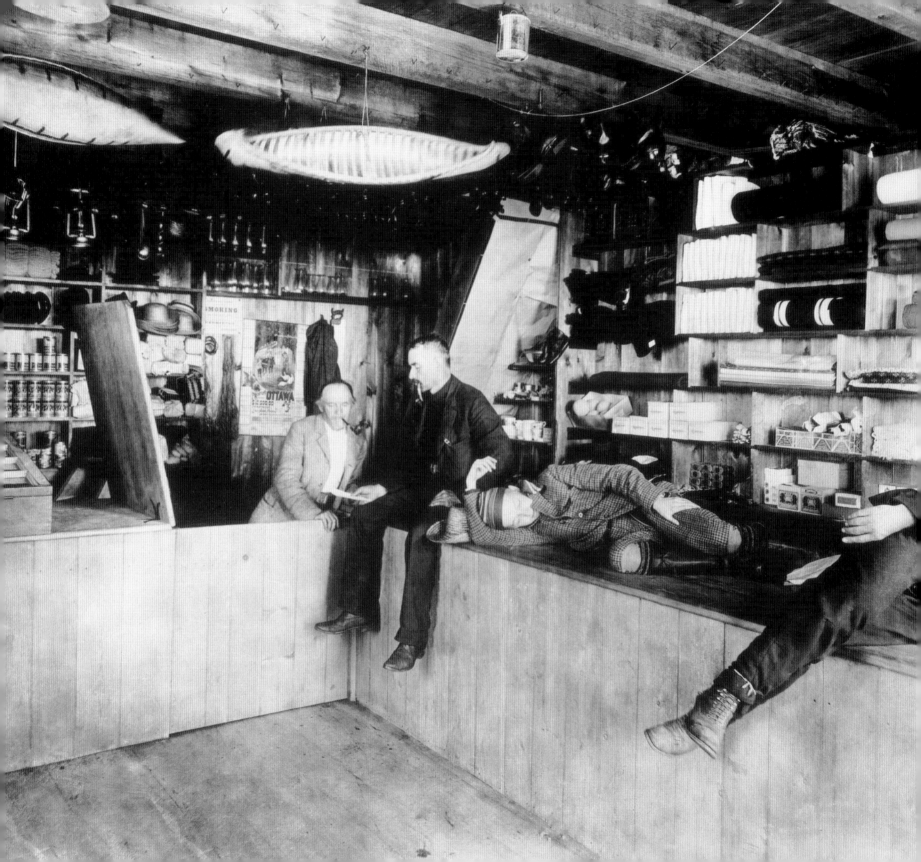

Canadian Pacific Railway and Hudson's Bay Company

The Hudson's Bay Company (HBC) store at Fort Témiscamingue on the shore of Lake Timiskaming, Quebec, was strategically located at the source of the Ottawa River and the doorstep of the vast Hudson's Bay Company lands. Established by the French in the early 1700s, it was acquired, along with other posts in the region, by Anglo-American traders in Montreal after the defeat of the French in 1760. The posts were purchased by the Northwest Company in 1794. After many years of competition in the fur trade, the Northwest Company merged with HBC in 1821.

The Hudson's Bay Company is Canada's oldest company and one of the oldest in the world. It was founded in 1670 by a charter from Britain's King Charles II, who also ceded to HBC all the land in North America drained by Hudson's Bay—an area called Rupert's Land. After two hundred years of fur trading, setting up forts and trading posts, HBC outdid its political and commercial rivals and was ready to do business with the fledgling country of Canada in 1869 and 1870. Canada acquired the 1.5-million-square-mile Rupert's Land for a mere dollar per square mile, but HBC kept its trading posts and was also allowed to keep one-twentieth of the more desirable prairie land "fairly fit for settlement." When CPR's charter was given royal assent in 1881, 25 million acres of the former HBC Rupert's Land was granted to the railway company. These 25 million acres, valued at 640 times what they were worth a dozen years before, were for the railway company to convert into cash, at a dollar an acre, to help defray the costs of building a transcontinental railway.

The Hudson's Bay Company and CPR came together primarily through one man—CPR's senior director, Donald A. Smith, who drove the last spike at Craigellachie in 1885. Born in Scotland, Donald Smith came to Canada in 1838 at the age of eighteen. Arriving in Montreal, he worked for the HBC and ended up in remote company outposts He endured great hardships, went snow-blind, was cured, and then was banished to Labrador. Through determination and perseverance, he rose to the top job at HBC, becoming its governor in 1889. However, a lot of fur flew before he reached the top job at HBC—and a lot of it had to do with CPR.

As the Selkirk (Winnipeg North) Member of Parliament in the 1870s, Smith went "independent" and voted against his Conservative mentors. The brash move toppled the government and caused Sir John A. Macdonald's Conservatives to resign. The reason for his "no" vote was the Pacific Scandal. Macdonald's Conservatives had accepted Sir Hugh Allan's 1872 campaign contributions, which were supposed to secure him the

Hudson's Bay Store,
Fort Témiscamingue,
in about 1900.

Anonymous, NS.974

Opposite page: Beginning in 1884, CPR's bilingual exhibition car criss-crossed Ontario and Quebec promoting the "great openings for immigrants to the boundless limits of the great Canadian North-West." Lavishly displayed inside the car were varieties of grains and vegetables that could be grown on the prairies, together with specimens of ore, copper, and iron from the Bow River. The heads of Rocky Mountain goats, mountain sheep, and antelope convinced the viewer of the abundance of wild game. Canadian Pacific Railway's use of photography as a promotional tool is evident from the series of framed photographs mounted on the wall.

Anonymous, NS.12974

Although spartan in appearance, the colonist sleeping cars introduced by CPR in 1884 were a decided improvement over the ordinary day coaches that previously transported immigrants to the western prairies. Available at no extra cost over the coach fare, the colonist cars provided upper and lower sleeping berths and were equipped with a combination car heater and cookstove on which the occupants could prepare their own hot meals.

Anonymous, NS.12968

CPR presidency. Smith's "thumbs down" vote forced the government to resign and hold a new election, resulting in a win for Alexander Mackenzie's Liberals. When Macdonald was back at Canada's helm and still had to produce a transcontinental railway, Smith's name was left off the official CPR charter, as a concession to the prime minister. Smith remained, however, very much involved in the new CPR syndicate, even though he was a dyed-in-the-wool HBC man. He was also cousin to George Stephen, CPR's first president.

For almost as long as Smith was CPR's senior director, a post held since the company's founding in 1881 until his death in 1914, he was also HBC's governor. After becoming a knight and later a lord, Smith was also the United Kingdom's High Commissioner for Canada. As such, he enticed British immigrants to come to Canada and settle the fertile land of the western prairies, which was, after all, ex-HBC land.

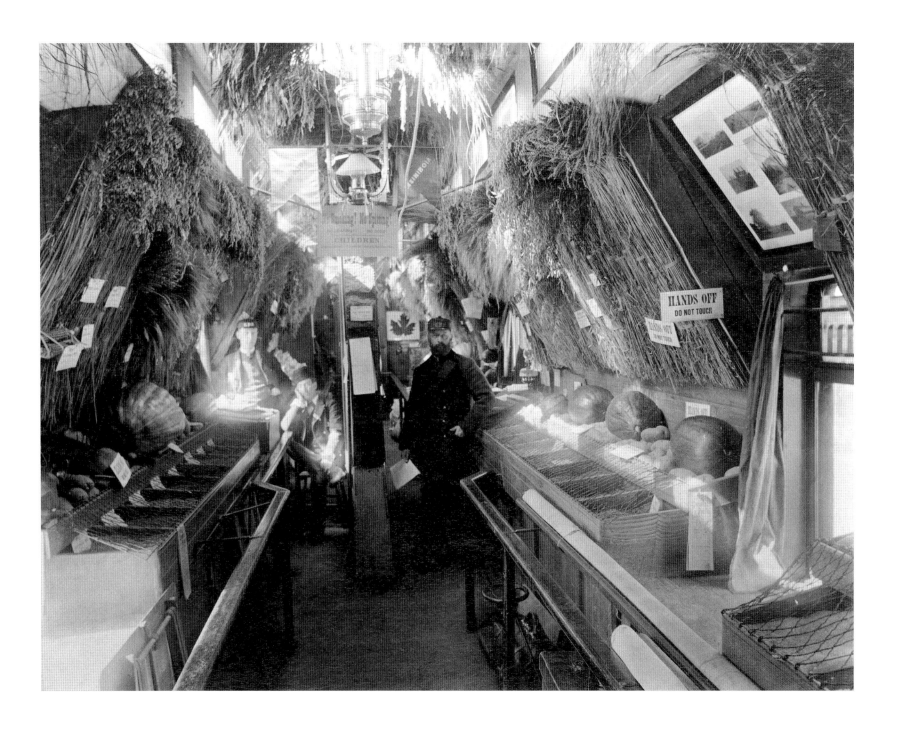

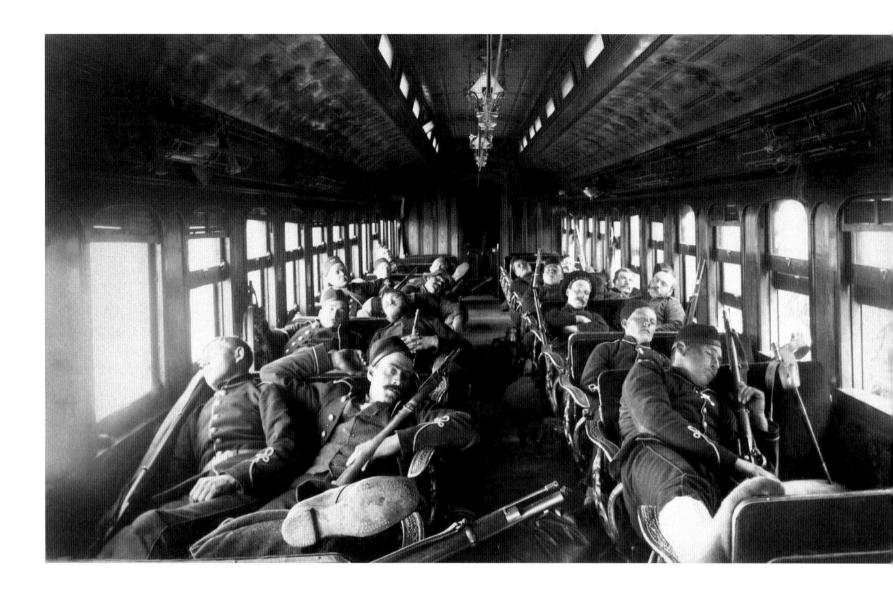

When the encroachment of civilization triggered the North-West Rebellion in 1885, CPR moved troops, such as these photographed by Oliver B. Buell, from the east to the Winnipeg staging area in about a week, a journey that had previously taken about three months. The efficient movement of the troops convinced the federal government of the railway's importance and prompted it to secure CPR's outstanding loans.

Oliver B. Buell, A.4253

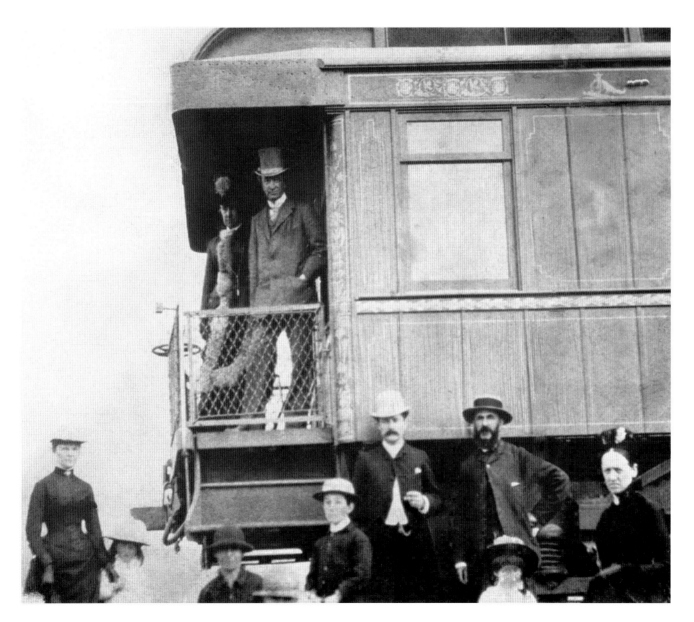

Prime Minister Sir John A. and Lady Macdonald travelled across Canada on the Jamaica, one of CPR's official private cars, shortly after the first scheduled transcontinental train in July 1886. Their journey included stops at Port Arthur, Winnipeg, Regina, Gleichen, and Calgary. Macdonald's sense of accomplishment is evident in this photograph, as he and Lady Macdonald stand aboard the rail car. He had fulfilled his promise, made a decade and a half earlier, to build a transcontinental rail line and to bring the province of British Columbia into Confederation. Lady Macdonald, who accompanied her husband across the country, was so inspired by the beauty of the Canadian Rockies that she decided to travel on the locomotive's cowcatcher. "This is lovely, quite lovely. I shall travel on this cowcatcher from summit to sea!" she said, much to the consternation of the train crew.

Anonymous, NS.10217

Unable to let such an auspicious occasion slip by unrecorded, an unknown photographer captured a group of CPR employees staging their own last spike celebration near Donald, British Columbia, on 7 November 1885, after the official last spike had been driven at Craigellachie.

Anonymous, NS.1340

Opposite page: At noon on 4 July 1886, the first scheduled passenger train to cross Canada over the completed CPR line arrived "sharp on time" at Port Moody, British Columbia, the company's westernmost terminus. The momentous journey began 139 hours earlier with the departure of the westbound Pacific Express from Montreal. Ten months later, Port Moody would become a station-stop en route to the company's new terminal in Vancouver.

Thomas Sinclair Gore, NS.19991

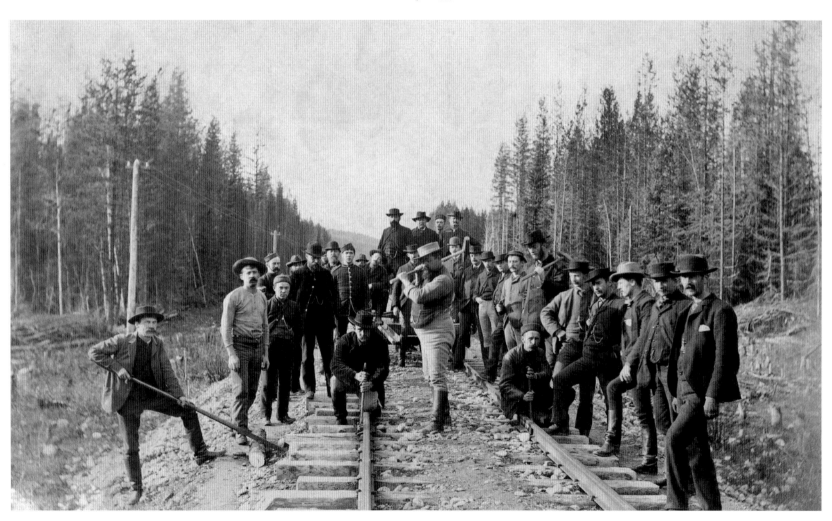

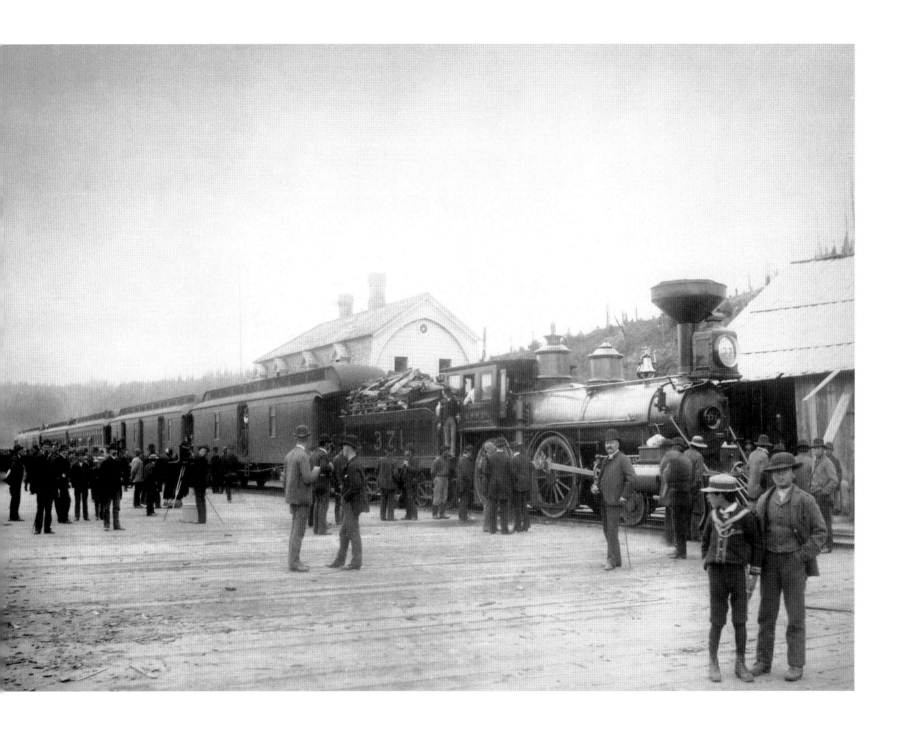

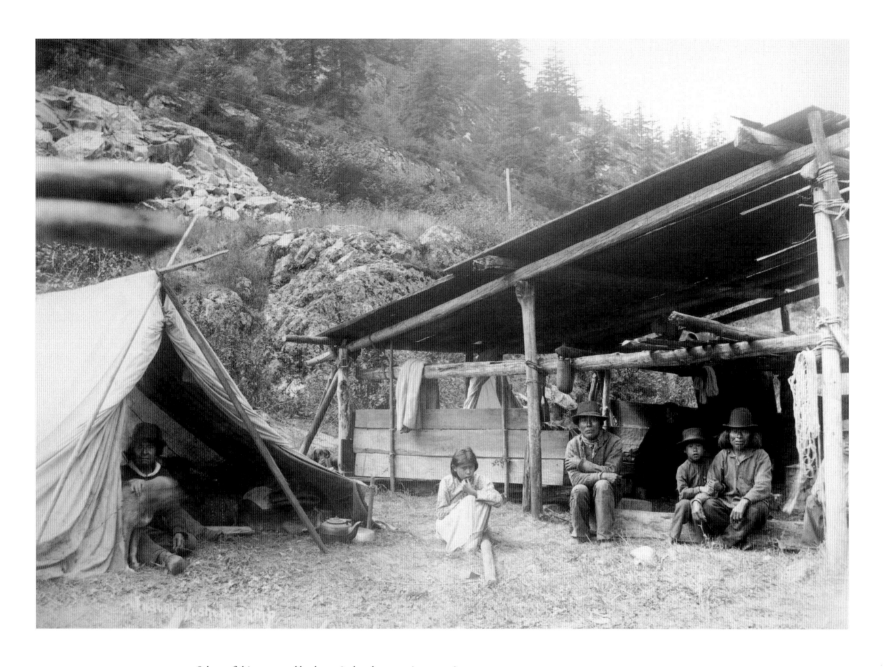

Salmon fishing ensured both survival and economic prosperity
for many British Columbia First Nations peoples. An
unsuccessful salmon run could mean starvation not only to
the members of this fishing camp, but to an entire community.
The people in this fishing camp were photographed in 1886,
the year the first transcontinental trains reached the west coast.

J. A. Brock, A.11407

Boorne & May

William Hanson Boorne and his cousin Ernest Gundry May were amateur photographers in England. They immigrated to Canada and opened a studio in Calgary in 1886. Boorne travelled widely and is largely credited with the studio's published work, while May operated the darkroom and studio. Their views of the west, and especially of First Nations people, provide an important record of the era. Although May quit the business, the Boorne & May firm continued until 1893, when it went bankrupt. Boorne and his family eventually moved back to England.

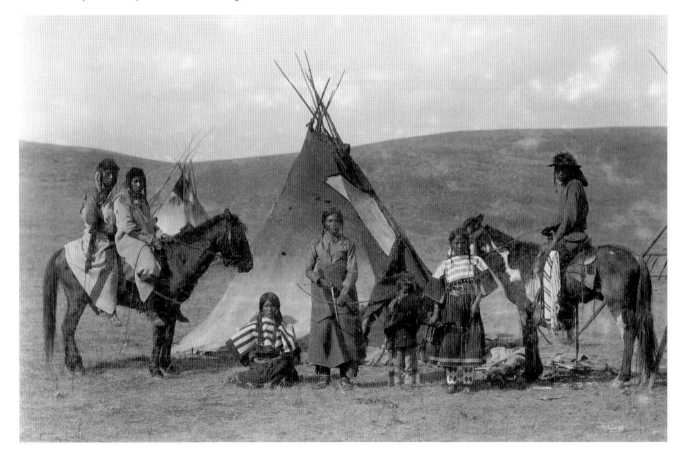

Astokumi, a Tsuu T'ina (Sarcee) Native, who was also known as Crow Collar, poses for a photograph with his family around 1887. Astokumi lived on the Tsuu T'ina reserve adjacent to Calgary on the Elbow River.

Boorne & May, A.1729

Fairly Fit for Settlement

In 1881, CPR received a federal grant of 25 million acres of land "fairly fit for settlement" and $25 million cash to build a transcontinental rail link across the prairies. The cash helped build the $165.5-million transcontinental line, but the land was of little value as it was, with few original settlers and only pockets of First Nations and Métis peoples serving as a potential traffic base for the railway.

In the mid-1880s, CPR embarked on a program to settle the west. The company set up no fewer than ten experimental farms along the prairie main line. English and French CPR posters were plastered across Ontario and Quebec and a special bilingual CPR advertising car travelled the rails showing off what could be grown bountifully on the prairies. The aim was to entice crowded easterners into the west and stem a growing nineteenth-century move off the farms of eastern Canada into the industrialized northeastern United States. Immigration and colonization programs later spread overseas to Europe, especially after CPR got its own fleet of ships on the Atlantic Ocean.

Since parts of southern Alberta were parched during much of the grain-growing season, CPR embarked, at the beginning of the twentieth century, on a $40-million irrigation scheme on the last 3 million acres of its original land grant. By the mid-1930s, the scheme had only netted $26 million for the railway—a shortfall of $14 million. It did, however, help grow and settle the prairies, providing CPR with inbound passengers and goods and outbound crops and natural resources. Canadian Pacific Railway also brought trainloads of settlers up from the United States.

In the first decade of the twentieth century alone, Canada's population grew by one-third, from 5.3 million in 1901 to 7.2 million in 1911. Nine hundred thousand people settled on the prairies, tripling the population there. Saskatchewan wheat crops grew elevenfold from half a million planted acres to 5.5 million acres. Canadian Pacific Railway set up new experimental and supply farms and a sugar beet factory, raised cattle, horses, and pigs, and built a honeycomb of new branch lines, reaching an apex in 1909. That year, CPR spent more on immigration and settling the prairies than the Canadian government did.

Colorado settlers arrive at
Bassano, Alberta, in 1914.

Anonymous, A.827

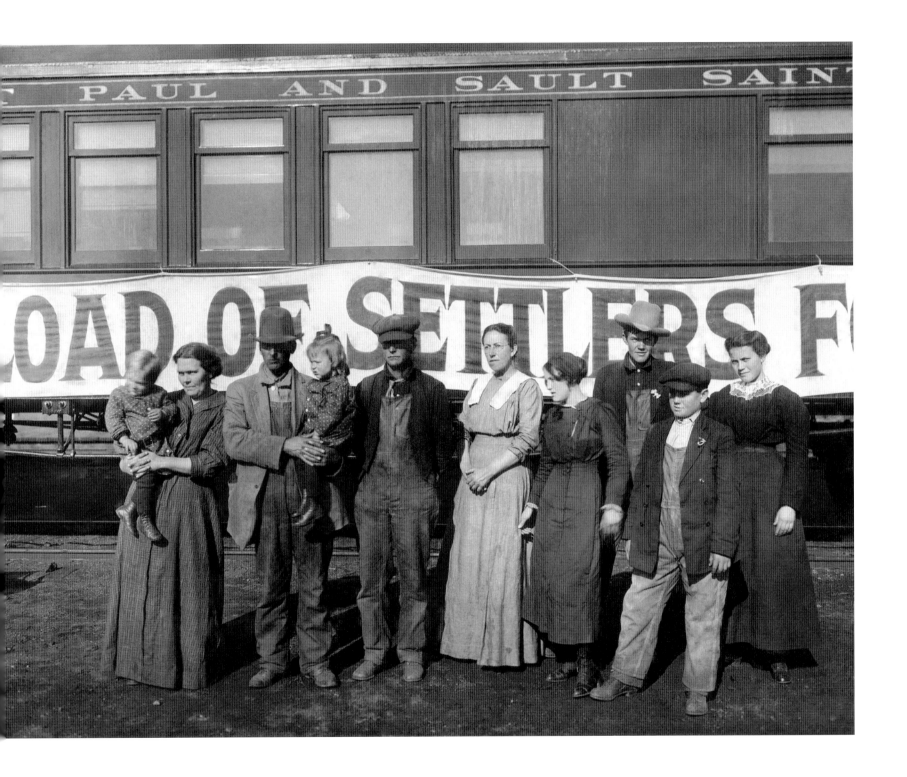

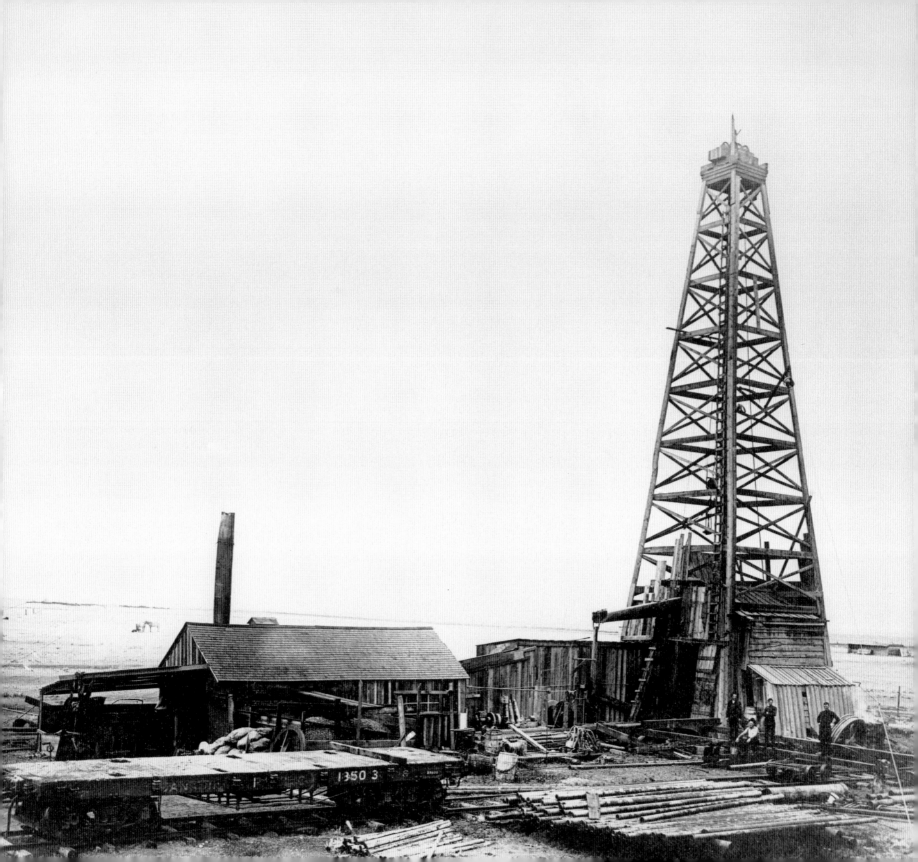

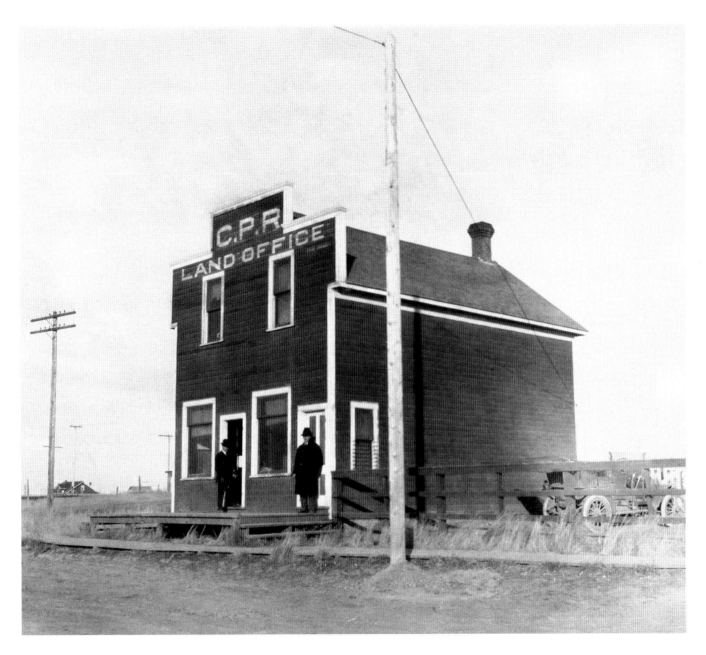

In 1914, about a year before this photograph was taken of CPR's land office at Bassano, Alberta, the company had completed an aggressive scheme to irrigate a large area of semi-arid land in southeastern Alberta. The plan included a 3.2-kilometre aqueduct constructed at Brooks, an enormous dam built at Bassano on the Bow River, and about four thousand kilometres of canals and ditches. The whole system was expensive to maintain and the irrigation scheme itself was a money-loser for the railway company, but the traffic and commerce created by the new crop of Alberta settlers benefitted CPR and Canada immeasurably.

Anonymous, A.2081

Opposite page: In December 1883, a CPR construction crew drilling for a source of water for the company's steam locomotives accidentally discovered natural gas at the Langevin siding, about fifty-six kilometres west of Medicine Hat, in the future province of Alberta. This marked the beginning of western Canada's petroleum industry. In 1909, the Old Glory well, the largest of its time, was drilled by CPR on Bow Island. In 1912, at about the time this photograph was taken of a derrick in southeastern Alberta, the first gas pipeline in Alberta was built from Bow Island to Calgary.

Anonymous, A.37360

Ready-Made Farms

Perhaps the most intriguing of CPR's settlement schemes was the ready-made farm program. By 1909, CPR's last big block of land-grant sections for colonization in southern Alberta was still largely unoccupied. Even when CPR had sold the land, settlers were seldom seen. In the Bow Valley, only one out of every ten parcels of CPR land sold to settlers was actually occupied. Absentee landowners held most of the land, many of them unsure how to go about raising crops in this dry portion of the Canadian prairies. Canadian Pacific Railway tried irrigating some of the land, but when it still wasn't being settled, the company set up ready-made farms sure to attract British settlers.

The farms were not for just anybody. Only married men could buy the land and the big publicity push—"Get your home in Canada from the Canadian Pacific"—went on in England only. Each turnkey farm had a ready-made house, barn, well, and pump. Attractive pamphlets with a photograph of well-dressed British-looking families on the porches of cozy little farmhouses circulated around the "old country." The pamphlet tantalized future farmers with quarter-section and half-section farms that came already fenced and with one-third of the land plowed and ready to seed.

Ready-made farms were located near schools, churches, and, of course, the railway. The colourful posters promised "Special farms on virgin soil near the railway. And close to schools, markets, churches, etc." The posters also promised that farms "are prepared each year for British farmers of moderate capital—payments in easy installments." Ten equal payments of thirteen hundred dollars a year got the British expatriate a smaller farm. Twenty-five hundred a year would get you a larger one—a half-section or 320 acres.

The ready-made farm scheme went on for ten years, resulting in twenty-four separate colonies of ready-made farms, most in Alberta, but also some in Saskatchewan. All told, the railway company developed 762 ready-made farms in the ten-year span between 1909 and 1919. The new farmers, however, did not all prosper. The company's advertising was a victim of its own success, appealing mostly to the English urban poor—hardly a savvy bunch of soil and livestock harvesters. For those who did know what they were doing, the relatively small size of the ready-made farms made them suitable for subsistence-level farming, but not for commercial exploitation. Once the Dirty Thirties kicked in, some of the British urbanites-turned-farmers weren't able to sustain themselves on their ready-made farms.

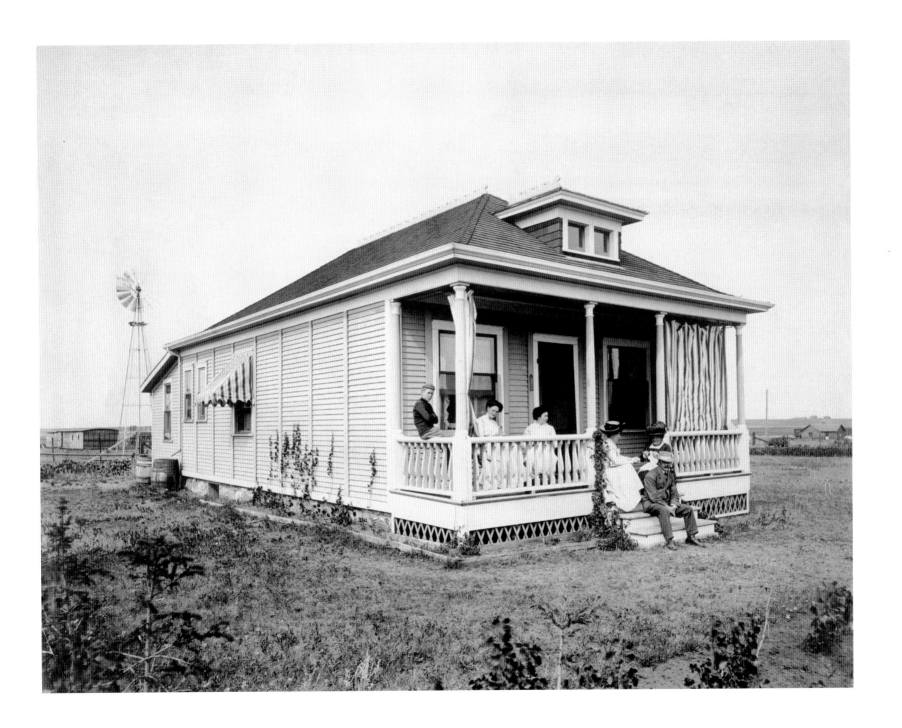

Thomas Shaughnessy, CPR's president during World War I, put the resources of the company at the British Empire's disposal. In this photograph taken about 1916, women help the wartime effort by manufacturing munitions in CPR's Angus Shops in Montreal.

Anonymous, A.15505

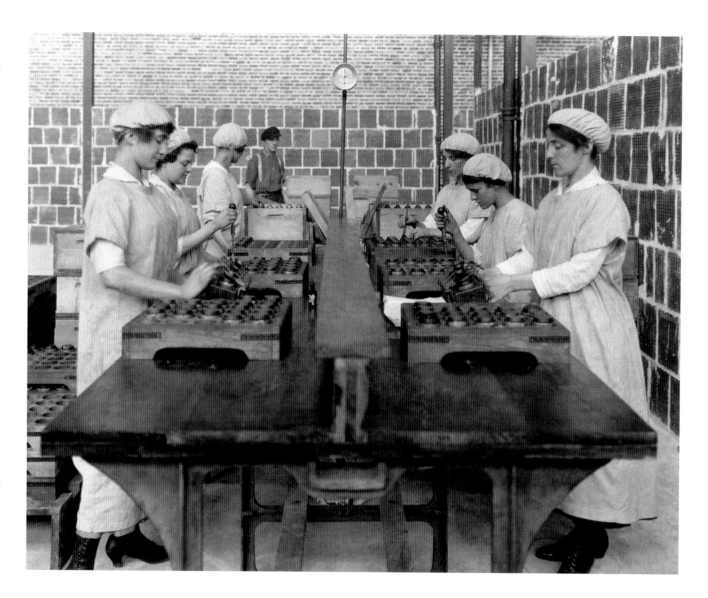

Opposite page: In addition to providing medical treatment and humanitarian aid overseas and raising funds in Canada, the Red Cross also staffed hospital cars, such as the one shown in this World War I photograph. Converted from former CPR passenger cars, the hospital cars transported wounded soldiers to their homes across the country.

Anonymous, NS.3871

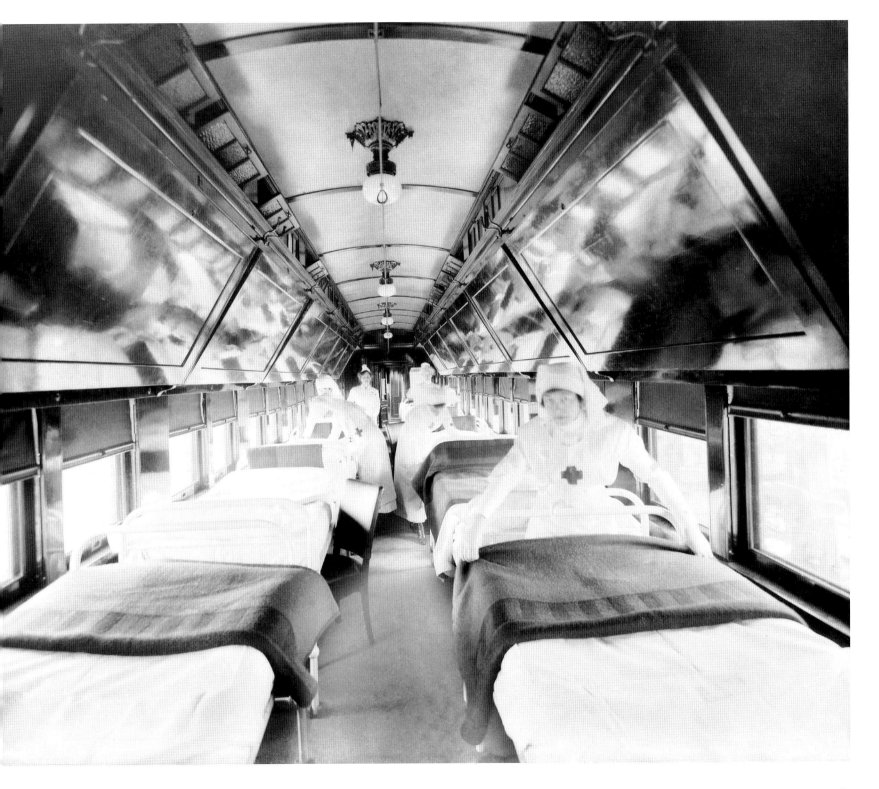

Canadian Pacific Railway and World War I

During World War I, not only were CPR's trains and tracks at the British Empire's beck and call, but also its ships, shops, hotels, telegraphs, and its people. Aiding the war effort meant transporting and billeting troops, building and supplying arms and munitions, and arming, lending, and selling ships. Fifty-two CPR ships were pressed into service during the war, carrying more than a million troops and passengers and four million tons of cargo. Twenty-seven survived and returned to CPR. Twelve sank, mostly torpedoed by U-boats, two sank by marine accident, ten were sold to the British Admiralty, and the Maharajah of Gwalior turned CPR's *Empress of India* into a hospital ship. Many of the company's ships that served in the war were cloaked in distinctive "razzle dazzle" camouflage paint. This puzzling zigzag paint job helped to confuse the enemy. Enemy spy glasses and periscopes could hardly differentiate the camouflaged ships from the choppy sea or distinguish them as ships on the horizon.

But CPR's most important contributions were its men and women, at home and abroad: 11,340 CPR employees enlisted. A catastrophic 10 per cent (1,116) were killed, and nearly 20 per cent (2,105) were wounded. Two CPR employees received the coveted Victoria Cross and 385 others were decorated for valour and distinguished service.

The company also helped the war effort with money and jobs. It made loans and guarantees to the Allies to the tune of $100 million and also took on 6,000 extra people, giving them jobs during the war. When the fighting was over and the troops came home, CPR found jobs for the ex-soldiers—7,573 CPR enlistees came back to jobs with the company, while an additional 13,112 veterans were hired.

Canadian Pacific Railway was also the backbone of the Canadian Overseas Railway Reconstruction Corps—a group of skilled railroaders and engineers who went to Europe during and after World War I to rebuild its damaged railway infrastructure.

The *Empress of Russia*, a World War I troop ship with razzle dazzle camouflage, photographed about 1915.

Anonymous, NS.25229

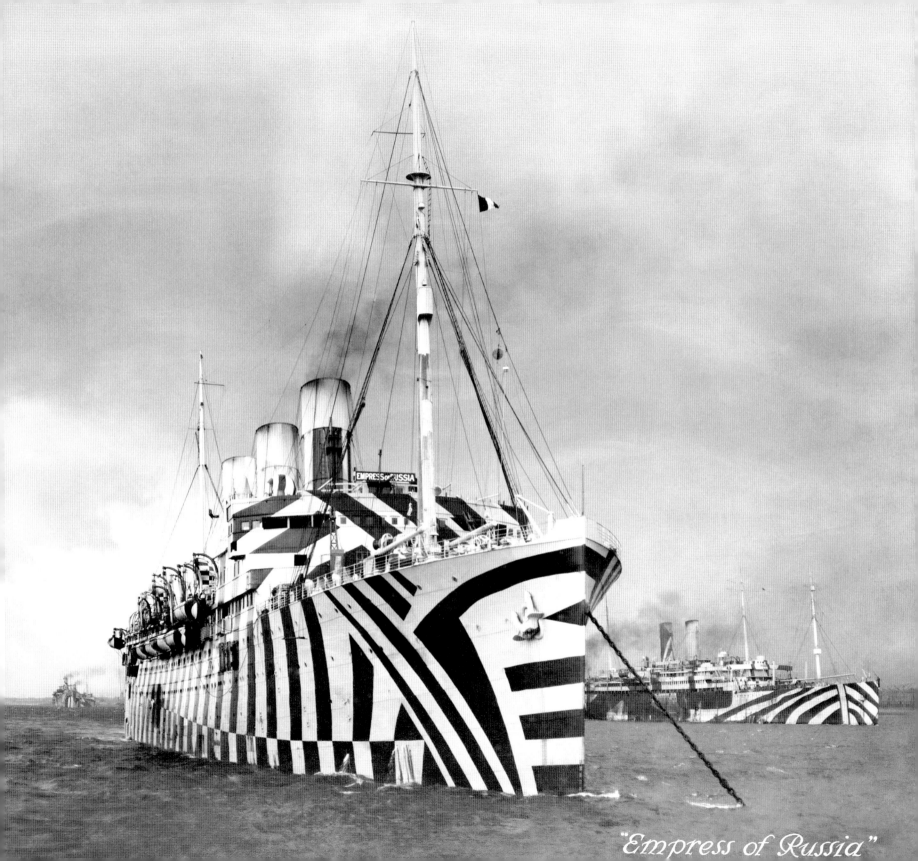

"Empress of Russia"

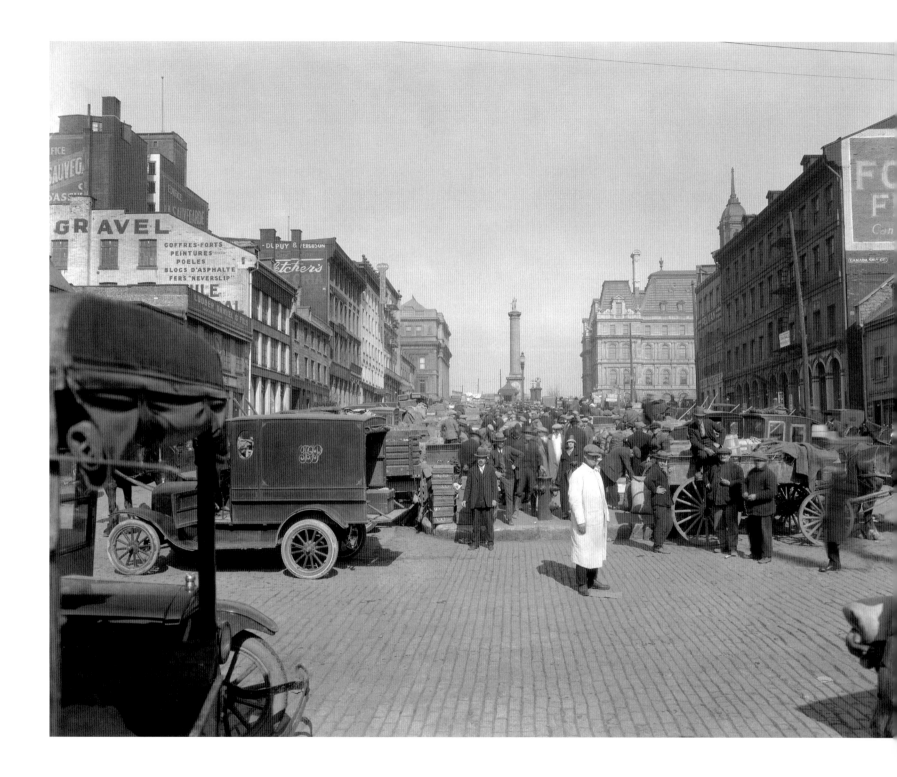

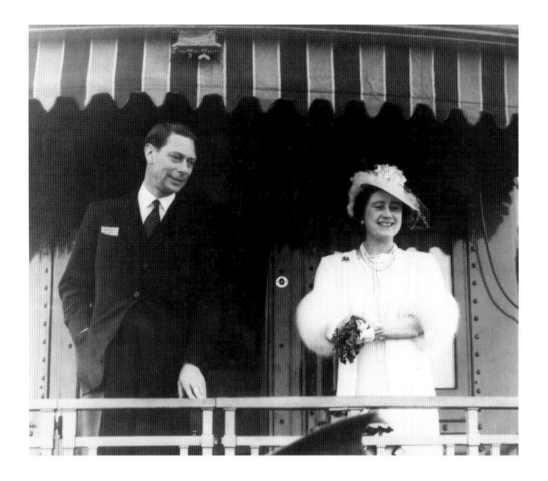

Opposite page: Situated in the heart of Vieux Montréal, Place Jacques Cartier has changed little since it was first opened as a public market in 1847. At the time, Montreal, the largest city in British North America, was the commercial hub and political capital of a united Upper and Lower Canada. At the foot of Place Jacques Cartier were the growing port of Montreal and the Lachine Canal, which allowed commerce with the rest of Canada to flourish. At the upper end of the place, in the centre of this 1927 photograph, stands the Nelson Column, honouring Lord Nelson's victory over Napoleon Bonaparte's French navy at Trafalgar.

J. C. S. Bennett, NS.18228

In 1939, King George VI and Queen Elizabeth embarked upon the first royal visit of a reigning monarch to Canada. A specially marshalled and painted train transported the royal couple westward on the CPR lines and eastward on Canadian National. Thousands of well-wishers greeted the royals during their forty-four-day trip. The trip also marked another Canadian first when photographs transmitted by CPR telegraph around the world allowed newspapers to print "today's pictures today."

Anonymous, A.15194

Canadian Pacific Railway and World War II

The entire CPR network was again pressed into action in World War II. On land, CPR moved 307 million tons of freight and 86 million passengers, including some 300,000 army, air force, and navy personnel. At sea, twenty-two CPR ships went to war; twelve were sunk and two more lost by marine accident. As in World War I, CPR employees paid the price in human terms. Of the 21,787 employees enlisted in World War II, 658 sacrificed their lives.

In 1940, CPR collaborated with the British and Canadian governments in organizing the Atlantic Ferry Bomber Service—the "Atlantic Bridge." Under the company's newly created Canadian Pacific Air Services department, Burbank, California-built Lockheed-Hudsons were flown to St. Hubert near Montreal and then dispatched, via Newfoundland, to the British Isles. The first transatlantic bomber delivery took place on 11 November 1940, when seven Hudson bombers took off from Gander, Newfoundland, and arrived safely in Britain less than ten hours later. The service was eventually handed over to the Royal Air Force. Canadian Pacific Railway also helped open Canada's strategic far north and set up pilot training schools.

Much of Angus Shops in Montreal was turned over to building Valentine tanks and munitions. In March 1942, at the height of production, 4,200 Angus shop employees, working seven days a week over three shifts, turned out three Valentine tanks a day. Calgary's Ogden Shops were mostly dedicated to naval guns, building them not only for Canada and Great Britain, but also for the United States. Weston Shops in Winnipeg became the main locomotive shops for the system. Wartime shop production signalled the end of the Great Depression and provided jobs to many laid-off CPR employees. The company also offered jobs on the home front to CPR employees' offspring who wanted to contribute to the war effort. One such job recipient was an Angus Shops carpenter's son, hockey legend Maurice "Rocket" Richard, who worked as a machinist for CPR's munitions department after being rejected by the Canadian army because of bad ankles. Although on leave since October 1942, the Rocket didn't resign his "secure" CPR job until he was comfortable with his hockey career—a few weeks into the 1944–45 hockey season, when he scored his record-setting fifty goals in fifty games.

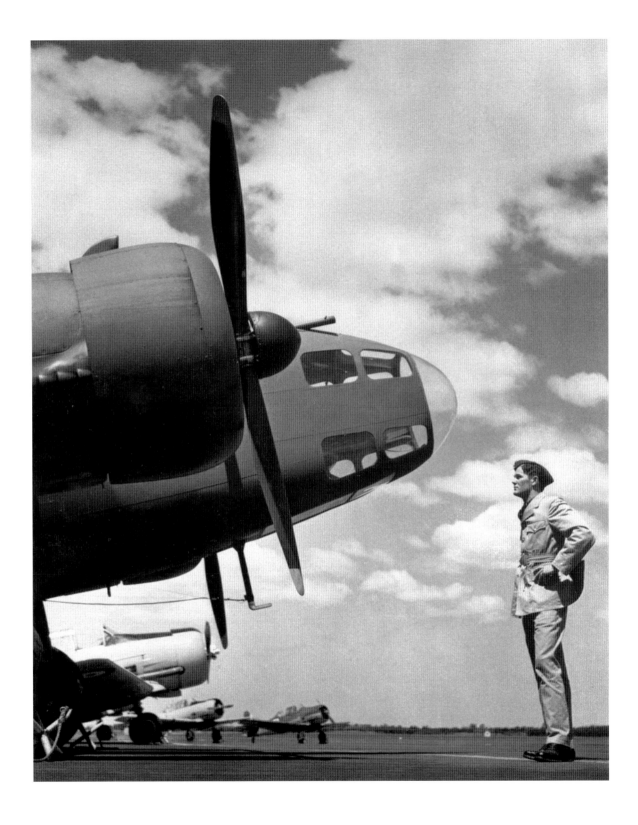

The Atlantic Ferry Bomber
Service delivered Lockheed-
Hudson bombers to the British
Isles during World War II.

Anonymous, NS.3807

In this World War II photograph, Angus Shop employees work on locomotive bells, continuing to maintain CPR's fleet of locomotives and rolling stock while manufacturing tanks, munitions, naval gun mounts, and engines for the navy's corvettes at its main shops.

Anonymous, NS.3003

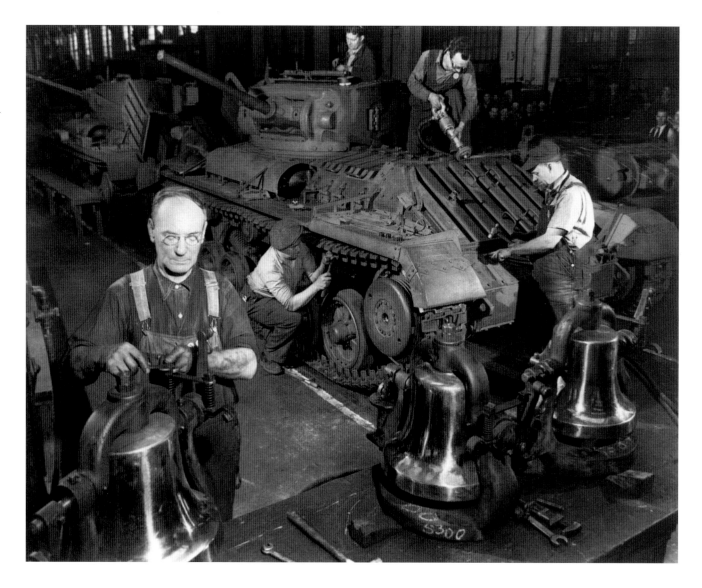

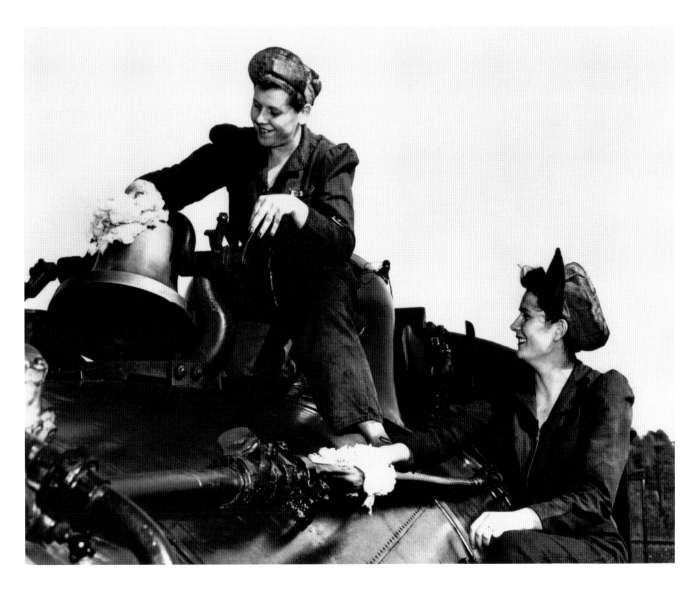

With the ranks of male employees thinned by enlistment in the armed forces during World War II, hundreds of women volunteered to take over a variety of jobs connected with the day-to-day running of the railway, particularly in the operating, mechanical, maintenance-of-way, and communications departments. At the Sudbury engine terminal in 1943, CPR employees Myrtle Pearson (left) and Julia Patrash took over the traditionally male task of wiping down locomotives between runs.

Anonymous, *Sudbury Star*, NS.4760

Opposite page: With the end of World War II in 1945, thousands of soldiers like the men in this photograph returned to Canada and began looking for work in a newly prosperous economy. Between 1939 and 1945, the Canadian economy had doubled, agriculture had become modernized, manufacturing had grown quickly, unemployment had become almost non-existent, and more than a million women had joined the workforce. Canadian women were not allowed to fight, but they participated in the war effort by joining the women's divisions of the armed forces and by stepping into wartime jobs in business or industry. "The kind of girl we want … is the girl with a good head on her shoulders. We take girls absolutely unskilled in war industries and train them right at the plant," said an announcement in the 5 October 1942 edition of the *Regina Leader-Post*. When the war was over, many of the women left their jobs and returned to being homemakers, thus creating instant job opportunities for the returning soldiers.

Anonymous, War.9.2

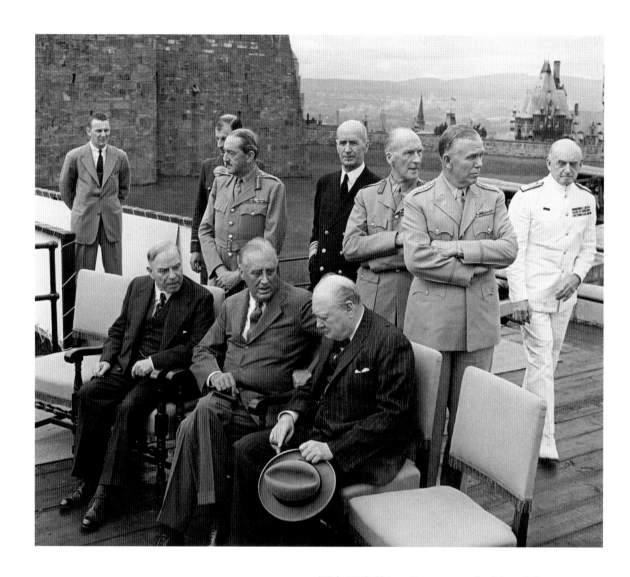

With CPR's Château Frontenac as a backdrop, (left to right, seated) Prime Minister Mackenzie King of Canada, President Franklin D. Roosevelt of the United States, and Prime Minister Winston Churchill of Great Britain pose for the press. In August 1943, the men met here for the First Quebec City Conference, code-named Quadrant, to plan the Normandy, France (D-Day), landing and invasion of German-occupied Europe for the following June.

Anonymous, War.96

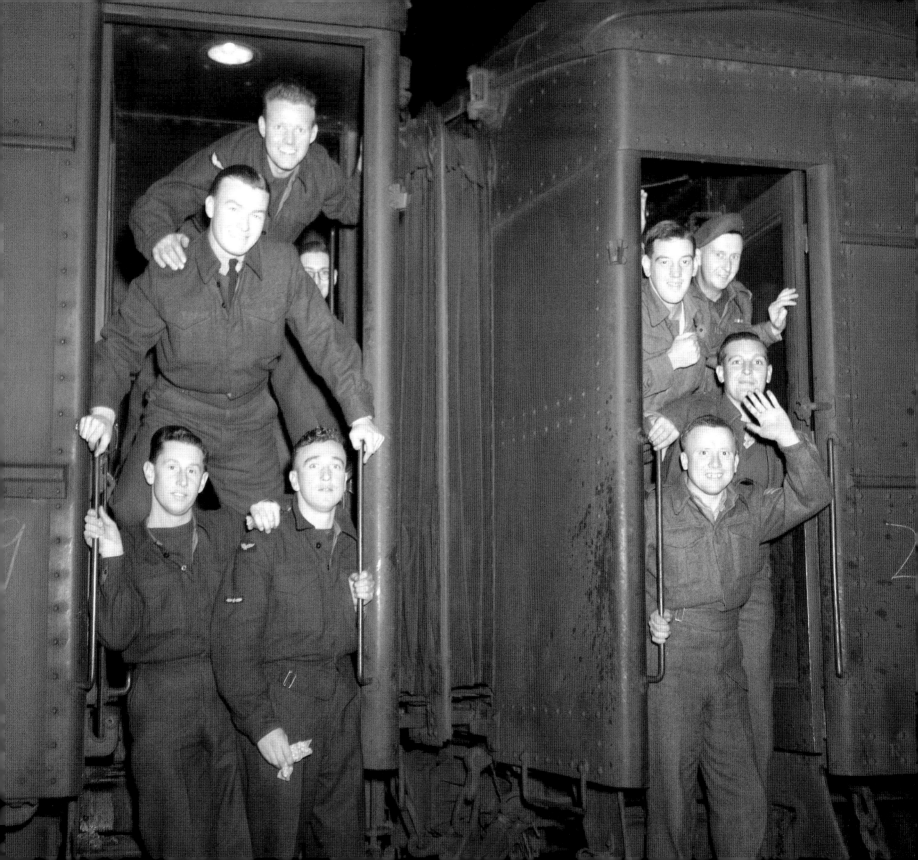

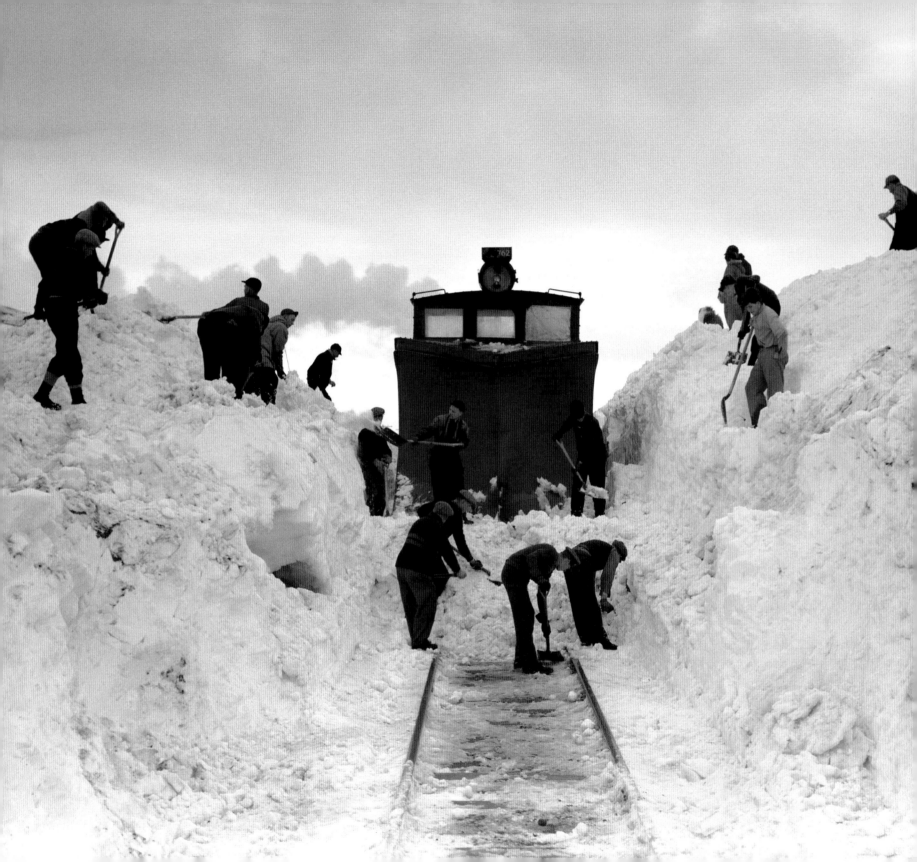

Mickey Potoroka

Mickey Potoroka was born in Arborg, Manitoba, a small town about one hundred kilometres north of Winnipeg in 1918. He joined the Royal Canadian Air Force in September 1939 and three months later, as a flight sergeant/photographer, was shipped to England to fly aerial reconnaissance. "You had to lie face down to see what you were doing," Potoroka said of his wartime photography experience, much of it spent in the belly of a small aircraft. He returned to Canada in 1941 and taught photography at the RCAF air school in Portage la Prairie until the end of the war. Potoroka put his considerable experience to work when he joined CPR in 1945 as photographer. His subjects ranged from airlines to farming to the harsh winter conditions encountered in prairie railroading. He was transferred to Toronto as a press representative and later returned to Winnipeg, retiring in 1981 after 35 years. His photographs are eloquent witnesses to the evolution of CPR in western Canada following World War II.

In February 1947, CPR public relations representative and photographer Mickey Potoroka took a series of photographs of one of the worst winter storms ever to hit Saskatchewan and Manitoba. Six-metre-high snow drifts, gale-force winds, and bone-chilling temperatures shut down the railway's prairie main line for several days—a first in the company's history. Work crews battled the snow with plows, bulldozers, and sometimes shovels, clearing more than 4,800 kilometres of main and branch lines.

Mickey Potoroka, P.906

Celebrity Train Travellers

It took more than a century to do it, but CPR has carried over 800 million passengers on its trains. So it's no surprise that some of these train travellers were celebrities. Canadian Pacific Railway has hosted senators, prime ministers, presidents, dukes and duchesses, princes and princesses, kings, queens, and emperors—past, present, and future.

Some were yet to be famous when they travelled on the CPR—like the junior senator from Massachusetts and his new bride, Senator John F. Kennedy and Jacqueline Bouvier Kennedy; or Crown Prince Akihito, the future Emperor of Japan. The Kennedys and Prince Akihito travelled in relative anonymity in the early 1950s.

There are just too many to name them all, but here's a sampling of celebrities beginning with CPR's first two special guest couples: Prime Minister Sir John A. Macdonald and Lady Agnes Macdonald in July 1886; and, in 1889, Canada's governor general, Lord Stanley of Preston, whose lasting legacy is hockey's Stanley Cup, and Lady Stanley. Both couples travelled across Canada and started a trend of riding on the locomotive's buffer beam through the mountains. Later, in 1901, the Duke and Duchess of Cornwall and York crossed Canada via CPR, soon followed by Japan's Prince Fushimi and much later by Prince Akihito. Other celebrities included twentieth-century Canadian prime ministers Laurier, Bennett, and Mackenzie King; American president Franklin D. Roosevelt; the United Kingdom's Duke and Duchess of Windsor (the former King Edward VIII and Wallis Simpson); Winston Churchill (three times); British princesses Margaret and Anne; and King George VI and Queen Elizabeth. The king and queen travelled on the most famous CPR special train ever—the 1939 Royal Train. Queen Elizabeth II and Prince Philip toured Canada by rail during their first visit in 1951, before Elizabeth's coronation.

Noteworthy CPR travellers have included sports figures (Stanley Cup hockey teams, Grey Cup fans and players), clerics (Cardinal Léger), and even the world's first surviving quintuplets, the Dionne Quints. Industrialists and business tycoons travelled on the CPR, too. Chrysler's Lee Iacocca, General Electric's Jack Welch, Chinese shipping magnate Tung Chee Hwa, and the richest of all, Bill Gates, experienced the special business cars that are part of today's CPR luxury cruise train, the Royal Canadian Pacific. Among the entertainers who travelled on CPR trains were "America's sweetheart" Mary Pickford, Montel Williams (twice), Francis Ford Coppola, and George Lucas, to name but a few.

Queen Elizabeth II and the Duke of Edinburgh at a Royal York Hotel banquet in 1959.

Anonymous, A.16411

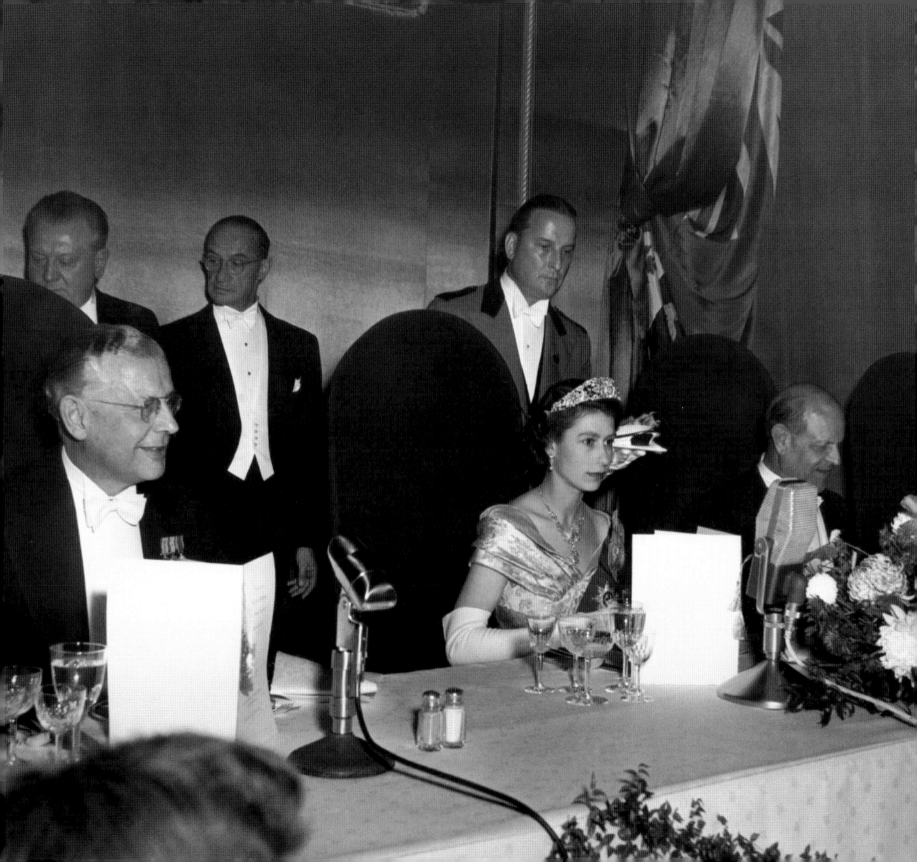

Arnold Harrington

Arnold Harrington began his career at CPR in 1945 in the expense accounts department; however, when he showed up at the company bowling league with his camera, a colleague suggested he apply to the railway's photography department. He did, and his hobby became his profession. Within a year, Harrington was offered a job as darkroom technician. Among his first tasks was making glass lantern slides.

The company's photographers were on call twenty-four hours a day and it was an after-hours assignment that led Harrington to take his memorable photographs of John F. Kennedy, then the junior senator from Massachusetts, and his new wife, Jacqueline, as they arrived near midnight at a deserted Windsor Station on a cold December evening in 1953.

In 1962, Arnold recognized that the future of the photography department depended on its lab acquiring equipment to produce colour prints. He obtained a budget of $250 to have the display department build eleven epoxy-lined wooden troughs to process colour prints and murals. Harrington also knew that a more automated machine capable of processing large murals would be needed in order for the department to remain competitive. In 1964, after convincing management of the machine's viability, Harrington and a seasoned Angus Shops foreman travelled to Kodak's Rochester, New York, facility to photograph and measure prototype colour processing equipment. The foreman returned to Angus and built an identical stainless steel state-of-the-art processor. The machine cost more than was budgeted and department heads had to spend an additional $35,000 for plumbing, wiring, and reinforcing the floors to accept the weight of the robustly built Angus Shops colour processor. No sooner had the first 40 x 60-inch print dried when Harrington ran it down to his bosses' office. The results were well received and the cost overruns soon forgotten.

Harrington's progressive flair earned him the top spot in the CPR photography department. By the early 1980s, when the company's diverse business portfolio made it Canada's second-largest company, Harrington managed the largest in-house photography department in the country. He retired in 1989, one month shy of forty-five years with CPR.

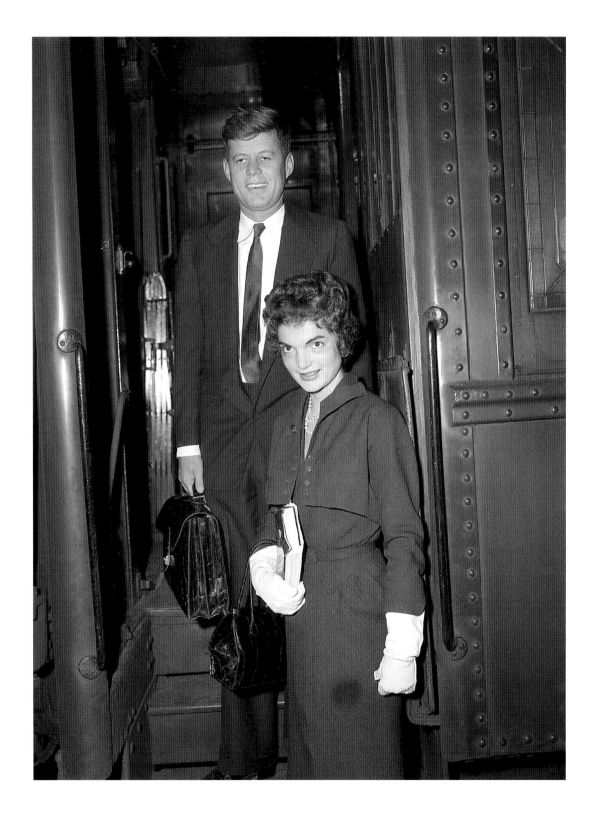

On a cold December night in 1953, John F. Kennedy, a United States senator at the time, and his wife, Jacqueline, stopped to have their picture taken as they arrived by train at Montreal's Windsor Station. The young photographer behind the camera was Arnold Harrington, a CPR staff photographer who accepted the late-night assignment. Kennedy was in Montreal to deliver a speech to students at the University of Montreal.

Arnold Harrington, B.3339.2

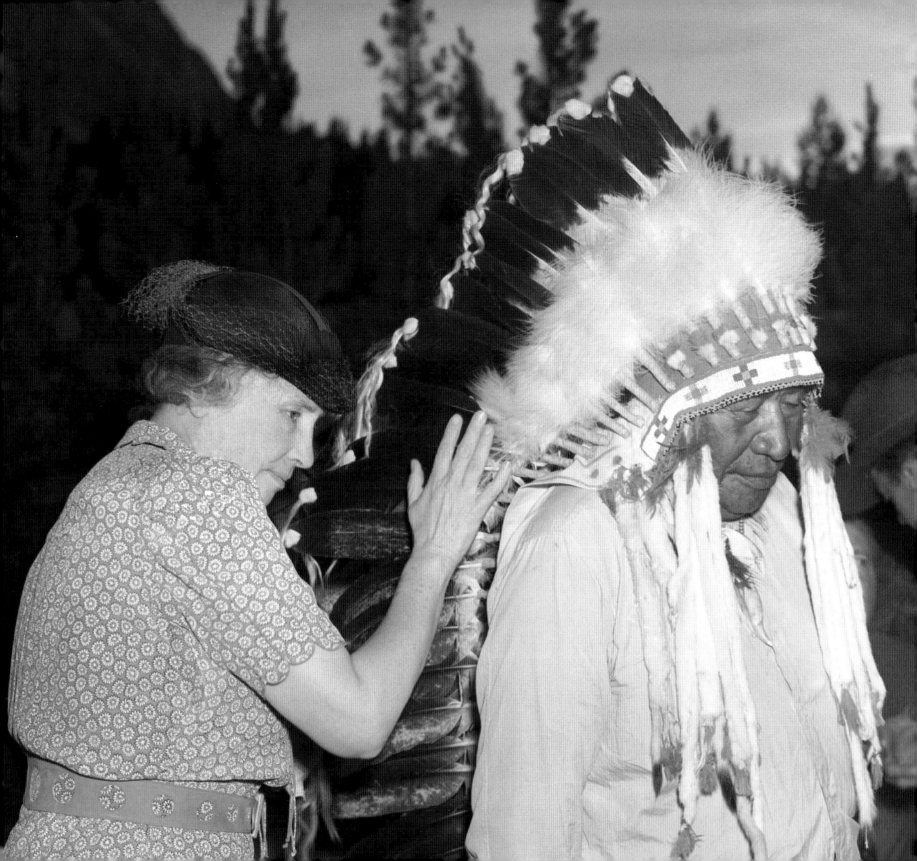

Postcards from Canada

"If we can't export the scenery, we will have to import the tourists."

—CPR President William Cornelius Van Horne, 1890s

In fact, Van Horne did eventually export the scenery—photographically—but he was not always sold on the idea. With the exception of the Notman Studio, Van Horne generally thought photographers were a nuisance—that is, until he was promoted to vice-president. As general manager and boss of all construction, he didn't want any freeloading freelancers impeding his progress in his dash across the prairies. Anyone who wanted to photograph the rapid construction progress on the prairies had to pay full fare, plus an extra baggage stipend if he had too much camera equipment, for the privilege of recording the event for posterity. As a result, there are few photographs of the building of the CPR on the prairies.

But in 1884, Van Horne had a photographic epiphany. It happened when the railway was working its way through the first mountain pass in the Canadian Rockies, the scenic Kicking Horse Pass. Whether it was caused by the magnificent mountains that Van Horne caught a glimpse of for the first time in the fall of 1883, or by the expanded duties that came to him with his August 1884 promotion to vice-president, Van Horne changed his mind. Suddenly he realized the great benefit of photographers and their work. Photographs of all these splendid landscapes could be turned into etchings, engravings, and artwork, or even used as they were to promote the majesty of the Canadian Rocky Mountains to potential travellers and tourists. From then on, Vice-president Van Horne contracted with photographers and artists, gave them free passage, and turned them loose on Canada's scenery and culture.

Once the railway was completed at the end of 1885, Van Horne set about mining what he perceived as a renewable resource—tourism. Before he could import the tourists, he had to build railway hotels and resorts in the mountains and at terminals. He made sure railway hotels were classy and comfortable, just like his homemade sleeping and dining cars. He then started bragging about his creations, promoting tourism and CPR's resorts through photography.

At first, Van Horne used photography as an interim medium, not as an end in itself. He asked photographers to capture a picture-perfect postcard scene, then turn it over to an artist or a steel engraver. Van Horne's artists or engravers rendered the photograph

From 1889 to 1978, for one week each year, Banff Indian Days celebrated the rich cultural heritage of the Stoney, Blackfoot, Peigan, and Cree. Appearances by celebrities were not uncommon. This photograph taken in about 1939 shows the Stoneys paying special tribute to Helen Keller, the remarkable deaf and blind woman, by making her an honorary princess.

Nicholas Morant, M.2068

as artwork suitable for a travel brochure or poster. Van Horne, being an amateur artist himself, couldn't stop himself from directing the artist. Regardless of what the true-to-life photograph depicted, Van Horne insisted the engraver or artist "make those mountains loom a little larger," or "make that glacier colder, crisper and cleaner."

Soon technology made it easy and inexpensive enough to use the actual photographs in CPR's promotional material. Picturesque scenes from all across Canada cropped up in the CPR publicity department and were sent around the world. Peggy's Cove, Quebec City, Montreal, Toronto, the prairies, the Canadian Rocky Mountains, and the Pacific coast all came before the CPR viewfinder to help sell Canada to tourists.

Scenes like this occurred frequently as World War II soldiers returned from overseas. Volunteers with the Canadian Legion War Services handed out cigarettes and candy to help welcome the soldiers home. During the first six months of 1945, CPR carried an estimated thirty-one thousand returning veterans and operated a virtual shuttle service between Halifax and Montreal.

Anonymous, NS.8128

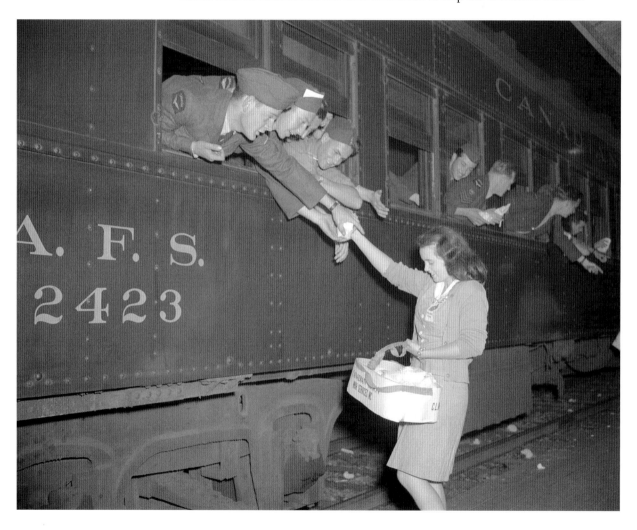

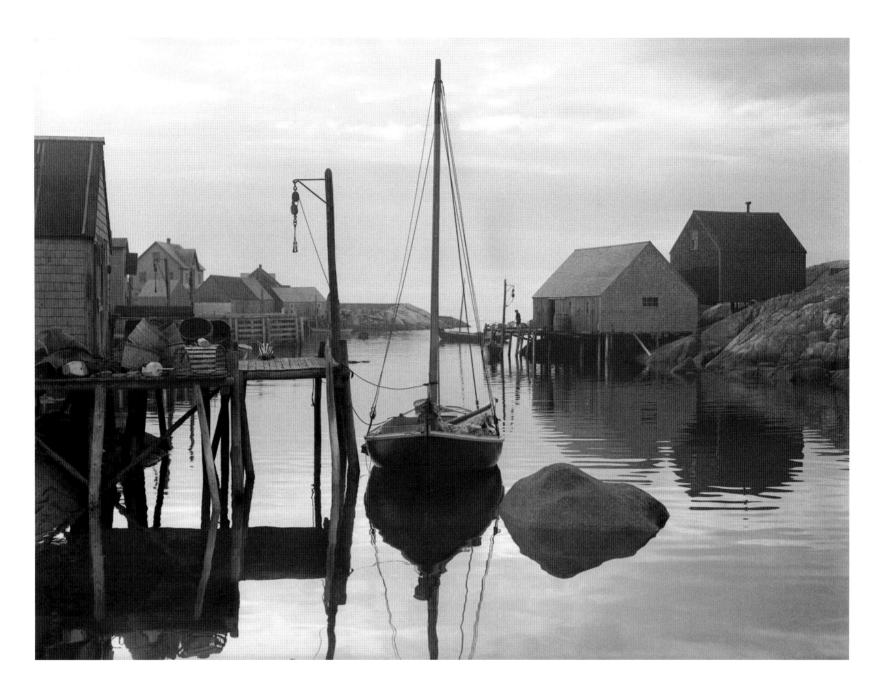

To help promote the Dominion Atlantic Railway and tourism in Nova Scotia, CPR assigned Nicholas Morant to photograph some of the province's most scenic locations. The sites included Lunenburg, the Annapolis Valley, and Kentville, as well as this tranquil scene at one of Canada's most recognized locations, Peggy's Cove, photographed about 1950.

Nicholas Morant, M.2357

From Halifax, the Dominion Atlantic Railway, a subsidiary of CPR, crossed the peninsula of Nova Scotia and followed the western shoreline of the province down the Bay of Fundy. The line passed through the beautiful and romantic Annapolis Valley, where each spring is ushered in with the Apple Blossom Festival. Pastoral scenes like this one, photographed in the mid-1930s, celebrated the festival, which began in 1933 to promote the valley's apple industry and attract tourists.

Anonymous, NS.11099

Opposite page: The picturesque village of St. Bernard, where Nicholas Morant photographed these models around 1939, is located on St Mary's Bay, known locally as Baie Sainte Marie, on Nova Scotia's southwestern shore. The region is largely made up of descendants of Acadian settlers who came from France in the 1600s and who continue to identify themselves as Acadians through their culture and language.

Nicholas Morant, M.2624

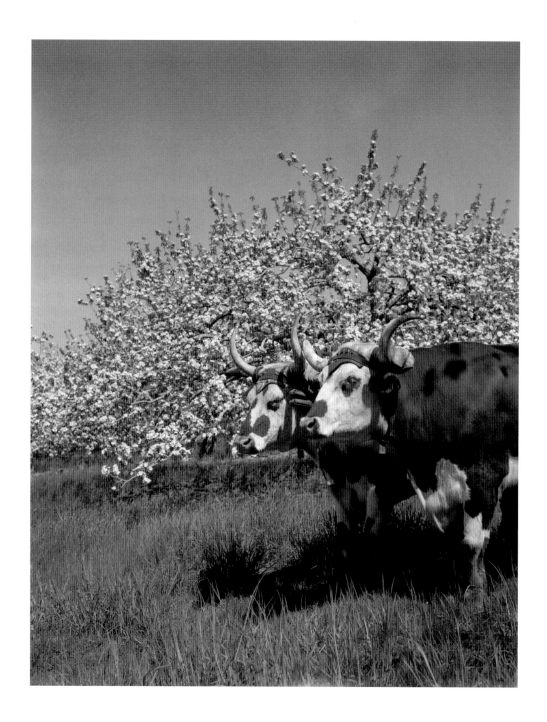

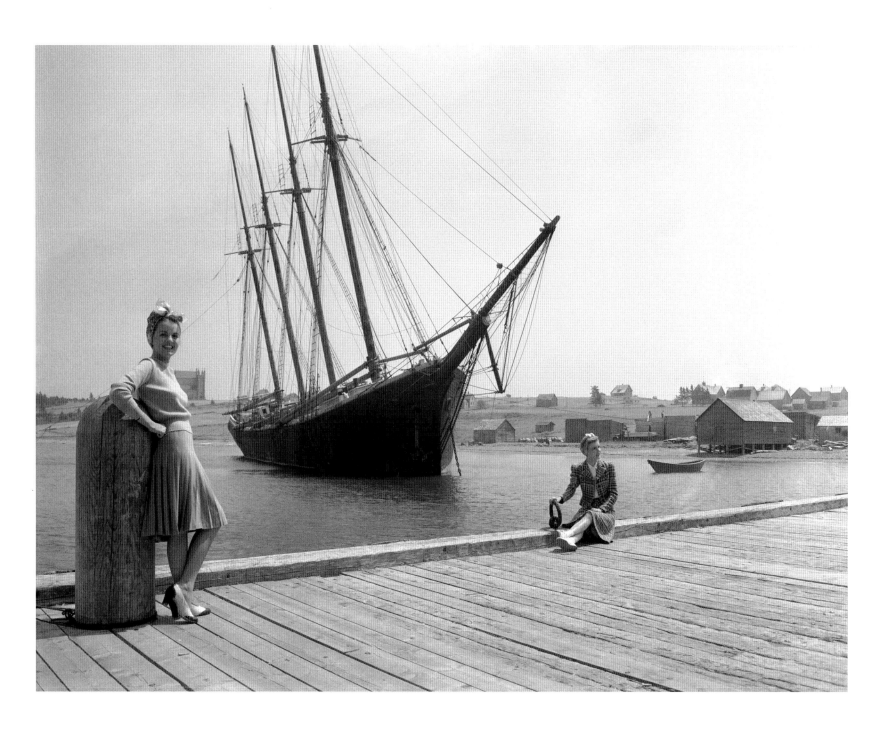

Opposite page: Niagara Falls, which straddles the Canada/United States border, is a year-round phenomenon. In winter, a combination of water, slush, and mist freeze to form gigantic mounds of ice. During exceptionally cold years the Niagara River freezes over for several kilometres. When Oliver B. Buell captured this frosty winter scene around 1890, Niagara Falls was an established tourist destination where photographers and tourists alike ventured out onto what was known as the "ice bridge."

Oliver B. Buell, A.17346

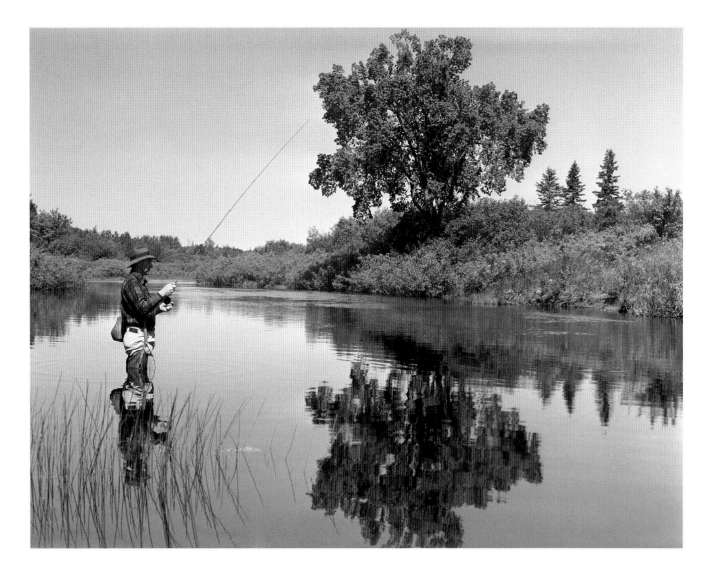

In 1948, when Nicholas Morant took this photograph of a sport fisherman on the Digdeguash River, CPR operated summer trains from Saint John, New Brunswick, to the resort town of St. Andrews-by-the-Sea, where CPR owned and operated the famed Algonquin Hotel. The resort hotel's promotional brochures boasted of landlocked salmon and trout from the best of New Brunswick's nearby rivers, lakes, and streams.

Nicholas Morant, M.4501

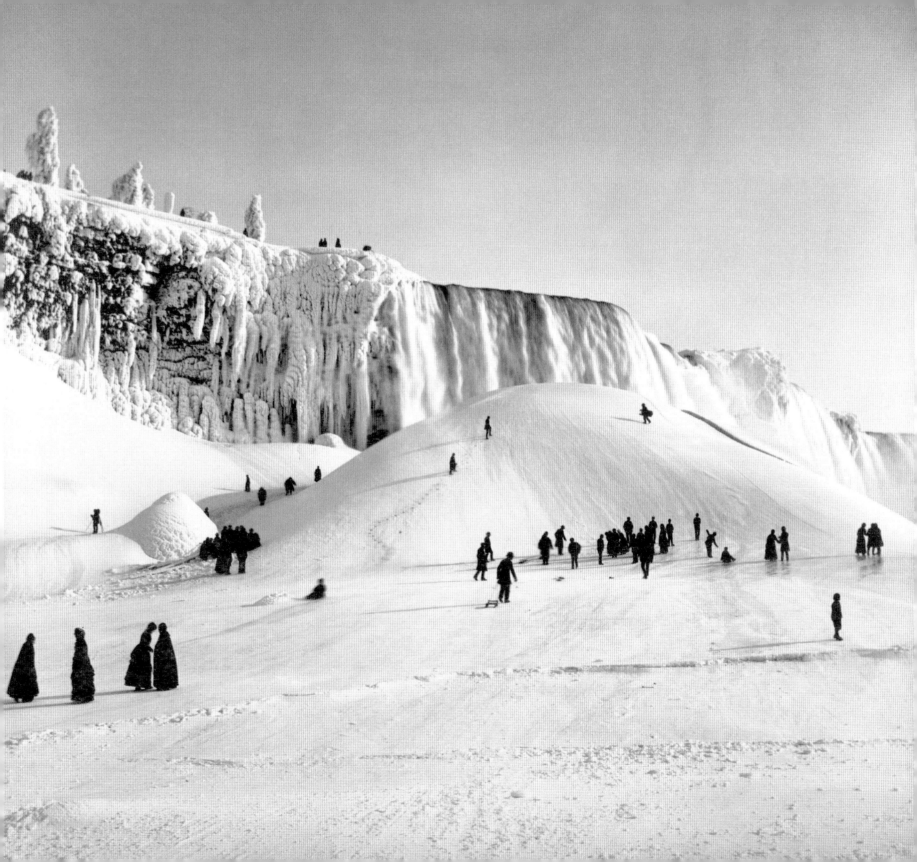

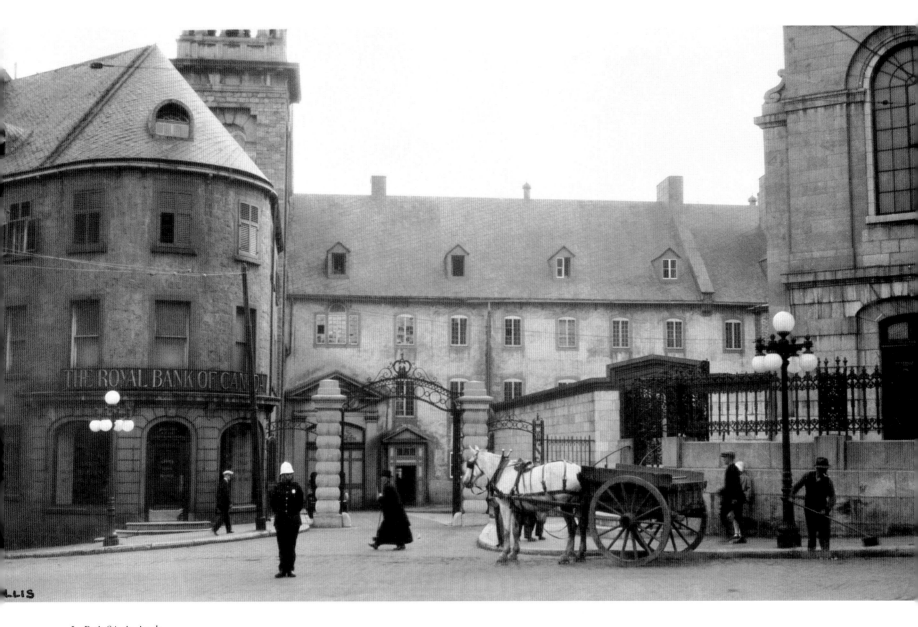

Le Petit Séminaire de
Québec in about 1935.

Anonymous, NS.24072

Quebec City: Le Petit Séminaire

Le Petit Séminaire de Québec was established in Quebec City by François de Laval, the first bishop of New France. Laval first founded the grand séminaire in 1663 to provide for the training of an indigenous clergy. Le Petit Séminaire, which was opened in 1668 by request of Louis XIII of France, was originally a preparatory school for future priests. After the English conquest of 1759, it became a college that taught humanities and philosophy, replacing the Jesuit College that the English authorities had requisitioned as barracks. The first classes began in the fall of 1765 and included twenty-eight students. In 1852, Le Séminaire de Québec, having become renowned for its expertise in the field of education, founded Laval University. The priests from the séminaire, who were in charge of the university until 1970, became closely associated with the preservation and diffusion of French culture. In 1989, the University of Laval, reviving part of its past, moved its Faculty of Architecture and Planning into a wing of Le Petit Séminaire.

The old walled town of Quebec, where the séminaire is located, was founded in 1608 by Samuel de Champlain. It was made capital of New France in 1663 and became a centre for fur trade. Four hundred years of colonial conquests are reflected in the mosaic of picturesque streets and architecture of the city. Quebec's old town was added to UNESCO's heritage list in 1985 in recognition of its universal value and exceptional appeal. It is the most complete fortified colonial town in North America and the cradle of French civilization on the continent. The city of Quebec now has approximately 650,000 inhabitants, of which 89 per cent speak French.

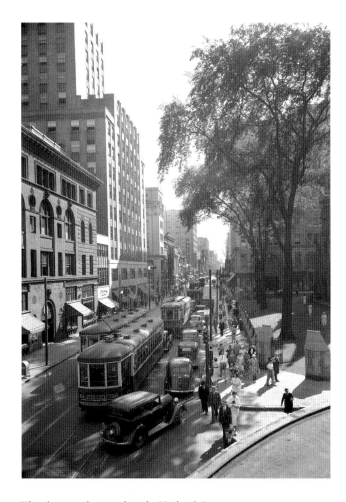

The photographer stood on the Hudson's Bay Store canopy to capture the late afternoon hustle and bustle along Montreal's Ste-Catherine Street in the summer of 1937. Electric streetcars were in use and automobile traffic along the city's best-known thoroughfare was still allowed in both directions.

Anonymous, NS.2247

In 1930, the R100 dirigible was photographed on its maiden voyage from the roof of CPR's Windsor Station as it sailed over the city of Montreal. In the mid-1920s, in an effort to provide communication links and improved military capabilities, the British government launched an ambitious program to build and sail helium-filled dirigibles to the far corners of its vast Empire. The R100 dirigible left England on 29 August 1930 and arrived at the St Hubert Air Station, just south of Montreal, 79 hours and 5,413 kilometres later. The R100 was an enormous flying machine, measuring 216 metres in length and 40 metres in diameter. Six Rolls Royce 650-horsepower engines allowed a cruising speed of 130 kilometres per hour. The return to England was the R100's last voyage after the crash of a sister ship brought an end to the innovative program.

Anonymous, NS.21900

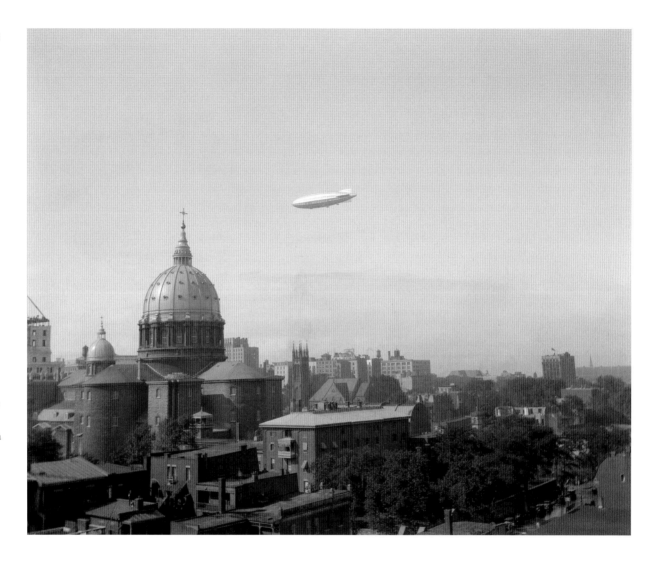

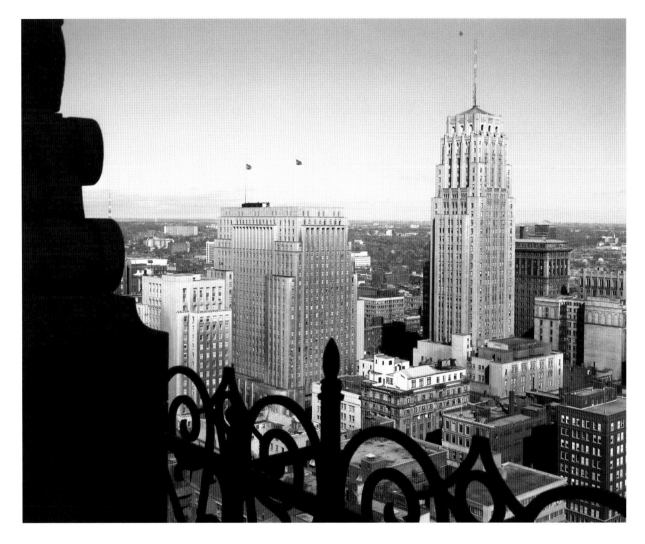

The view from Toronto's Royal York Hotel was virtually unobstructed when this photograph was taken in 1964. However, the landscape was soon to change as Toronto became the home of the head offices of many Canadian corporations, transforming it into Canada's largest city.

Nicholas Morant, M.7644

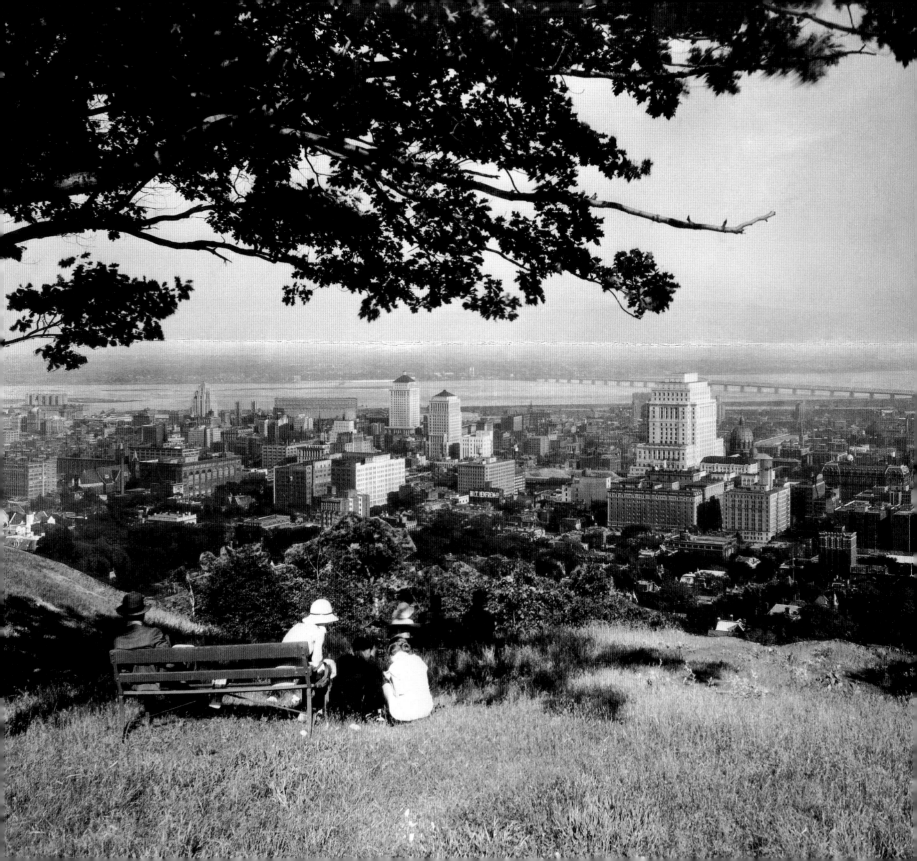

Montreal: The Island Metropolis

Montreal, built on an island in the St. Lawrence River, was once as far upstream from the Atlantic Ocean as one could go by boat before reaching the Lachine Rapids. Europeans first discovered the island in 1535 when Jacques Cartier, stymied by the rapids, went ashore, climbed the igneous intrusion on the island, and erected a cross there. He named the island mountain Mount Royal, which later evolved into Montreal. Little did Jacques Cartier know, but the igneous intrusion he climbed was actually a dormant volcano.

In 1642, Sieur Paul de Chomedey de Maisonneuve established Ville Marie de Montréal, a religious settlement, to convert First Nations peoples to Christianity, but the settlement didn't flourish in the seventeenth century because of the frequency of Native attacks. Montreal came into its own in the eighteenth century as the centre of the fur trade and was an integral part of New France until the British captured it in 1760. For one brief year, Montreal was American. At the outbreak of the American Revolution, Americans captured the city from the British in November 1775 and held it until June 1776.

Montreal grew as a fur trade, banking, and shipping centre to become the metropolis of Canada in the nineteenth century. It was even the capital of Canada between 1844 and 1849. In fact, by the end of the century, half the wealth of Canada was concentrated in the pockets of the Scottish and British entrepreneurs who built their palatial homes on the southeastern slope of Mount Royal. The mountain slope where these rich fur barons, bankers, and industrialists lived was called the Golden Square Mile. At the top of Mount Royal—overlooking the Golden Square Mile, Montreal's downtown, and its harbour— is a park designed by the famous American landscape architect Frederick Law Olmsted at the end of the nineteenth century.

The founders of CPR lived in the Golden Square Mile when the railway company was incorporated in 1881. Montreal was the site of CPR's head office, but because the transcontinental railway's charter made no mention of building track into the city, CPR had to buy two existing railways—one to get it as far east as Ottawa and another to get it from Ottawa to Montreal.

A 1930s view of the St. Lawrence River and the island city of Montreal as seen from Mount Royal.

Anonymous, NS.25260

81

Winnipeg: Gateway to the Prairies

On 9 October 1877, the arrival of a CPR steam locomotive, the Countess of Dufferin, with six flatcars and a caboose, by barge down the Red River to Winnipeg sparked a new era of development for western Canada and marked a significant turning point in the history of the Canadian prairies.

The Countess of Dufferin arrived to a much different western Canada from today's network of cities, towns, and farms. Thirteen decades ago there were few settlers from Europe, eastern Canada, or the United States, and none from the Far East. Those who were not native to the area or had intermingled with the First Nations peoples were in small, identifiable enclaves, living in newly established militia forts or cultivating long lots along the Red River or its tributaries. At this time, the prairies were still the domain of Canada's First Nations and Métis population, but the simple arrival of a steam locomotive started the winds of change to blow.

By 1877, the First Nations' main means of subsistence, the buffalo, was dwindling to near extinction, and prairie First Nations were signing treaty after treaty with the federal government limiting them to reserves. The arrival of the train, dubbed the iron horse, brought settlers, industry, goods, communications, and a whole new way of life to the Canadian prairies. Railways would soon criss-cross the prairies and carve it up into parcels. The First Nations' former nomadic lifestyle would forever change as their people were relegated to reserves. The region they once roamed offered substantial riches, above and below ground, to enterprising encroachers from eastern Canada, the United States, and Europe—and Winnipeg was the entrance to those riches.

The arrival of the Countess of Dufferin was significant enough, but a few short years later Winnipeg, not the older Red River settlement of Selkirk, was declared CPR's gateway to the prairies. Winnipeg's importance was assured. The city vaulted into permanent prominence and significance in the development of the Canadian prairies, and the railway was the lifeline. Finished goods and people flowed in; wheat, grain, and livestock flowed out. Railway shops, yards, trains, and infrastructure employed thousands. There was no turning back.

Nicholas Morant

Nicholas Morant joined the ranks of CPR's Winnipeg press bureau in 1929. Although he left the company briefly in 1935 to pursue his passion for photography with the *Winnipeg Free Press*, he returned to the railway in 1937. In 1939, Morant and Swiss guide Christian Häsler were attacked by a grizzly bear near Lake Louise, Alberta. Morant's heroic efforts to save Häsler were ultimately unsuccessful and Häsler died from his injuries one year later. Morant spent three months in hospital recovering and was rejected for service in the Canadian navy because of his injuries. As a consequence, Morant was loaned from 1940 to 1945 for special duties as chief photographer to the Dominion Government's Wartime Information Board, where his "photographs helped to publicize Canada's contribution to the war effort."

For more than fifty years, Nicholas Morant enjoyed the well-earned title of CPR Special Photographer, which gave him the opportunity to take the iconic photographs for which he became known. He travelled widely on assignment and the time he spent preparing for a photograph was legendary. It was not uncommon for Morant to set up his equipment and then wait days for the perfect light and moment. Perhaps his most recognized work was carried out in the Rocky Mountains close to his home in Banff, Alberta. In fact, a sweeping curve on CPR's main line along the Bow River near Lake Louise, Alberta, where Morant took many of his most recognized photos, has been officially renamed Morant's Curve. It has been said that Morant had the remarkable ability to blur the distinction between an industrial photo and a fine-art photograph.

Morant's photographs were published in *Time, Look, Life, The Saturday Evening Post*, and *National Geographic*, appeared on Canadian postage stamps, and graced the backs of Canadian $10, $50, and $100 bills. Morant retired from CPR in June 1981.

In 1990, Morant received the Order of Canada for his lifework in photographic art. Bob Rice, CPR's vice-president, public affairs, wrote at the time, "Mr. Morant's photography has documented a long, important era in the history of Canadian Pacific, CP Rail and Western Canada … The quality and scope of Mr. Morant's work reflect the vitality of Canadians and the beauty of Canada and bring honor to both."

What began as an agricultural fair in the mid-1880s reinvented itself in 1912 as the world-renowned Calgary Stampede. It took the powerful promotional skills of Guy Weadick, a trick roper, who envisioned a gathering of cowboys, cowgirls, and First Nations peoples, to organize the event that would become known as "The Greatest Outdoor Show on Earth." Weadick is also credited with coming up with the idea to race chuckwagons. The fast and furious sport of Rangeland Derby chuck-wagon racing became one of the Stampede's premier events, as demonstrated in this 1938 photograph of driver Dick Cosgrave leading the pack on his way to another championship.

Nicholas Morant, M.1201

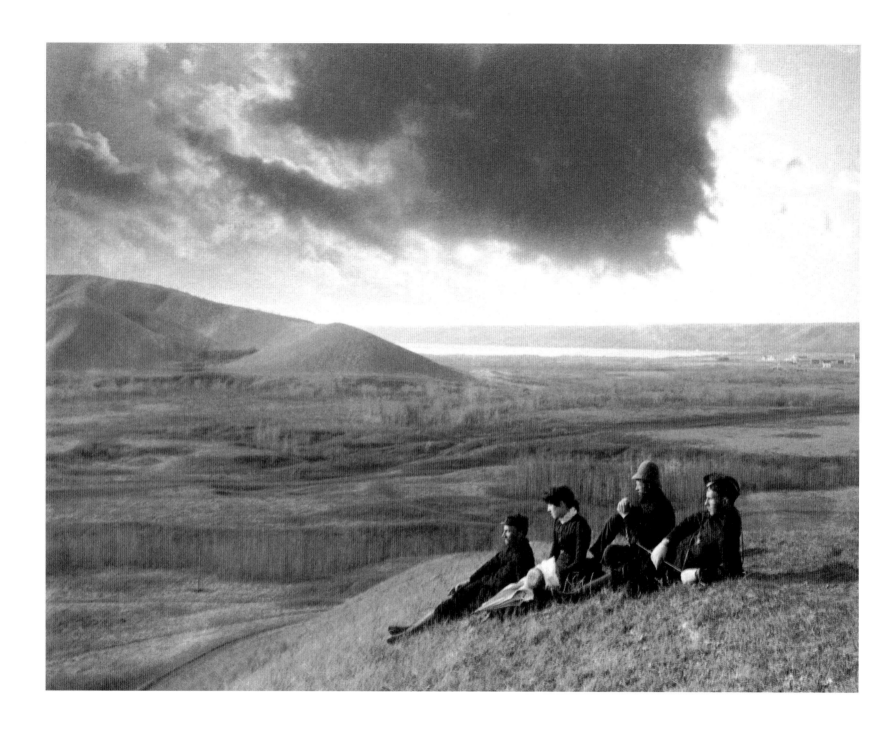

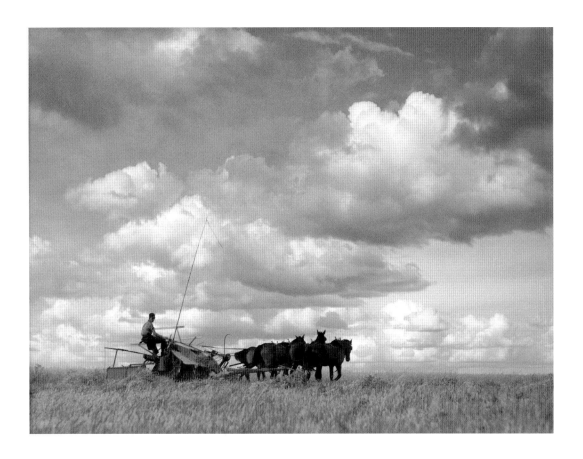

Under billowing prairie clouds, a farmer steals
a backward glance towards Nicholas Morant's
camera. In the late 1930s, when this photograph
was taken, few farmers still operated horse-drawn
grain binders. Most had made the switch to more
efficient mechanically powered equipment.

Nicholas Morant, M.1363

Opposite page: In 1885,
Oliver B. Buell photographed
Mrs. French and companions
looking out on the vast, virgin
prairie near Fort Qu'Appelle.
Established in 1864, Fort
Qu'Appelle was a Hudson's
Bay Company fur-trading post
at the centre of trading trails
and commerce. It was also
here, in 1874, that the Cree
and Saulteaux bands signed
Treaty Four with the Canadian
government, surrendering
their right to 75,000 sections of
land in what is now southern
Saskatchewan and agreeing to
keep "peace and good order."
The North-West Mounted
Police established a small
outpost in Fort Qu'Appelle
in 1876, which by 1880
was greatly enlarged and
under the command of a
superintendent, an inspector,
and two staff sergeants.

Oliver B. Buell, A.108 .

Two of Canada's best-known iconic symbols are seen in this 1930s photograph, set against the majestic backdrop of the Bow Valley in the Rocky Mountains. People from around the world were attracted to romanticized images of the "ne'er-do-wrong" Royal Canadian Mounted Police and "free-spirited" First Nations people.

Anonymous, NS.25375

Opposite page: Towering natural pillars of eroded sandstone, known as hoodoos, frame the town of Canmore, Alberta, gateway to the Rocky Mountains, in this 1885 photograph. The town prospered as a divisional point for CPR and from the discovery of coal in the region.

Oliver B. Buell, A.4188

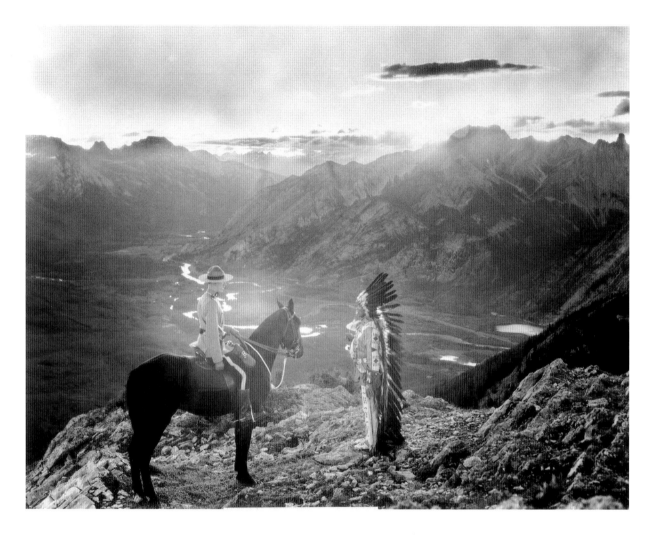

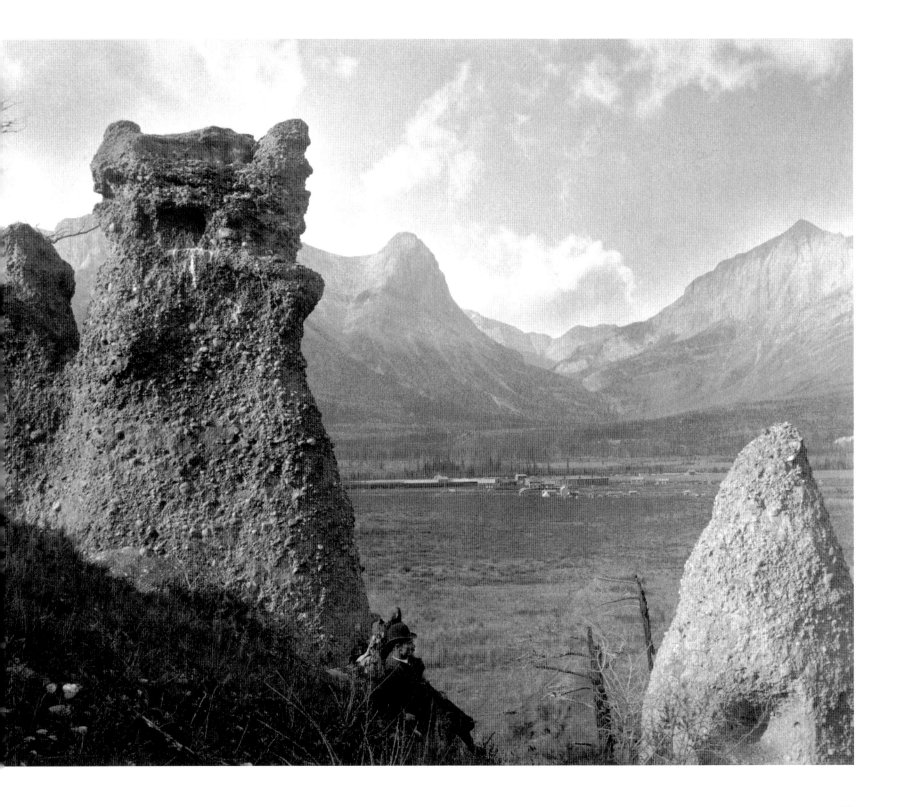

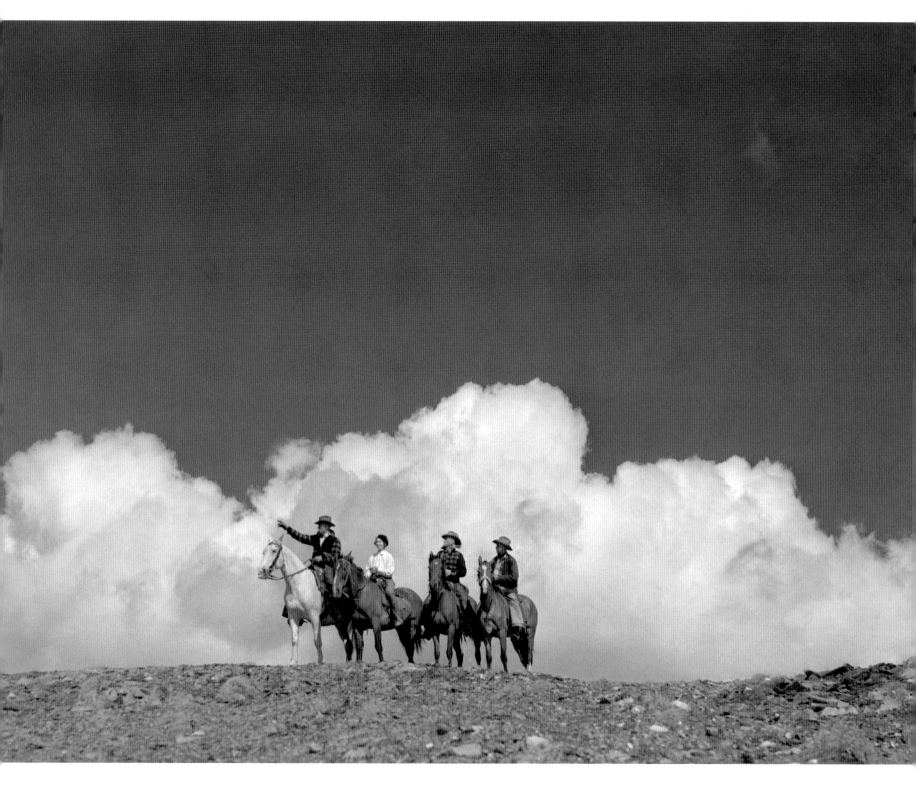

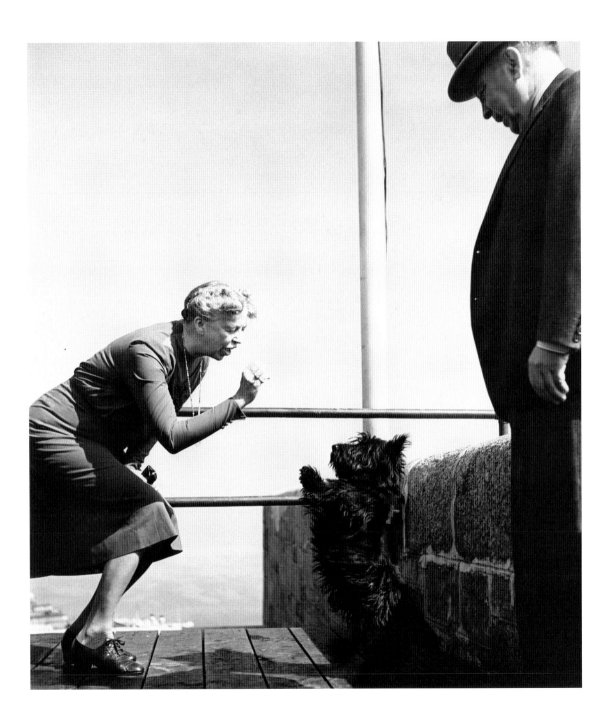

Opposite page: Nicholas Morant took this spectacular photograph of mountain riders in 1939. The year before, Morant had become an official member of the Trail Riders of the Canadian Rockies and contributed photographs to its publications. He joined an illustrious group of people from Canada's cultural community who were members at the time, including renowned artists W. J. Phillips, Carl Rungius, and Reinhold H. Palenske, and photographers Harry Pollard and Byron Harmon.

Nicholas Morant, M.539

"Murray the Outlaw of Falahill," or "Fala" for short, was a Scottish terrier and the constant companion of American president Franklin D. Roosevelt from 1940 until FDR's death in 1945. One of the most famous presidential pets, he accompanied Roosevelt and his wife, Eleanor, on many official trips. Fala knew how to do tricks and his antics were well covered by the press. In this photo, taken during a lighter moment at the 1943 Quebec City Conference, Mrs. Roosevelt is seen making Fala beg for a biscuit while Canadian prime minister William Lyon Mackenzie King looks on.

Anonymous, War.98

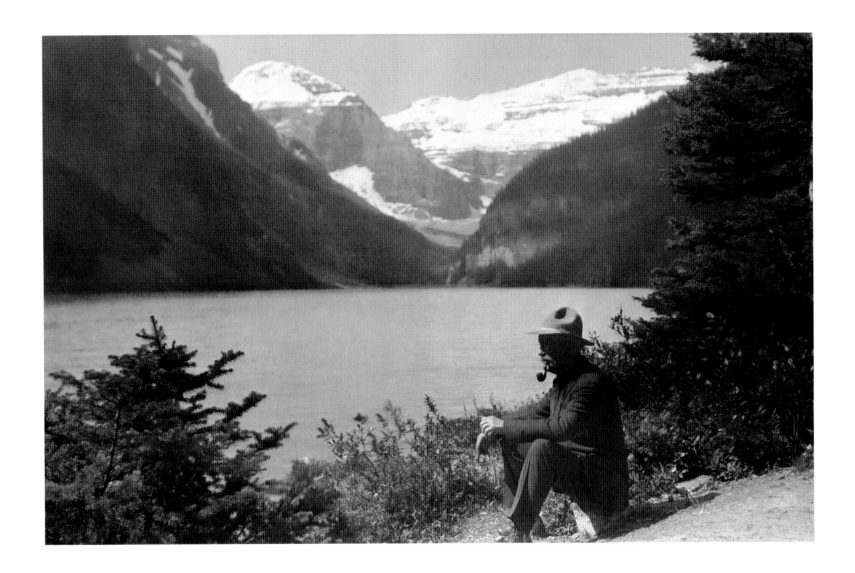

Opposite page: In its early days, the Banff Springs Hotel was only open from May through September, but the town of Banff continued to attract tourists to winter sports. In 1927, the Banff Winter Carnival crowned Emilie Mason (sitting in the dogsled) as its queen.

Anonymous, NS.1881

Tom Wilson, photographed sitting at the shore of Lake Louise in about 1915, was the first non-Native to see the sparkling glacier-fed lake. Wilson, a former member of the North-West Mounted Police, was surveying the route for the CPR main line in 1882 when he was led to the remote mountain lake by his Stoney companion, Gold-Seeker. Known by the Stoneys as the "Lake of the Little Fishes," it would soon be officially named Lake Louise after Princess Louise Caroline Alberta, fourth daughter of Queen Victoria.

Anonymous, NS.17629

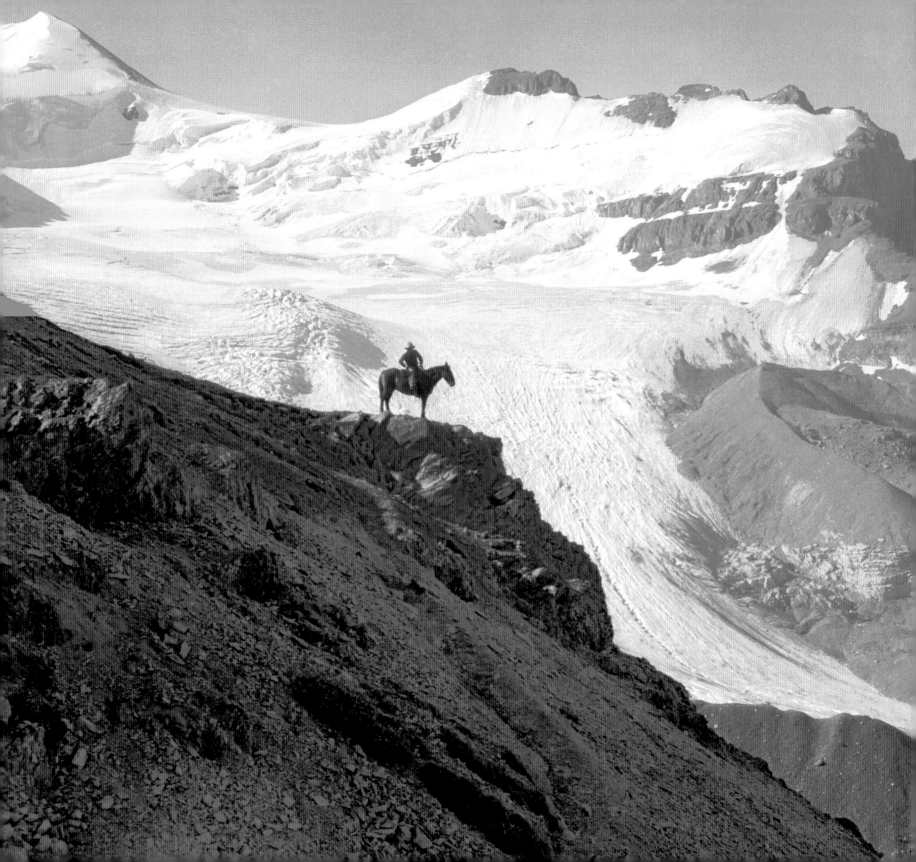

J. Armand Lafrenière

J. Armand Lafrenière was hired by CPR as a photographer in 1920 at the age of twenty-three. His assignments led him to record the day-to-day activities of the company's railway, hotel, ship, and telegraph services. The job was varied and exciting; he was photographing celebrities such as the King and Queen of Siam one day and documenting the inside workings of a hulking locomotive the next. Lafrenière was always on call. It was not unusual for him to embark on extended trips from his Windsor Station studio in Montreal—once on a five-week tour to Anticosti Island—on a short twenty-four hours' notice. "It's a seven-day-a-week job potentially and you work all night if you have to and think nothing of it," Lafrenière once said about his job.

In 1933, Lafrenière was appointed official CPR photographer. Putting his dedication and keen eye to good use, he criss-crossed the country on assignment. In the summer of 1940 alone, Lafrenière's assignment in the Rockies produced a legacy of more than three hundred images. Several of these outstanding photos garnered him Certificates of Merit from the Photographer's Association of America. Lafrenière worked almost exclusively with large format Speed Graphic and 8 x 10-inch cameras.

By 1942, Lafrenière was head of the company's nine-man team of photographers, darkroom technicians, and photo editors. In 1943, at the Quebec City Conference, Lafrenière photographed British prime minister Winston Churchill meeting with the Canadian War Council. Lafrenière processed his film in the darkroom of the city's *Le Soleil* newspaper. That afternoon, the film was flown by Canadian Pacific Air Lines to Montreal and then rushed to Windsor Station where the CPR photography department staff was on standby. "Wet prints" were made and delivered that night, and the next day Montreal's newspapers carried the history-making "spot news photo." Lafrenière retired from CPR in 1962.

This 1940 photograph of a lone trail rider set against the rugged Columbia Icefields captures the awesome beauty of the Canadian Rockies. Canadian Pacific Railway sponsored a group of committed riders and outfitters who became known as the Trail Riders of the Canadian Rockies in an effort to attract adventuresome tourists. Among hundreds of photographs taken by J. Armand Lafrenière while on this assignment, this photograph received a Certificate of Merit from the prestigious Photographer's Association of America.

J. Armand Lafrenière, NS.25099

The Swiss Guides

"Fifty Switzerlands in One" was how famed mountaineer Edward Whymper described the Canadian Rockies and the Selkirks. It was hyperbole for sure, but it didn't stop the CPR from adopting the slogan coined by the British engraver, who was the first man to climb the Matterhorn in 1865, and use it to entice tourists to visit the Canadian Rockies, or as the CPR unabashedly called them, the Canadian Pacific Rockies.

The slogan worked. People came from the four corners of the earth to climb Canada's breathtaking mountain peaks. Unfortunately, tragedy struck on 3 August 1896. Boston-area amateur alpinist Philip Abbot plunged hundreds of feet from the upper cliff bands of Mount Lefroy to the col below that now bears his name. His partner couldn't get medical help to Abbot in time and he died. This could have spelled doom to the Rocky Mountain tourist trade, but CPR decided to hire Swiss guides to rekindle confidence in its alpine offerings and keep the tourist taps flowing.

In June 1899, the first two Swiss guides arrived on the scene—Christian Häsler and Edouard Feuz. They offered their guiding skills to CPR hotel guests at Glacier, Field, and Lake Louise. Swiss guides made it safe for just about anyone to climb a mountain. In fact, in the fifty-five years between 1899 and 1954 that Swiss guides shepherded guests up and down mountain peaks, passes, and glaciers, not a single person died on their watch. There were a couple of tragedies, but they happened to hotel guests who decided they didn't need any climbing guidance. Swiss guides started out earning $2 a day, which doubled to $4 a day in 1909, and $5 a day in 1919, culminating at $7.04 in 1947. They also got monthly rates for portering and could sustain themselves in winter by shovelling snow off CPR hotel roofs.

W. J. Oliver photographed experienced mountain guide Ernest Feuz, son of Edouard Feuz, and accomplished climber Georgia Englehard on a 1935 climb in the Rocky Mountains. Born into a wealthy New York family, Georgia Englehard became interested in climbing at an early age. In 1930, Associated Screen News, a film and photography subsidiary of CPR, produced a documentary entitled *She Climbs to Conquer*, which featured Englehard.

In 1911, CPR built a Swiss guides' village outside of Golden, called Edelweiss, to house the guides and their families. Edelweiss was built to be picturesque, back when travellers could see the quaint Tyrolean chalets from the passing trains. After the Glacier House hotel closed down in 1925, most of the guides moved out of Edelweiss, but the ninety-five-year-old "Swiss" chalets are still there, just off the Trans-Canada Highway.

There were thirty-five CPR Swiss guides between 1899 and 1954. They were credited with 250 first ascents of Canadian mountain peaks.

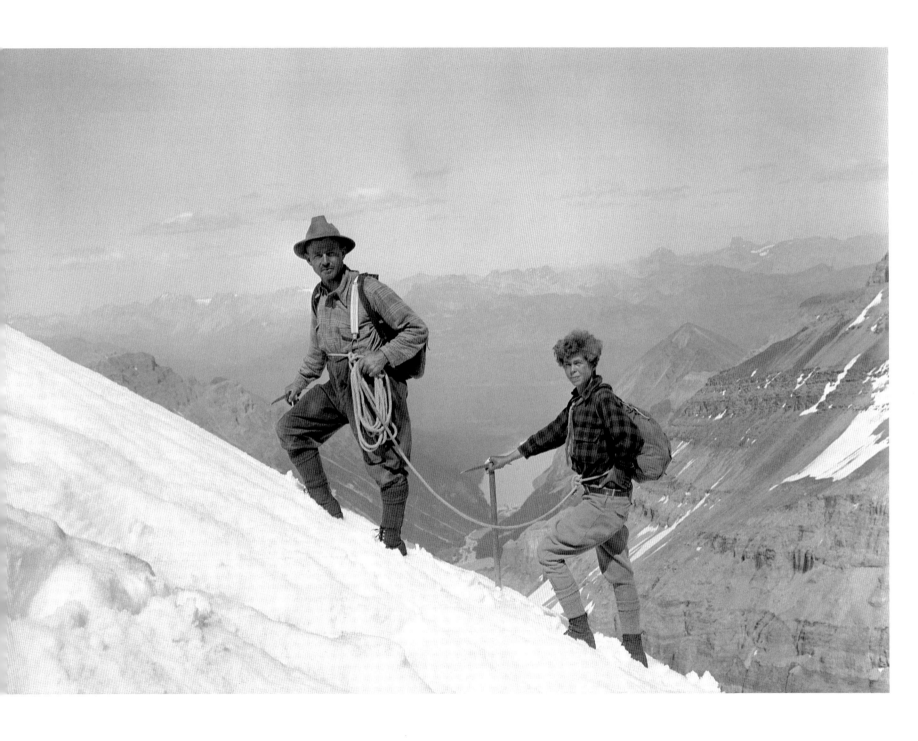

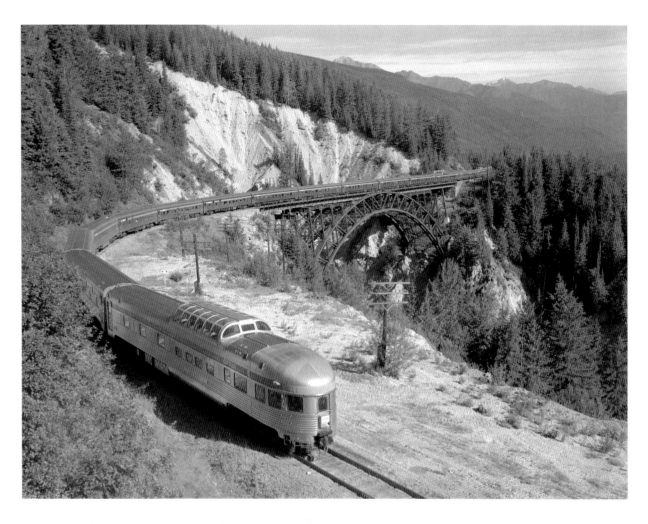

In 1970, Nicholas Morant went to one of his favourite locations at the Stoney Creek Bridge to photograph CPR's The Canadian passenger train. Since the days of steam locomotives, Morant had chosen this site to capture everything from royal trains to freight trains. On occasion, Morant stayed in a caboose placed on the nearby back track, reminiscent of the days when photographers had their own specially outfitted rail cars.

Nicholas Morant, M.2305

Vancouver's Stanley Park, originally used as a British military installation to defend against an impending American attack, was named in honour of Lord Stanley of Preston, Canada's late-nineteenth-century governor general. First opened in September 1888, the one-thousand-acre park became an important tourist destination, drawing fifty thousand visitors per week by 1913. The people in this early-1900s Stanley Park photograph are dwarfed by a giant fir tree.

Anonymous, NS.2173

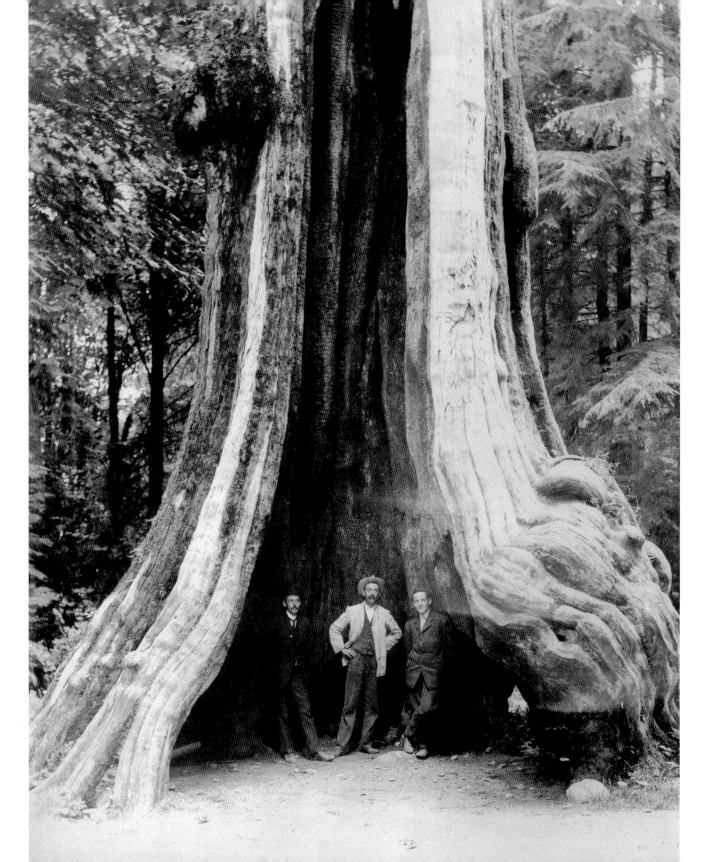

Being Canadian

"One of the first things to be done is to show our resolve to build the Pacific Railway to unite the country."

—Prime Minister Sir John A. Macdonald, 1871

With the completion of the transcontinental railway, CPR had physically linked Canada, east and west, but did it truly create a unified country? Sir John A. Macdonald's directive to use the railway to unite the fledgling nation was a tall order—perhaps more dream than reality. What the CPR accomplished was to connect Canada's diverse pockets of regionalism with a national railway of which all Canadians could be proud. Canadian Pacific Railway's unmistakably Canadian cachet and identity had a practical side, too. Out west, it helped fend off the Americans and kept them strategically and commercially at bay below the forty-ninth parallel.

The photographs of Canadians at work illustrate just how much the country's economy depended on the railway. Fish, dairy products, fresh produce, and even maple syrup could now travel to market in boxcars or ice-cooled refrigerator cars. Prairie canola, flax, and wheat travelled by train from Canada's central granary to North America's millers and food markets, or even to port for overseas markets. Saskatchewan potash extracted from below the surface of the fertile prairies went into covered hopper cars to fertilizer plants in North America and overseas to help increase crops and guard against world hunger. Western coal and metals came out of the ground and went by train to large manufacturing centres at home and abroad. Even British Columbia's Bunyan-sized timber was piled onto CPR flatcars and delivered to North America's construction industry. Canada's economy was on the move.

The railway also made it possible, for the first time, for ordinary Canadians to travel across the continent with relative ease. Canadians could now see the varied landscapes and people of their huge country first-hand and understand more fully what being Canadian meant. Travellers on the CPR could meet the masterful Maritimer, the Catholic Quebecer, the enterprising Ontarian, the productive prairie farmer, and the busy British Columbian. To market this Canadian mosaic at home and abroad, CPR photographers crossed the country coast to coast, capturing on film Canadians at work and play—being Canadian.

Framed by the window of a CPR passenger car, Paul-Émile Cardinal Léger greets a waiting crowd at Montreal's Windsor Station in 1953. Born as a shopkeeper's son, Paul Émile Léger was ordained as a priest in 1929, appointed Archbishop of Montreal in 1950, and elevated to cardinal three years later. Léger's steadying influence on Quebec's Catholic culture was critical during the social revolution of the 1950s. Léger went on to perform vital missionary work among handicapped children and lepers in West Central Africa.

Anonymous, B.2880.15

Opposite page: The Montreal General Hospital first opened its doors as a small, twenty-four-bed facility near Montreal's harbour in 1819. Two years later, a larger, seventy-two-bed facility was opened and the hospital's reputation for quality care and skilled physicians grew. Many of these physicians made up the faculty of Canada's first medical school, the Montreal Medical Institute. This photograph of a patient and medical staff at Montreal General Hospital was taken in 1892.

Anonymous, NS.2729

Tuna fishing off the coast of Nova Scotia, sugaring off in Quebec, learning the three Rs in a school car in northern Ontario, flax farming on the prairies, trail riding in the Rockies, and felling firs in British Columbia—all are distinctly Canadian activities, rooted in regional diversity, and recorded for posterity by the CPR.

This photograph was published in a 1929 brochure illustrating the virtues of the Boy's Farm and Training School at Shawbridge, Quebec. The school, which taught farming, carpentry, and other practical skills, was established in 1917 for problem boys. Edward W. Beatty, who became CPR's president in 1918, was also president of the school for twenty years. Beatty took great interest in the school and devoted much time and money to the cause.

Anonymous, NS.19135

Opposite page: Scottish-born merchant William Finlay played a large role in Quebec's burgeoning nineteenth-century commerce. Among other accomplishments, he built two substantial warehouses on Quebec City's lower town wharf to accommodate his import and export business. Finlay's success as a businessman allowed him to bequeath one thousand pounds sterling to improve streets and public spaces and to construct a new public market. Marché Finlay, as it became known, served a wide variety of clientele, including the nuns in this photograph taken around 1920.

Anonymous, NS.5736

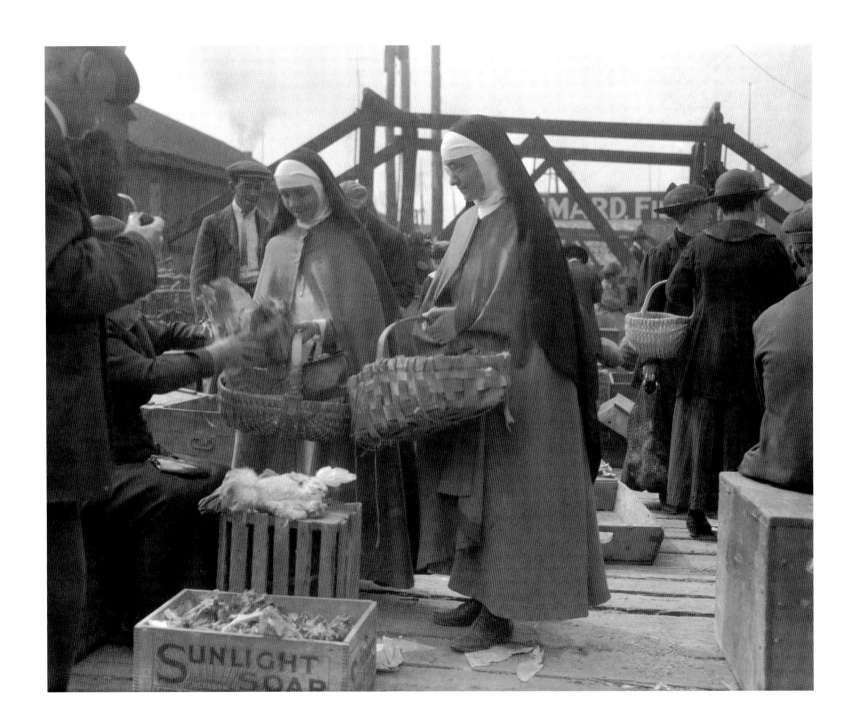

In 1937, Nicholas Morant travelled to Vancouver Island where he took a series of photographs to help illustrate Canada's emerging role as one of the world's leading exporters of lumber. That year, British Columbia led the country with an output valued at more than $53 million—more than half the combined output of rest of the provinces.

Nicholas Morant, M.264

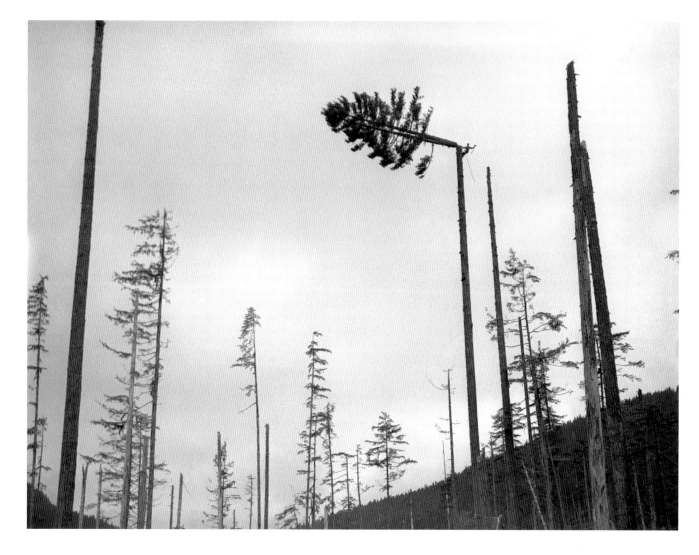

Opposite page: A Quebec City Marché Finlay merchant and a young boy are absorbed in conversation, oblivious to the hustle and bustle surrounding them.

Anonymous, NS.5735

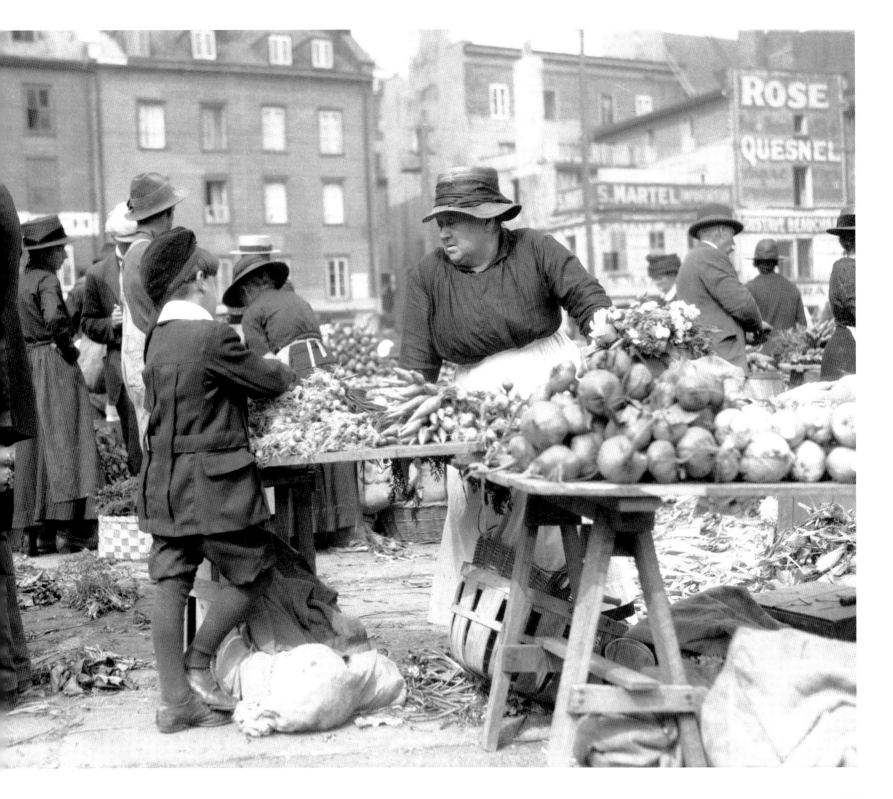

School Cars

School-aged children in remote areas of Ontario needed a formal education, but many of them lived far away from established schools. In 1926, the Government of Ontario collaborated with Ontario's railways, including CPR, to come up with a solution. Canadian Pacific Railway outfitted some of its rail cars as travelling classrooms, or school cars. Half of the car was a classroom, complete with chalkboard, charts, a map, desks, and a library. The other half was where teachers and their families lived in comfort, with kitchen, sitting room, two easy chairs, a sofa bed, an upper and lower berth, toilet facilities, and a bathtub.

For three decades, these school cars roamed the railway timberlands of northern Ontario tracking down kids to teach. They mostly preyed on "railway brats"—children of railway employees—but also catered to the children of fishermen, woodsmen, trappers, and First Nations people. Canadian Pacific Railway started out with one school car and later ran two cars on separate circuits with approximately twenty-two students on each circuit. Chapleau, Ontario, was home base. One car went to Cartier and the second went to White River, each making several stops in between. Each stop lasted five days —a regular school week. The cars were placed on a siding for the full school week and travelled to the next stop over the weekend. Students made their way to the siding on foot or snowshoe, by rail, plane, or canoe. School-car teachers used the regular Ontario curriculum and taught grades one through eight (and occasionally grades nine and ten). The school day started with the teacher raising the Union Jack to the top of the flagpole at the vestibule end of the car. Once the flag was raised, school was in session. The teacher covered enough of the curriculum in one week and assigned enough homework to carry the students through to the next school-car visit—sometimes seven weeks away.

The last two school cars in CPR service, Nos. 50 and 51, were converted in 1942 from old wooden, enclosed-vestibule coaches. School car No. 51 was originally an 1898 passenger coach. It is now on display at Exporail in St-Constant, Quebec.

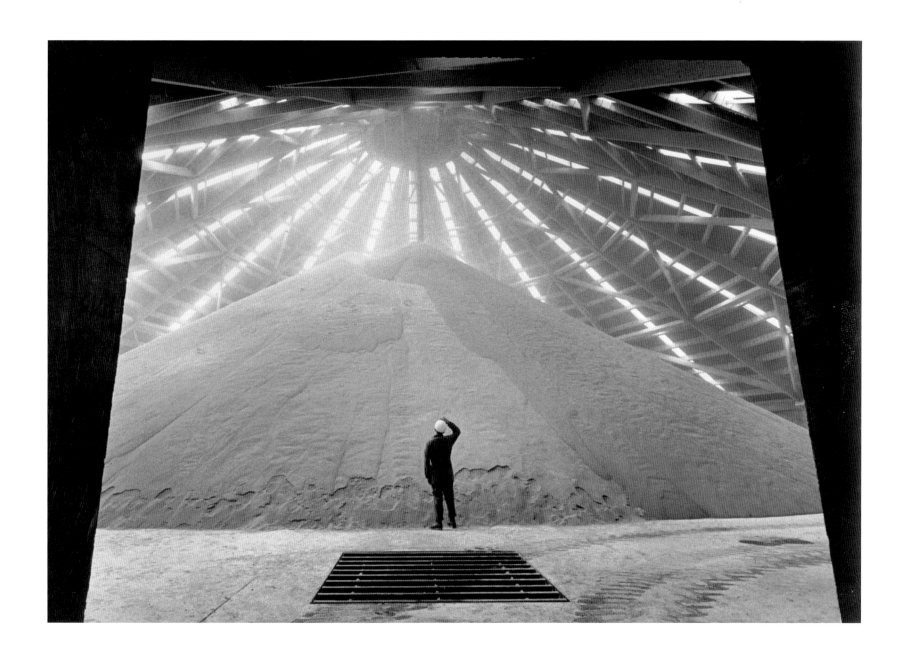

Harry Pollard

Harry Pollard was born in Tillsonburg, Ontario, in 1880. He moved to Calgary, where he opened a studio on Stephen Avenue in 1899. Pollard's portraits of First Nations peoples earned him much praise and are considered one of the most complete photographic records of their kind of the early 1900s. He was made an honorary chief of the Blackfoot Nation. In the mid-1920s, CPR invested in the Montreal-based film company Associated Screen News (ASN). As CPR's appetite for still photographs grew, ASN hired photographers, including Pollard in 1924, to fulfill the company's needs. Pollard was active throughout North America and covered more than twelve world cruises for the CPR, photographing in such exotic locations as Bali and China.

The farmer in this late-1920s photograph is inspecting flax, a crop that has played an important role in Canadian agriculture. In the mid-1850s, European settlers began seeding the unbroken western prairie with flax, which flourished in the clean environment. High-quality flax is an ingredient in many foods and other products. Today, Canada is the world's leader in the production and export of flax.

Harry Pollard, A.12031

Opposite page: Saskatchewan's potash industry was still relatively young when this 1967 photograph of a potash stockpile at Esterhazy was taken. Saskatchewan's high-grade potash reserves, almost all of which go into the making of fertilizer, are estimated to be of sufficient quantity to last for several hundred years.

Anonymous, NS.12834

In 1947, when Nicholas Morant took this photograph, zucca melons were an important agricultural commodity in the temperate climates of Summerland in southern British Columbia. Often made into candied fruit, each gargantuan melon weighs in at more than thirty-five kilograms and easily grows to more than a metre long.

Nicholas Morant, M.4189

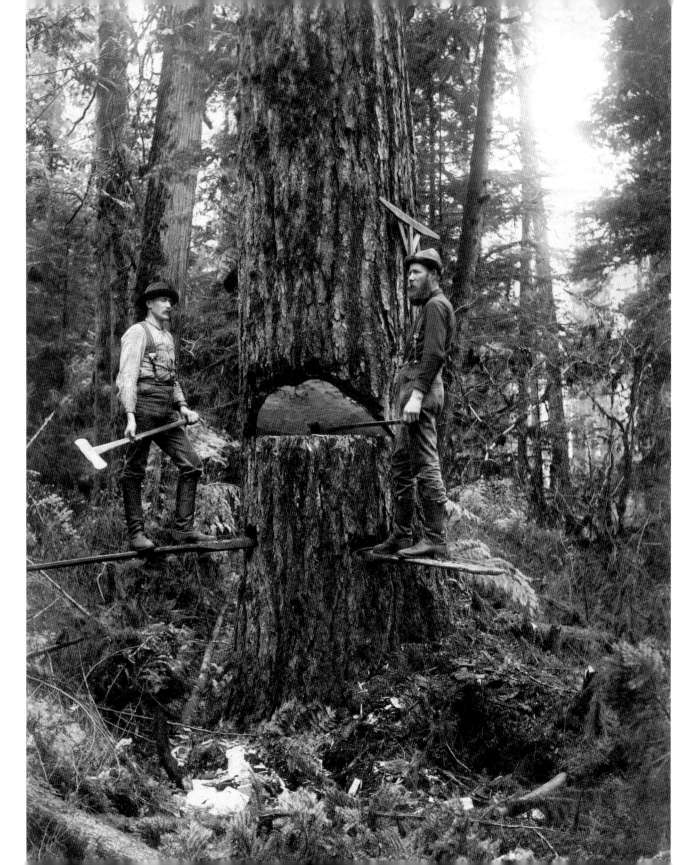

West-coast photographers and partners Bailey and Neelands are credited with this 1890 photograph of the labour-intensive process of felling an enormous tree. By this time, CPR provided a link to eastern markets and demand for British Columbia forest products grew substantially.

Bailey and Neelands, A.11524

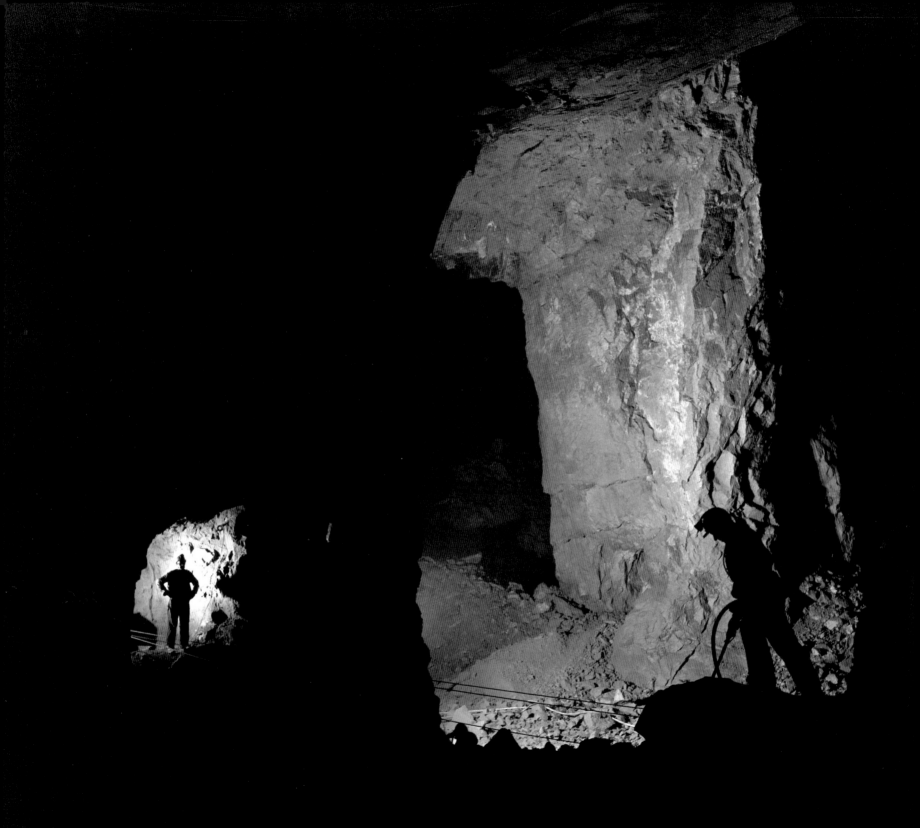

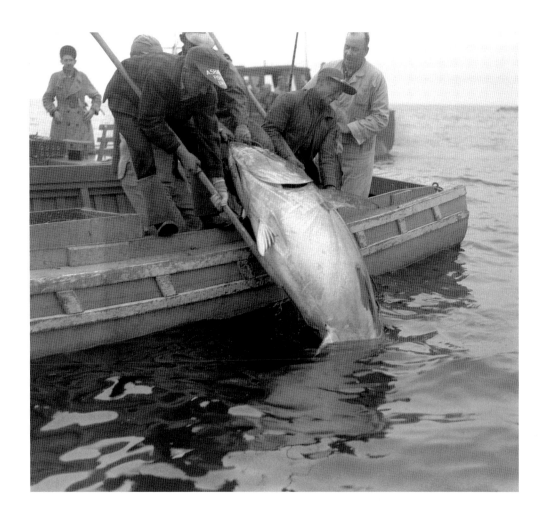

Opposite page: When it came to lighting a scene, few photographers could compare to Nicholas Morant. In preparing to shoot this late-1940s photograph, taken deep inside the Sullivan Mine at Kimberley, British Columbia, Morant would have connected powerful flashbulbs together and then strung a firing cord back to the camera.

Nicholas Morant, M.4282

The demanding sport of tuna fishing was one of the prime attractions offered to guests staying at CPR's Lakeside Inn in Nova Scotia. From August through October, anglers left the dock at about 5 a.m. in as many as twenty chartered boats equipped with custom-built, thousand-dollar fishing rods. When this photograph was taken in 1948, one of the favourite fishing spots was Soldier's Rip off the shore from Wedgeport, where the prize catches were giant 250-kilogram bluefin tunas.

E. C. MacPherson, NS.7677

Oscar and Daniel Peterson

When the great jazz legend Oscar Peterson turned eighty in August 2005, Canada Post marked the music man's milestone by issuing a fifty-cent stamp bearing his likeness. It was the first time a Canadian stamp paid tribute to a living Canadian.

The international jazz pianist is not only a famous Canadian, he is also a famous "CPR brat." The man who taught him music and genetically encoded him with his jazz genius was none other than his dad—CPR sleeping-car porter Daniel Peterson.

Daniel Peterson started out as an adolescent able seaman out of the West Indies, but he always wanted to play the piano—not an easy task for one who spent most of his time aboard a ship. "I solved my problem by buying me a collapsible organ. All folded up in a suitcase," said Daniel Peterson years later. He also bought music books and taught himself music in his spare time.

By the time he left the high seas, he was a fairly accomplished musician. In 1917, he settled down in Montreal, bought a piano, and started a family. Daniel started working for CPR in 1919, on sleeping-car service between Montreal and Toronto. Although he was "on the road" a great deal of the time, he didn't stint on his family's musical upbringing. He taught music to each and every one of his five children—Fred, Daisy, Charles, Oscar, and May. When Oscar was only five, his father discovered that the young musical prodigy had perfect pitch. Oscar, standing with his back to the piano, could accurately name any note he struck on the piano, and if Daniel complicated the test by striking a chord, Oscar could name each of the individual notes in the chord by ear alone.

Oscar began playing trumpet and piano at age seven. His first big break came when he won a local amateur radio contest. In his teens, he was the featured soloist of Montreal's Johnny Holmes Orchestra. Count Basie heard of the musically talented nineteen-year-old Montrealer and invited him to join his swing band. By 1945, Oscar was playing in a sixteen-piece dance band, had a weekly radio show, a recording contract, and two albums to his name. From then on, Oscar Peterson's work with other musical legends catapulted him into international fame.

It seems Oscar Peterson never forgot his father's CPR roots. In 1962, he recorded "Night Train."

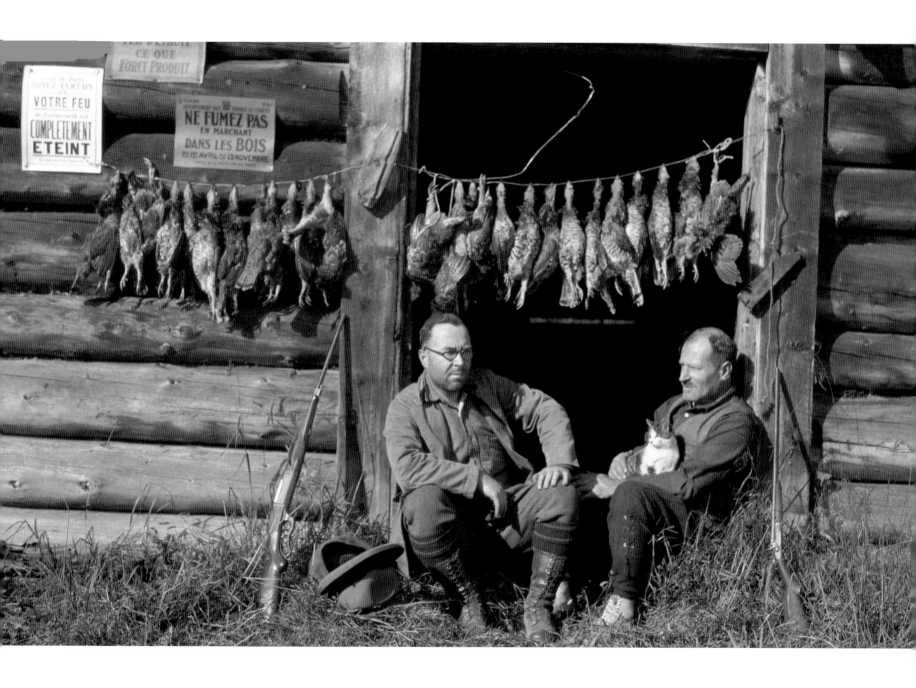

118

Associated Screen News

In 1920, CPR created the Associated Screen News Limited (ASN) of New York which in turn opened the subsidiary Associated Screen News Limited of Canada. The New York office, which distributed newsreels worldwide, floundered while the Canadian operations took off. Among many other titles, ASN Canada produced films which depicted life in Canada, screening these films for immigrants who were making their way to Canada on board Canadian Pacific Steamships. Besides CPR, ASN produced films for the federal government, the provincial governments of New Brunswick, Nova Scotia, Ontario, and Quebec, and the Massey Harris and Bell Telephone Companies. In the 1920s, ASN film crews and still photographers captured the luxury and romance of Canadian Pacific Steamship cruises to far-flung destinations such as Cuba, Haiti, Venezuela, China, Japan, and the United Kingdom. In 1926, ASN chose Montreal to build Canada's first movie film-processing laboratory and five years later added the country's first permanent sound stage for movie production. Beginning in 1931, ASN produced *The Canadian Cameo* series of shorts, which featured sports, musicals, fact, fantasy, and fiction. The popular series was suspended during the war but resumed production in 1948.

In the 1930s, CPR published *Montreal and the Laurentians* to promote the old-world charm of Montreal and the natural beauty of the Laurentian Mountains. The brochure described the company's rail line as it left the city and meandered north into the mountains and villages. The photographs depicted many activities of the region including golfing, fishing, and, as seen here, partridge hunting.

Associated Screen News, NS.20258

In the late 1920s, an effort to make the most of the sometimes long Quebec winters resulted in a new, exciting twist to the traditional sport of skijoring, when skiers, normally pulled by dogs or horses, were harnessed to a motorcycle. The sport was only one of many offered to guests of CPR's Château Frontenac. The hotel's promotional brochures at the time boasted the hotel had "all the winter sports known to man and approved by a keen, sport loving people."

Anonymous, A.28036

Opposite page: In Quebec, some consider the sport of downhill skiing to be a religion, and this notion was further encouraged by this late-1930s photograph, taken by Nicholas Morant, of four skiing clerics in the mountains near Ste-Agathe.

Nicholas Morant, M.1669

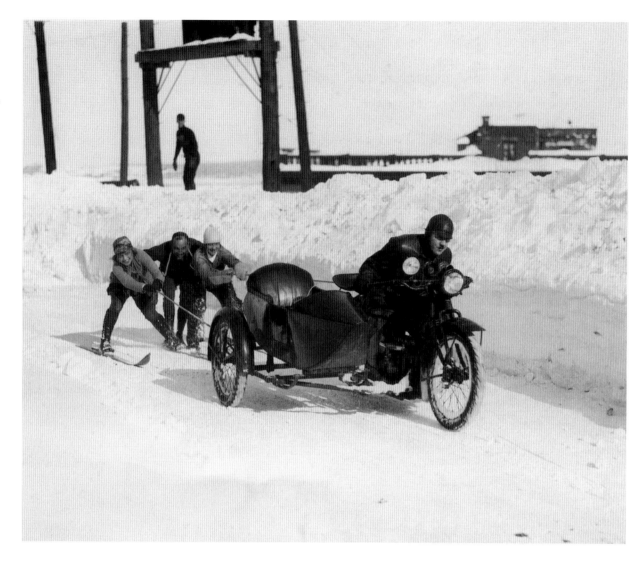

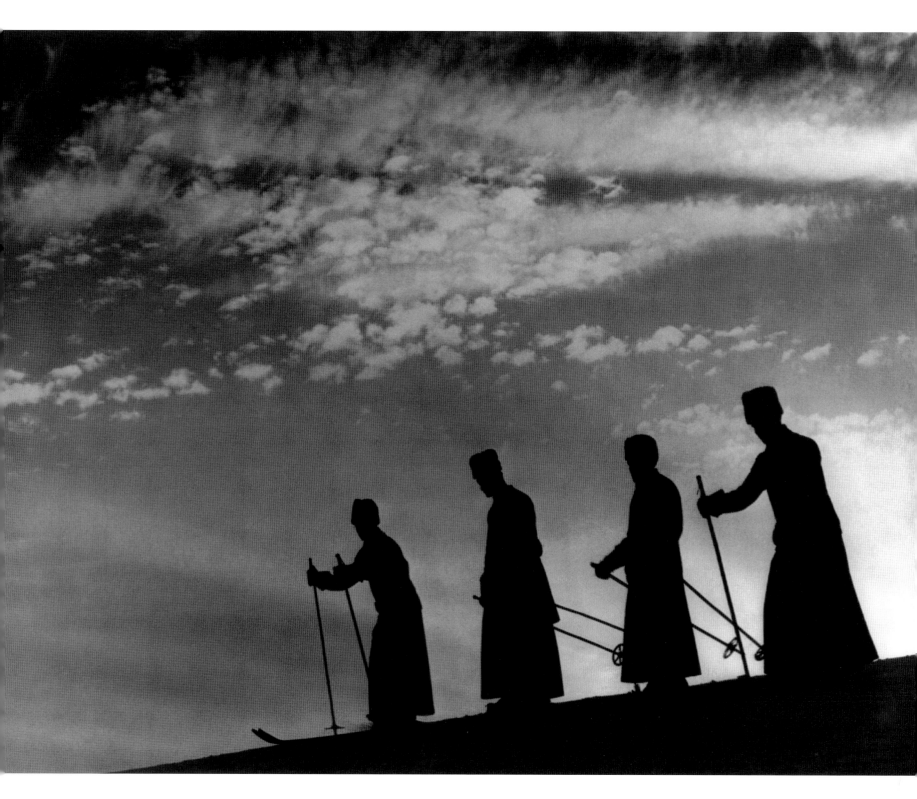

Ski Trains

Oddly enough, the skiing-and-CPR partnership popped up first on the prairies, possibly due to the influence of European settlers. In fact, Canada's first ski club, the Canadian Amateur Ski Association, was formed in Winnipeg in 1912. Canadian Pacific Railway employees got involved in the ski club and spread their ski smarts to the Canadian Rockies.

Surprisingly, winter tourism in the Canadian Rockies only kicked off in 1917, the year of the first Banff Winter Carnival. It wasn't until the 1930s that ski tourism developed at Mount Norquay and at Skoki, north of Lake Louise. Canadian Pacific Railway trains and hotels got into the act in 1937 when the Dominion Ski Championships were held in Banff. In that year, CPR dispatched the first "Snow Trains" to the resort and opened its two major hotels—Banff Springs and the Chateau Lake Louise—for the event and its skiers.

In the east, CPR helped develop ski tourism around Quebec City in the 1930s. The Lac-Beauport, Mount Murphy, Taylor Mountain, and Valcartier ski runs were at the Château Frontenac's doorstep. Canadian Pacific Railway advertised its luxurious fortresslike hotel as the place to stay for those who wanted to indulge in winter sports, especially skiing. Posters aimed at Americans touted the fact that you didn't even need to bring your passport.

Skiing north of Montreal in the Laurentians also took off in the 1930s. Canadian Pacific Railway put on more and more ski trains on winter holidays and weekends, serving such historic Laurentian towns as Piedmont, Ste-Marguerite, and Mont-Tremblant, where the ski hills were often only a sleigh ride away from the railway station. The Saturday and Sunday ski specials were enormously popular, and the trip was often as entertaining as the skiing. At the time, a one-day round trip from Windsor Station to Piedmont, near the slopes of St-Sauveur, cost $1.20.

Even though it was the depths of the Great Depression, traffic quadrupled in only five years. The 1934–35 winter season attracted 36,747 ski-train passengers. The 1939–40 figures clocked in at 143,500. Canadian Pacific Railway had to press its old wooden Montreal commuter coaches into ski-train duty. They were ideal because they had open-vestibule platforms at both ends of each car, which made it easy for skiers and their skis to get on and off the train. A CPR coach of this vintage, No. 141, was last used in ski-train service in 1951. Because it looked very much like an 1880s colonist car, it was refurbished for use in the filming of the CBC documentary on the building of the CPR, *The National Dream*. It is now an exhibit in Calgary's Heritage Park.

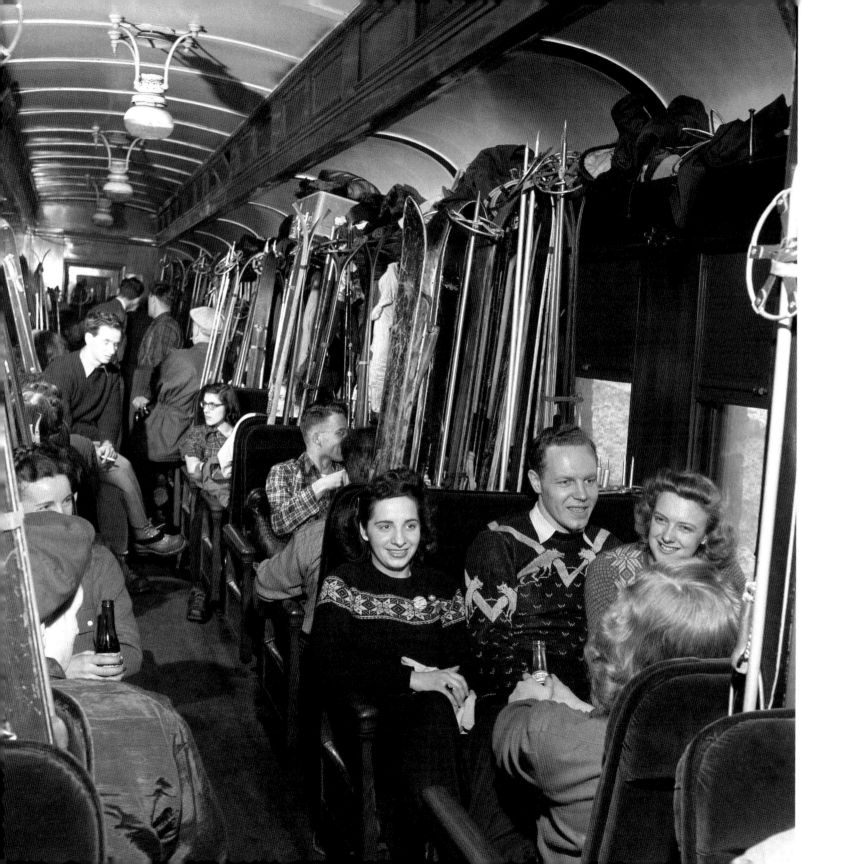

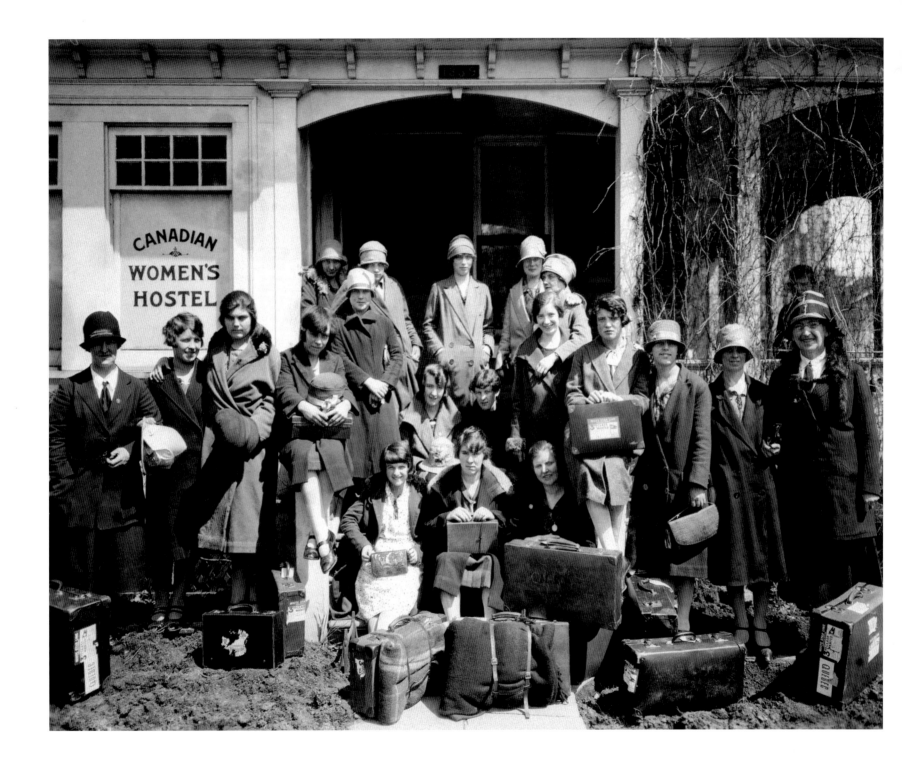

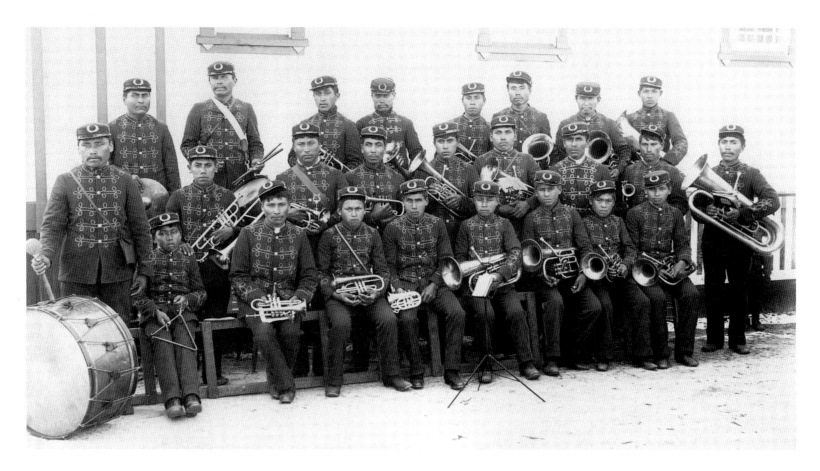

Opposite page: In the early 1920s, a group of what are most likely British women immigrating to Canada pose on the steps of the Regina Women's Hostel. Perhaps they had read the pamphlet *Openings for British Women in Canada*, published by CPR's European head office in London. The pamphlet described the wide range of employment opportunities available and the conditions they could expect to encounter throughout the country.

Anonymous, NS.22147

Little is known about this group of First Nations musicians, most likely photographed at Sechelt, British Columbia, about 1895.

Bailey Brothers, A.11527

Trail Riders

Ironically, trail riders got their start because of the rise of the automobile. Before World War I, there was an embargo on the use of automobiles in the mountain national parks. Once the embargo was lifted and new roads were built, CPR decided it could expand its tourist hotel network. In the 1920s, the original CPR mountain hotels—Mount Stephen House, Glacier House, Banff Springs, and Chateau Lake Louise—were joined by several other smaller hotels and camps that sprang up in more out-of-the-way places in the mountains.

Middle- and upper-class North Americans with a developing love for their cars could now drive to remote park places. Canadian Pacific Railway's Emerald Lake Chalet, Wapta Lake mountain bungalow camp, and Lake O'Hara camp popped up first. In the 1920s, CPR built rustic-looking bungalow camps at Lake Windermere, Castle Mountain, Vermilion River, and Radium Hot Springs. The company supplemented these with teahouses at Saddleback, Summit Lake, Twin Falls, Lake Agnes, Nakimu Caves, Plain of Six Glaciers, and at the Natural Bridge on the Kicking Horse River.

Paradoxically, once the new breed of motor tourists got to these places, they wanted to explore nature on trails suitable only for hiking and horseback riding, so in 1923 CPR founded an eco-tourism group known as the Trail Riders of the Canadian Rockies. This group on horseback complemented the hikers-on-foot club, the Alpine Club of Canada, which CPR had been instrumental in founding in 1906. Trail Riders could now go on guided horseback trail rides, camp overnight in tents high up in the Rocky Mountains, and join in singsongs and guitar playing around a roaring campfire.

Canadian Pacific Railway boosted its Trail Riders tourism with special all-inclusive rail fares to various bungalow camps and chalets and promoted a sense of belonging amongst Trail Riders with a minimum 50-mile horseback trail ride to qualify for membership. Higher trail-riding stages or "merit badge" plateaus could be reached, and CPR issued sequential buttons to those who had ridden 50, 100, 500, 1,000, and 2,500 miles of mountain trails on horseback. To give the program some cachet, CPR enticed the Prince of Wales, during his 1923 visit to Canada, to earn a Trail Rider membership with a 50-mile horseback ride.

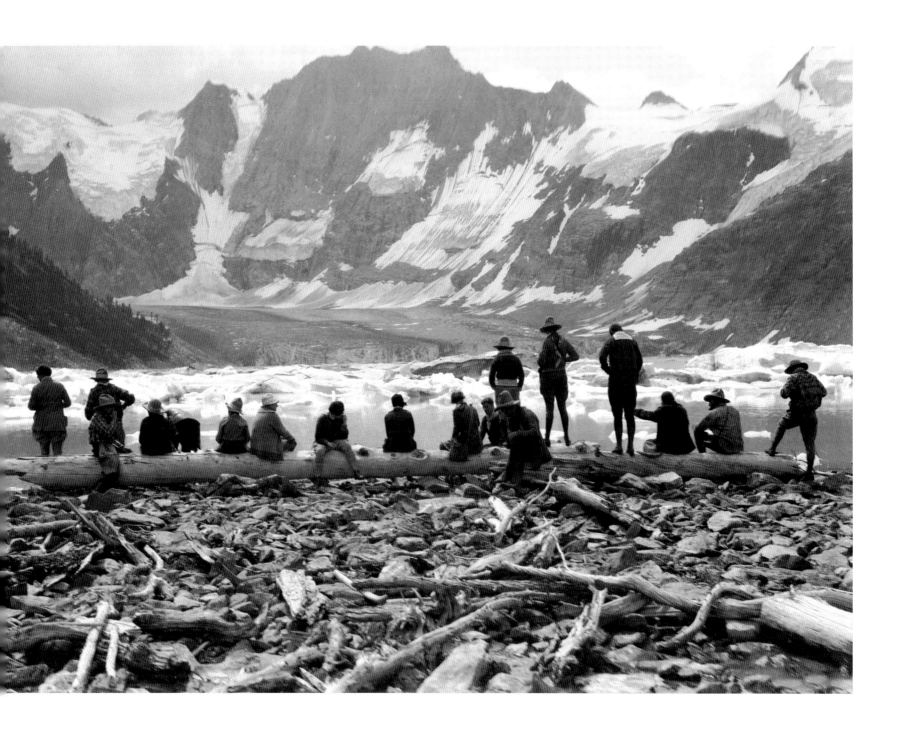

The rough-and-tumble appearance of Banff, in this 1927 photograph of the annual Banff Winter Carnival, is in sharp contrast to the town's modern-day resort image. The carnival, which began in 1917, was one of many schemes devised to encourage tourism and entertain the locals. The preparations went on for weeks and the carnival lasted for several days.

Cyril Littlebury, NS.15477

Opposite page: In the 1940s, the breathtaking vistas offered along the 230-kilometre road from Lake Louise to Jasper, now known as the Icefields Parkway, were favourites of the people who practiced the relatively new pastime of motor touring. The region boasts some of Canada's most spectacular scenery, including views of Mount Athabasca, the Columbia Glacier, and the Columbia Icefields.

Nicholas Morant, M.2203

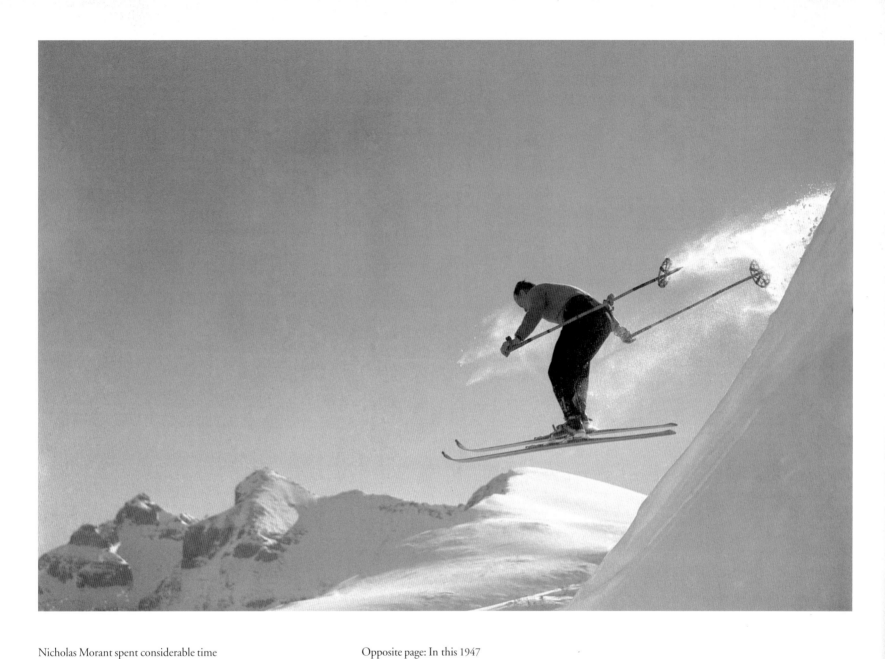

Nicholas Morant spent considerable time
and energy in the mountains of Alberta
photographing the emerging sport of
downhill skiing. This late-1930s photograph,
taken in the vicinity of the historic Skoki
Lodge in Banff National Park, captures the
essence of this exhilarating new activity.

Nicholas Morant, M.886

Opposite page: In this 1947
photograph, Nicholas Morant
captures a romanticized vision
of a skier waxing his skis, backlit
against a frosty window.

Nicholas Morant, M.4730

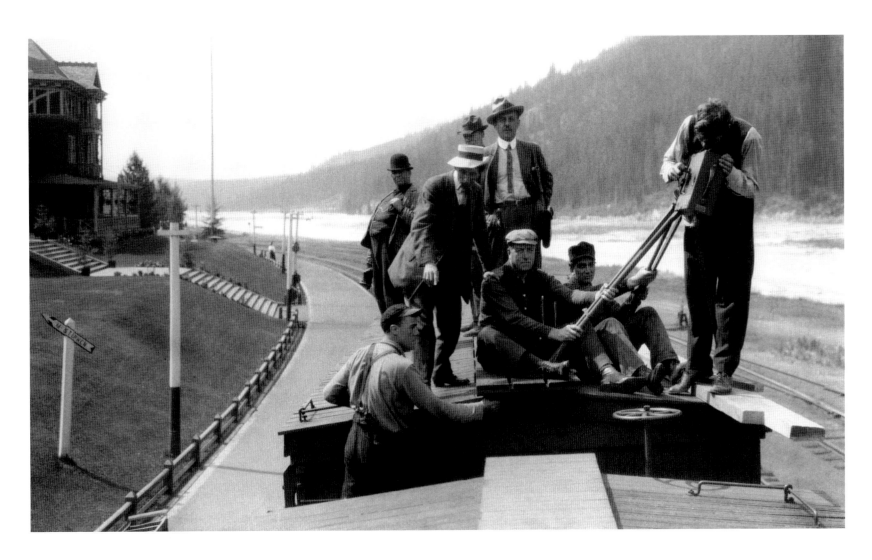

Opposite page: During the 1930s, the Rocky Mountains attracted a community of renowned artists. One of the main reasons for this was the camaraderie offered by the Sky Line Trail Hikers, which claimed a distinguished group of people among its membership, including (left to right) wildlife painter Carl Rungius, George B. Mitchell, who is known for his paintings of the Blackfoot people, and portrait-painter Kathleen Shackleton, the sister of Antarctic explorer Sir Ernest Shackleton. At various times, all three had commissions from CPR, which showcased their talents in railway, hotel, and steamship promotional publications. They gathered at the Trail Hikers Camp at Yoho Lake for Nicholas Morant, who titled his 1938 photograph "The Artists."

Nicholas Morant, M.1310

The scenery through which CPR operates has long been a favourite backdrop for filmmakers. In this photograph, taken in about 1910, CPR's Mount Stephen House and the mighty Kicking Horse River at Field, British Columbia, appear in what is likely the Edison Company's feature film *The Little Station Agent*, a story about a young station agent who performs an act of courage. According to contemporary reviews, the film was superbly photographed and the natural backdrops were much appreciated.

Anonymous, A.20780

Strongheart and the Movies

Canine movie star Strongheart, around 1924, with director and trainer Laurence Trimble (left) and Mr. W. W. Grant of the Albertan W. W. Grant Broadcasting Station in Calgary.

W. J. Oliver, A.20765

During the early days of movies, there were many heroes, and some were canine. Strongheart, the first of the dog superstars, was born in 1917 and originally trained as an attack dog. Discovered by animal trainer Larry Trimble, who brought him to Hollywood, Strongheart immediately took to acting. An instant favourite after his first movie, *The Silent Call*, was released in 1921, he travelled across the United States by train, greeting enthusiastic audiences at every stop. Strongheart even made it to Canada, where he broadcast an invitation to all Canadians and Americans and a challenge to dogdom to come to the 1924 Banff Winter Carnival and the 100 Mile Dog Grand Prix.

Strongheart continued to be a favourite throughout the twenties, despite increasing competition from newcomer Rin Tin Tin. After injuring himself during the making of a movie, Strongheart died in 1929.

Earlier, at the end of the nineteenth century, CPR had been quick to realize that films were a powerful means of promoting tourism and immigration and hired a series of filmmakers to show Canada at its best. One of the first to film for CPR was James Freer, who had emigrated from England to Manitoba. The railway sponsored Freer's touring show, which visited Britain in 1898 promoting Canada's agricultural riches. At about the same time, CPR hired William Harbeck to put western Canada on the movie screen and also sponsored the railway films of the American Mutoscope and Biograph Company and travel films shot for Charles Urban's Bioscope Company of Canada. It was reported that Bioscope received strict instructions to avoid any snow scenes that might discourage prospective visitors. In 1910, CPR commissioned the Edison Company of New York to film a series of dramas. The Edison team travelled the entire length of the CPR line in a special train, completing thirteen one-reel films. The connection between filmmakers and railways weakened after 1910 and during the years of World War I. Canadian Pacific Railway, however, has endured as a subject of interest for filmmakers searching for iconic Canadian subjects.

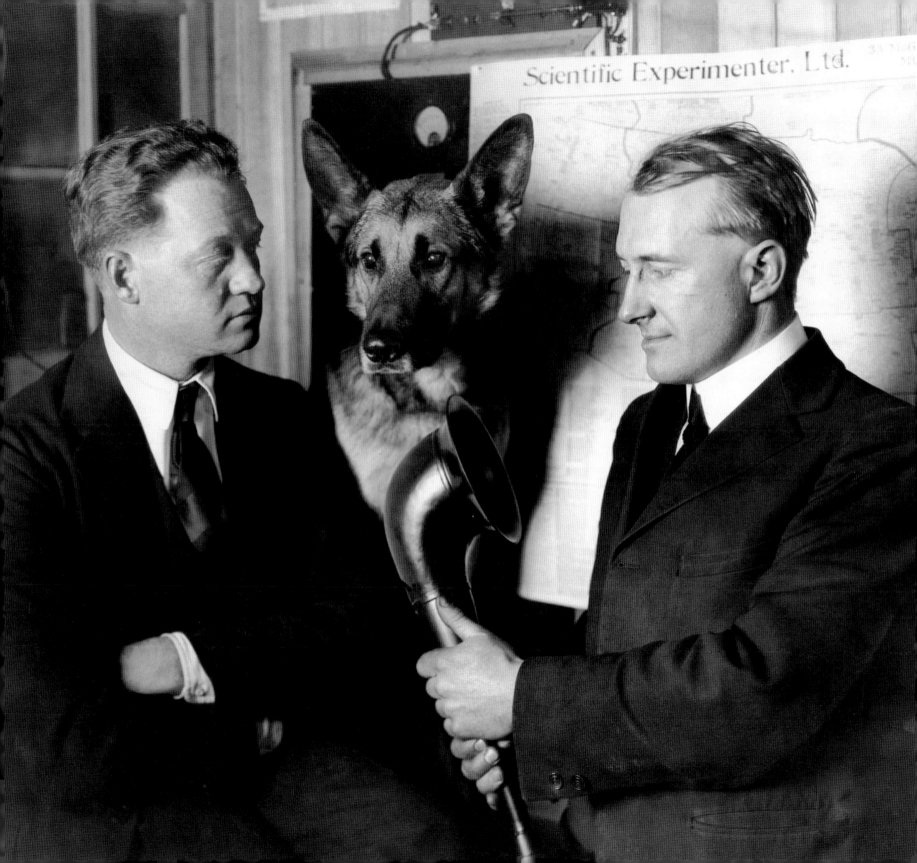

An elaborately decorated bicycle prepares to take part in Montreal's St. Jean Baptiste Day parade in 1928. First a pagan celebration of the summer solstice, then a religious celebration marking the birth of John the Baptist, the annual St. Jean Baptiste celebration on 24 June is now a national holiday in Quebec. It is more commonly known as La Fête Nationale and celebrates the province's unique character. St. Jean Baptiste Day is also celebrated as a festival of French-Canadian culture by Francophones in other Canadian provinces.

Anonymous, NS.18794

Travelling Machines

"See this World before the Next by the World's Greatest Travel System."

—CPR cruise ship travel slogan, 1920s

In 1889, CPR's general superintendent, Harry Abbott (standing), accompanies Lord Stanley of Preston, Canada's sixth governor general since Confederation, and his party on an elaborately decorated locomotive cowcatcher. Lord Stanley's journey, his first to western Canada, allowed him to see for himself the great beauty and potential of the emergent Canadian nation. Lord Stanley is chiefly remembered for his 1893 donation of hockey's coveted Stanley Cup.

Anonymous, A.17333

By the 1920s, Canadian Pacific Railway was truly a global enterprise. Although its advertising claim to be "the world's greatest travel system" may have seemed a little exaggerated, CPR had the machines to move people and goods around the world.

On land, CPR had a fleet of swift-moving steam locomotives. They were getting bigger, better, cleaner, and faster. In addition to using trains for the land transportation of freight, CPR had moved parcels and express packages by road in horse-drawn vehicles since 1882, and by the 1920s had progressed to motorized, chain-driven Mack trucks.

The railway company also covered the waterfront. Its earliest venture into steamships was on the Great Lakes. Three ships plied the waters between Owen Sound on Georgian Bay, to Port Arthur (Thunder Bay) on Lake Superior, even before the transcontinental railway was completed. The *Alberta*, *Algoma*, and *Athabasca* were built in Scotland and launched in July 1883, sailing across the Atlantic in one piece. In November, they were each cut in half in Montreal to negotiate the St. Lawrence River and Welland Canals. The halves were then rejoined in Buffalo, New York. The three vessels provided CPR's only passenger and freight Great Lakes link until the transcontinental rail line was completed over the north shore of Lake Superior in 1885. The company kept this popular service alive until 1965, allowing passengers to do part of their transcontinental voyage by ship.

Canadian Pacific Railway chartered ships on the Pacific Ocean as early as August 1886, setting up a CPR trade link with the Pacific Rim and spawning the fast-moving silk trains. Silk trains, with their precious and perishable payload, were given priority over all trains, even the Prince of Wales' special train, and cut twenty hours off the fastest transcontinental passenger run. By 1891, CPR had its own fleet of white *Empress* ships plying the Pacific. That very same year it ran a trial world cruise, which proved so popular it became a scheduled offering in 1893 with a fare of $610.

In April 1903, the railway company acquired fifteen Beaver Line ships from Elder Dempster in order to add transatlantic service to its existing transpacific service. The following month CPR acquired nine screw-steamers and five paddle-steamers for

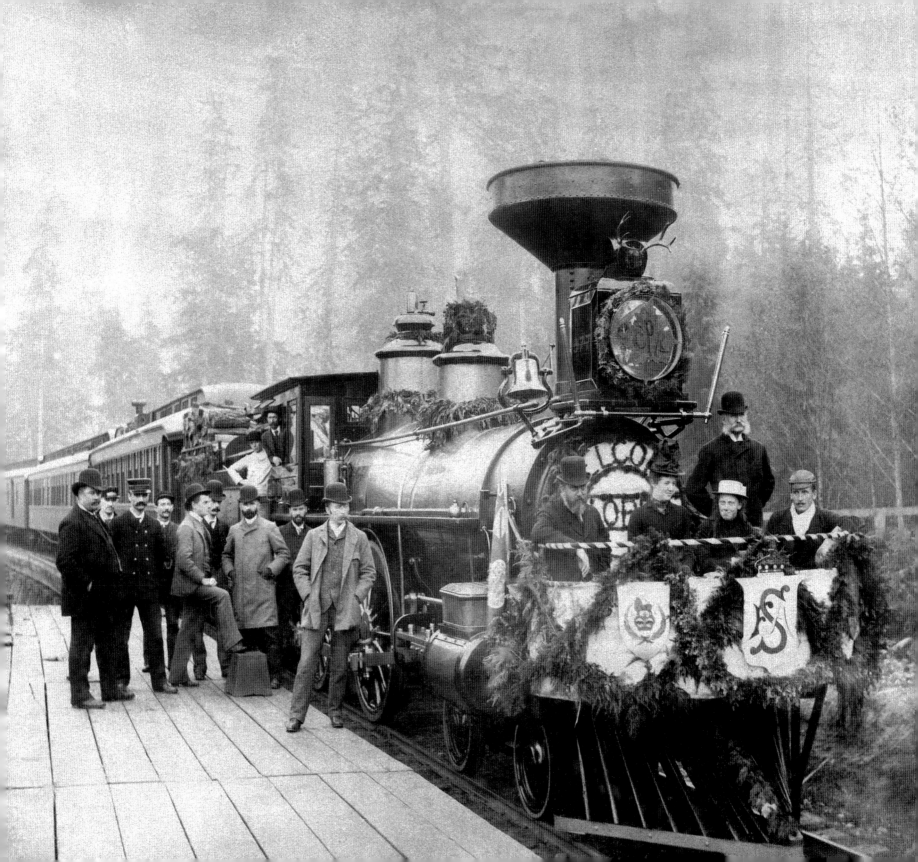

Fort William, Ontario, employees and four smartly dressed children gather in about 1886 to acknowledge locomotive foreman Harry Priest's invention, the Priest Pilot Plow. Harry, with felt hat, vest, and pocket watch, is standing immediately to the left of the apparatus. The snowplow was lowered by a series of levers and bell-cranks to work just above the rail.

Anonymous, A.656

coastal service up and down the Pacific coast of North America. The company later added service on the opposite end of the continent with Bay of Fundy service between New Brunswick and Nova Scotia. In 1906, CPR introduced the *Empress* ships to its Atlantic Ocean route, enabling it to deliver mail from Liverpool to Hong Kong in just twenty-nine days. The elite *Empress* ships weren't just fast, they were fashionable, too. Canadian Pacific Railway's luxurious trans-Atlantic, trans-Pacific, and world cruises rivalled the service on board Cunard and White Star Line ships. In fact, when CPR stopped cruising the seas in 1971, it sold *Empress of Canada III* and the cruise ship idea to the company now famous for the concept—Carnival Cruise Lines.

Canadian Pacific Railway also took to the air in its flying machines. The railway company got permission to operate a commercial airline in 1919 and formed Canadian Pacific Air Lines in 1942. The company's air service to Canada's remote far north opened up the country's farthest regions to passenger and parcel express service, linking the north with the rest of Canada. In 1949, Canadian Pacific Air Lines became the first North American carrier to serve China.

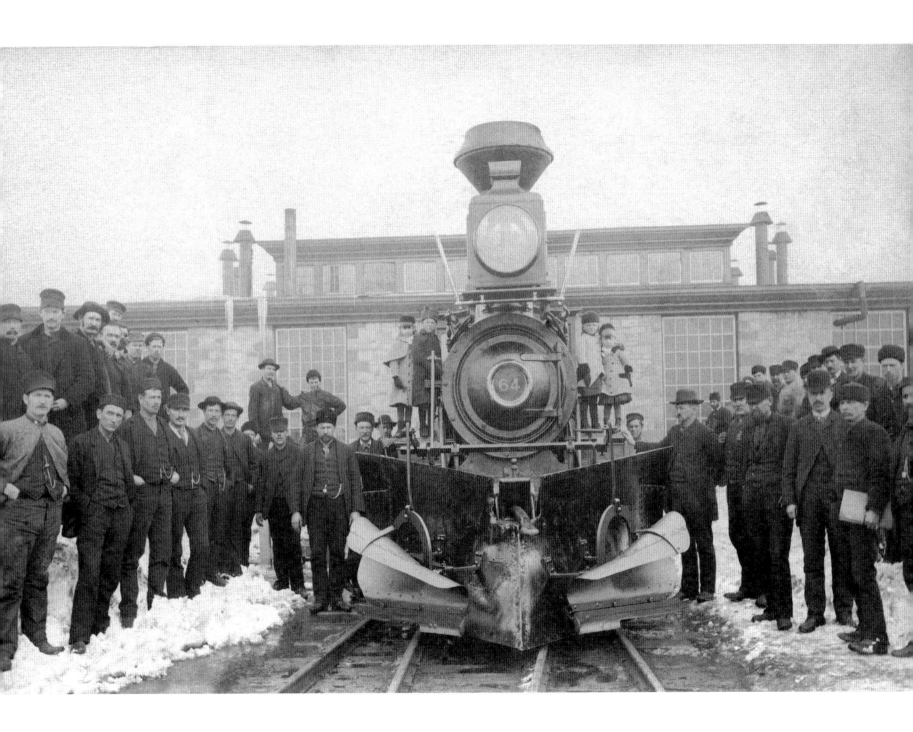

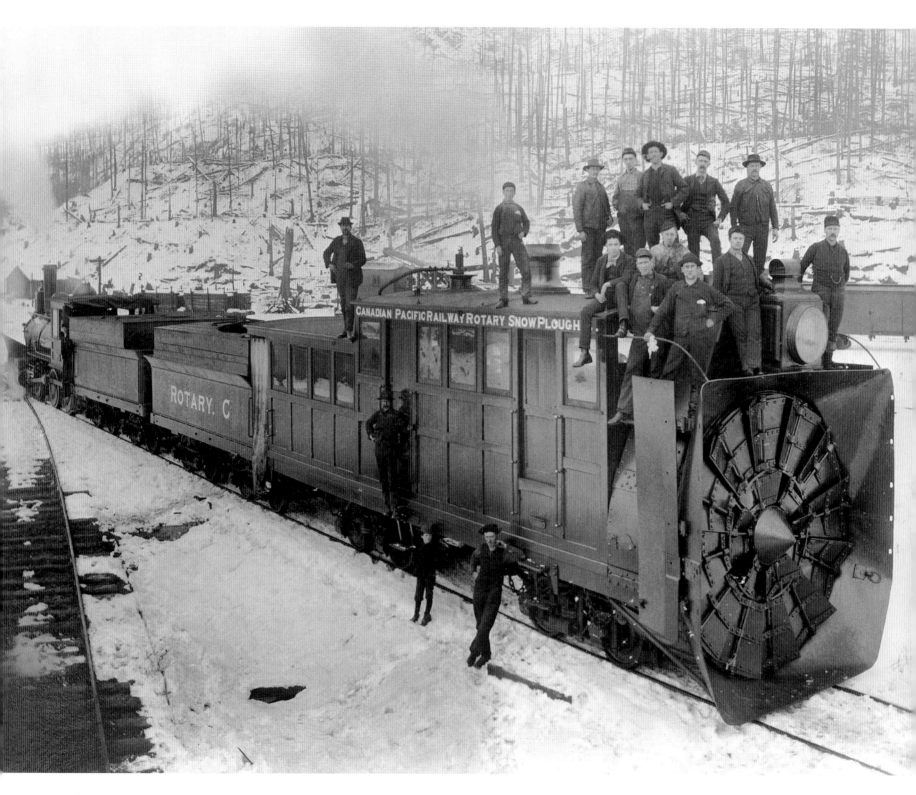

CANADIAN PACIFIC RAILWAY ROTARY SNOW PLOUGH

ROTARY. C

Snow

Donald Smith drove the last spike 7 November 1885, but the first transcontinental train only arrived at Port Moody on 4 July 1886. There was a valid reason for the delay—a pass in the Selkirk Mountains with lots of snow.

In the winter of 1885–86, a crew under the direction of division engineer Granville Cunningham stayed behind in Rogers Pass for the whole winter. The crew was there to monitor avalanches and snowfall and then decide where to build snowsheds. By spring they had all the information they needed and started building no fewer than thirty-one snowsheds within a twenty-six-kilometre stretch of track through Rogers Pass.

It took two seasons to build them. When the work was completed in 1887, Van Horne was both pleased and displeased. He was happy the job was done, but he didn't like the fact that the snowsheds cost more than a million dollars and they blocked the view. To solve the problem, even though it meant spending more money, Van Horne ordered construction crews to lay down "summer tracks." These tracks skirted the outside of three of the longer snowsheds and were used in the summer only. As a result, passengers could still enjoy the magnificent views of the Illecillewaet and Asulkan glaciers when avalanches weren't a threat.

In winter, CPR cleared the snow using rotary snowplows, a distinctly Canadian invention that looked much like a huge version of today's snowblowers. Canadian Pacific Railway developed and built these new rotary snowplows in the company's Parkdale, Ontario, shops and deployed the first six in 1888 where they were needed the most—in the Selkirks. The steam-powered, snow-eating machines were later used on the prairies, in northern Ontario, and in the snowbelt of eastern Canada.

Snowsheds and rotary snowplows notwithstanding, snow in Rogers Pass spelled doom. In the thirty winter seasons between 1885 and 1916, before the eight-kilometre Connaught Tunnel opened and trains went under the pass instead of through it, at least two hundred people died from snow and avalanches in the pass.

A rotary snowplow in the Rocky Mountains, about 1892.

Trueman & Caple, A.11355

Little is known about this 1906 derailment of locomotive 568 near the British Columbia–Washington border town of Sumas. This "affair" and others like it, as they were sometimes euphemistically referred to in railway terminology, were rarely photographed and any photographs taken were unlikely to be published.

Anonymous, A.500

Opposite page: The crew of a wayfreight pauses to service its engine in Dinorwic near Kenora, Ontario, in about 1910. This is one of many photographs of railway operations in northern Ontario collected by Cliff Howard, who worked briefly as a locomotive engineer for CPR in the late 1920s.

Anonymous, A.37304

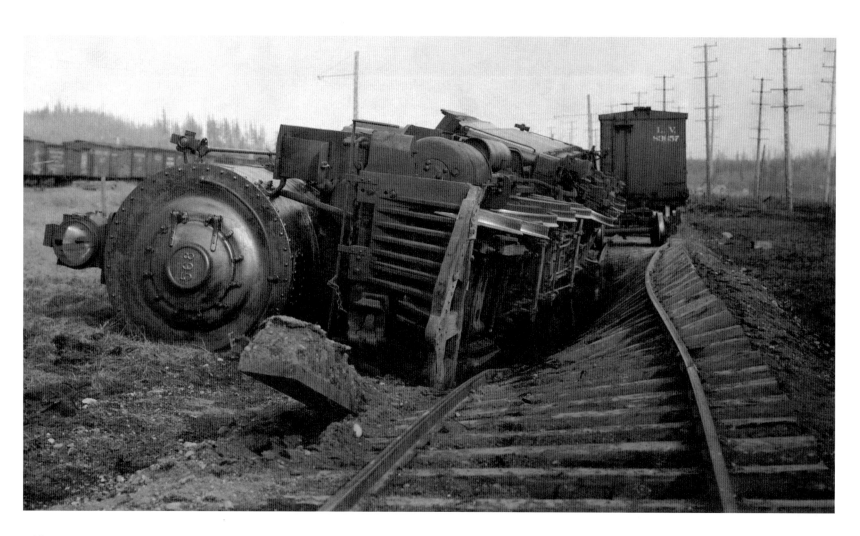

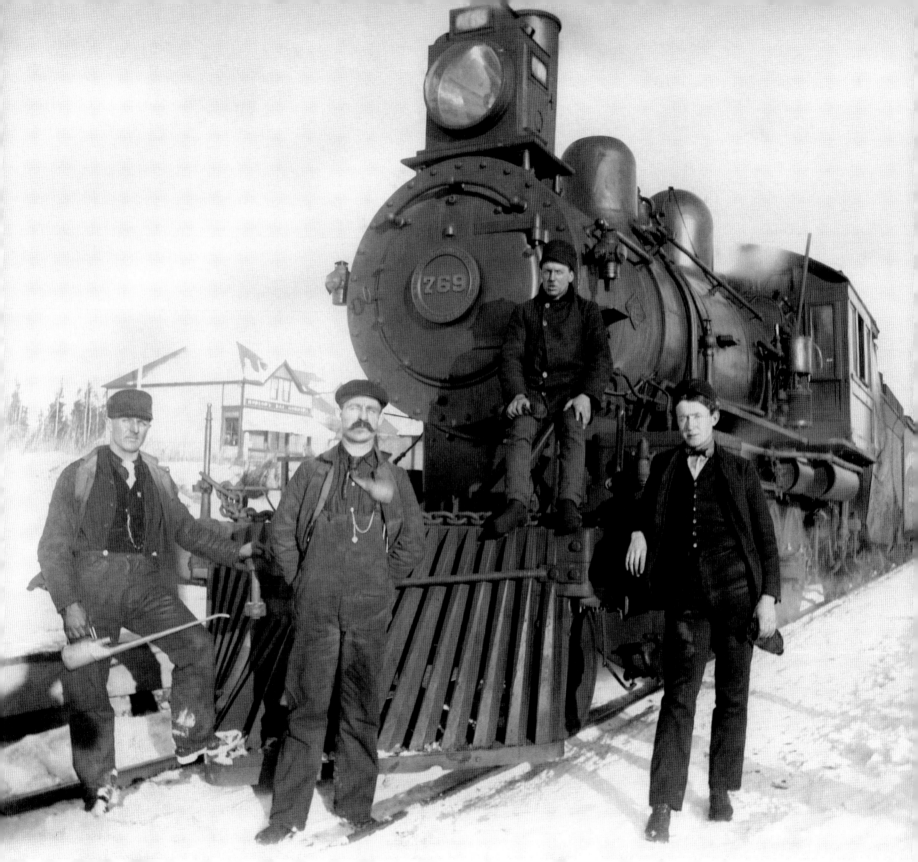

When Angus Shops, CPR's sprawling two-hundred-acre locomotive and car building and repair facility, first opened in Montreal in 1904, its fire service boasted 60 three-way hydrants, 13,000 automatic sprinklers, and two 1,500-gallon reservoirs. By the early 1920s, Angus Shops' Fire Brigade had grown to include this compact, yet efficient, fire truck.

Anonymous, A.233

Opposite page: A crowd gathers at Montreal's Windsor Station, where, in a rush of steam, what is most likely CPR's Pacific Express departs for Vancouver in about 1905. The photograph also provides a rare view of the station's original train shed. The Pacific Express passenger train generally consisted of a combination baggage/mail car, colonist and first-class coaches, and tourist and sleeping cars. Unable to run over the steep mountain grades, dining cars ran between Montreal and Laggan (Lake Louise) and then again between Revelstoke and Vancouver only.

Anonymous, A.14211

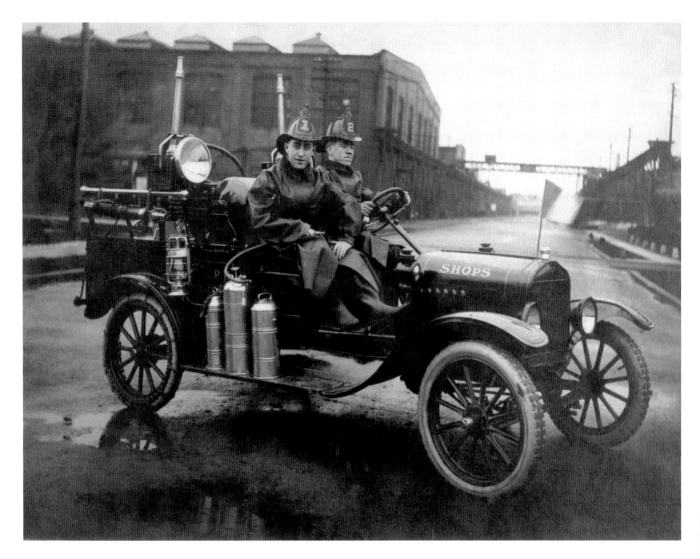

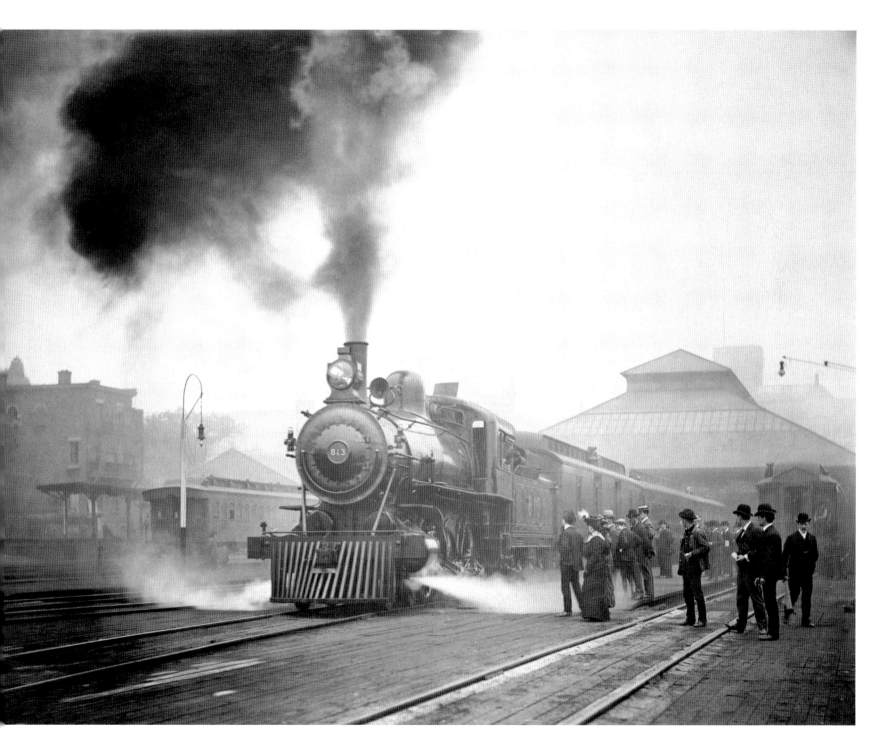

Trueman & Caple

The Vancouver-based partnership of Richard Henry Trueman, born in Ontario in 1856, and Norman Caple, born in Bristol, England, in 1866, was formed in about 1890. The partnership lasted about three years, during which time they photographed extensively along the CPR main line, capturing prairie grain being delivered to Oak Lake, Manitoba, elevators and Pacific Ocean–bound ships loading lumber at the docks at Moodyville (now Port Moody), British Columbia. Trueman & Caple also took rare photos of the rail line under winter conditions. After their partnership ended, Trueman continued to travel extensively and operated studios in Revelstoke and Vancouver. Caple operated both a photography and a stationery supply business.

Once CPR's transcontinental rail line had been completed, the arduous task of maintaining the line began. In this photograph taken on a trestle bridge on the Beaver River Canyon, British Columbia, in about 1892, four sectionmen ensure that track bolts are tight and spikes are well set. A crew ordinarily maintained sections of between eight and nine kilometres.

Trueman & Caple, NS.332

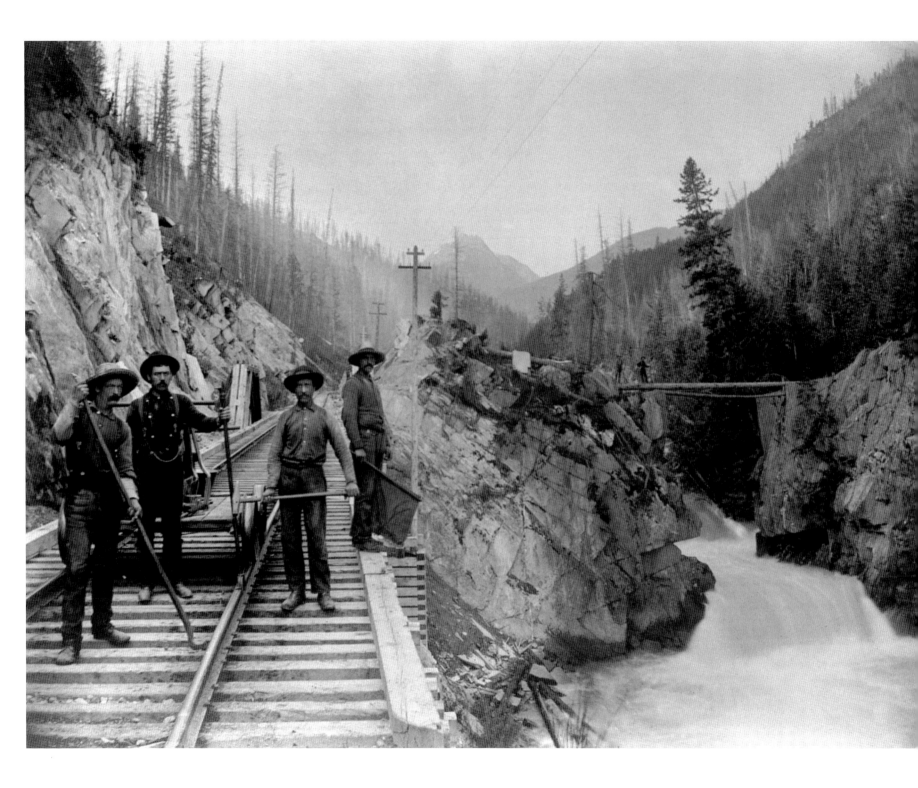

The Famous Trans-Canada Limited

The Trans-Canada Limited dining room in 1924. Toronto-based Brigden's Studios was hired by the CPR in the mid-1920s to capture the elegance of its renowned transcontinental passenger trains, luxury hotels, bungalow camps, and fleet of steamships. Often with professional models in tow, Brigden's staff of photographers set the scene of refined travel in locations across the country, giving credence to CPR's claim to be the "World's Greatest Travel System."

Brigden's Studio, A.28545

Canadian Pacific Railway has run passenger trains since 1 May 1881. Passengers have travelled on local, commuter, mixed, transcontinental, and special "named" trains—like the Pacific Express, the Imperial Limited, the Trans-Canada Limited, The Mountaineer, The Dominion, and, of course, beginning in April 1955, The Canadian, an all stainless steel transcontinental train featuring the longest dome-car ride in the world.

On 1 June 1919, CPR introduced a new summer season daily passenger train, the Trans-Canada Limited, tapping into a burgeoning market of upscale business and tourist travellers. The Trans-Canada Limited replaced the Imperial Limited that year as CPR's premier passenger train, and it soon became one of North America's famous "named" trains, ranking with the likes of the American Broadway Limited and 20th Century Limited. The well-heeled Trans-Canada Limited traveller of the 1920s could span the North American continent in less than ninety hours or could stop off at CPR's world-famous resorts in Banff or Lake Louise and then continue to the coast and board a CPR *Empress* ship to the Orient.

The on-board dining experience was second to none. "Chefs, trained in Canadian Pacific kitchens, serve from extensive menus that include seasonal and local delicacies," stated CPR brochures about the meal service. Other brochures boasted of "the cuisine and service for which Canadian Pacific is famous." Trans-Canada Limited passengers dined in style using CPR triple-plate Elkington cutlery and quadruple-plate silverware. They sat at tables draped with starched white linen and set with classic CPR crockery, Limoges and Minton china, and were surrounded by the elegant warmth of inlaid walnut and mahogany panelling. Oil-burning locomotives were used to "keep this delightful trip free from the discomfort of smoke and cinders." The upgraded 1929 edition of the Trans-Canada Limited featured a tail-end solarium car, complete with showers, writing desk, lounges, and a solarium with "wide vision, full length Vita-Glass windows," claiming to filter out harmful glare but still "admit healthful sunshine and afford unobstructed views."

Sadly, the Great Depression and its resulting decline in passenger traffic sealed the Trans-Canada Limited's fate. It was withdrawn from service in 1931.

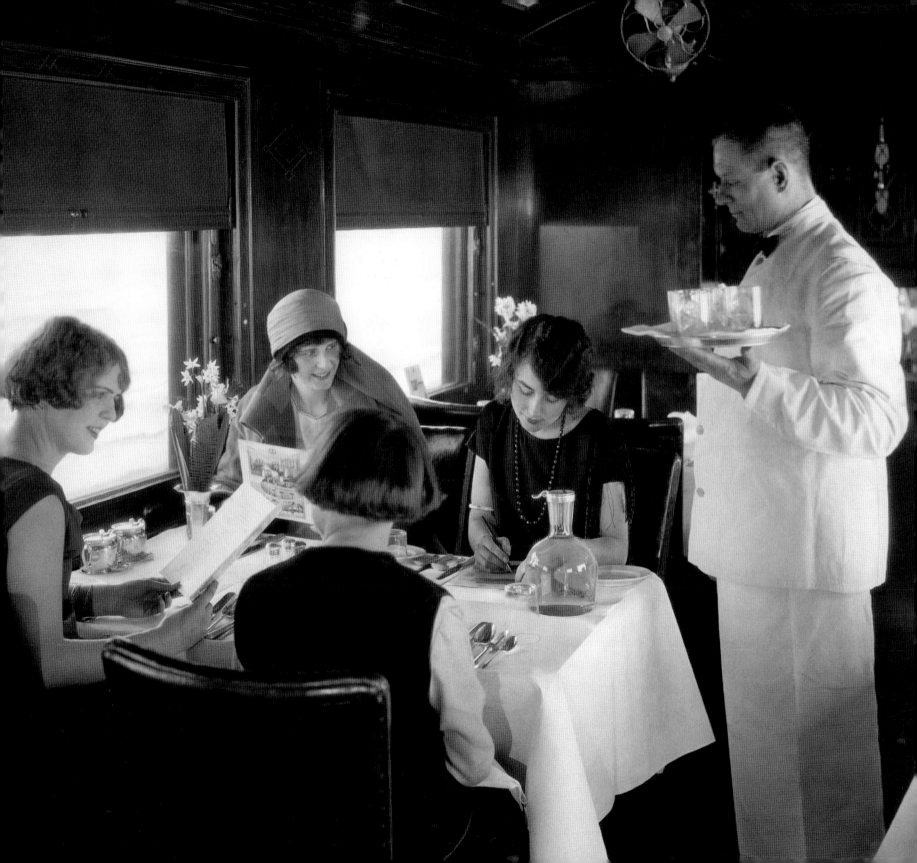

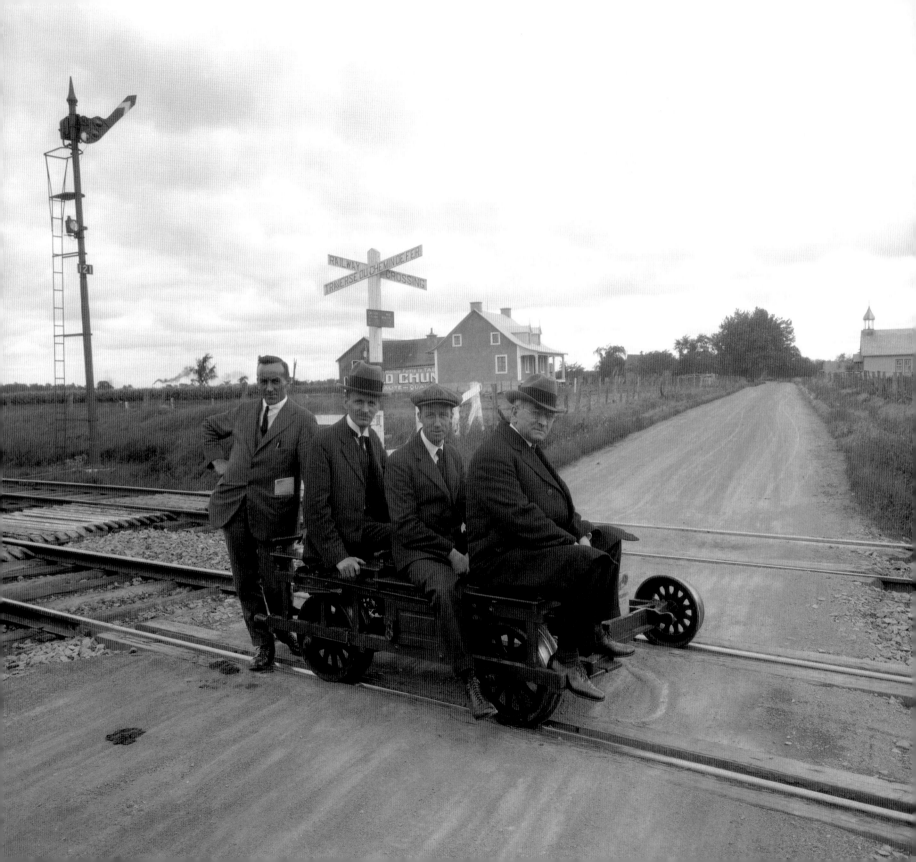

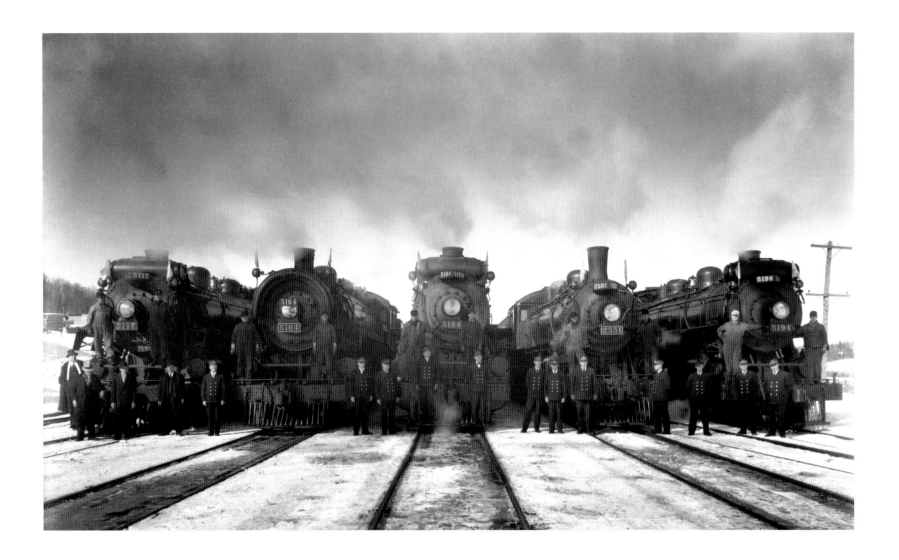

Opposite page: Four well-dressed CPR officials on a motorized track car inspect the rail line near Montreal in the mid-1920s. It is likely that the senior man is sitting in the front, while the man standing with a timetable in his pocket would be responsible for the group's safety.

Anonymous, NS.5048

The crews of these five locomotives gathered for this photograph to mark the record number of skiers they hauled into the Laurentian Mountains in the winter of 1938. That year, more than sixty thousand skiers boarded the ski trains to head to the slopes surrounding the nearby towns of Ste-Marguerite, St-Jovite, Ste-Agathe, and Val Morin.

Anonymous, NS.774

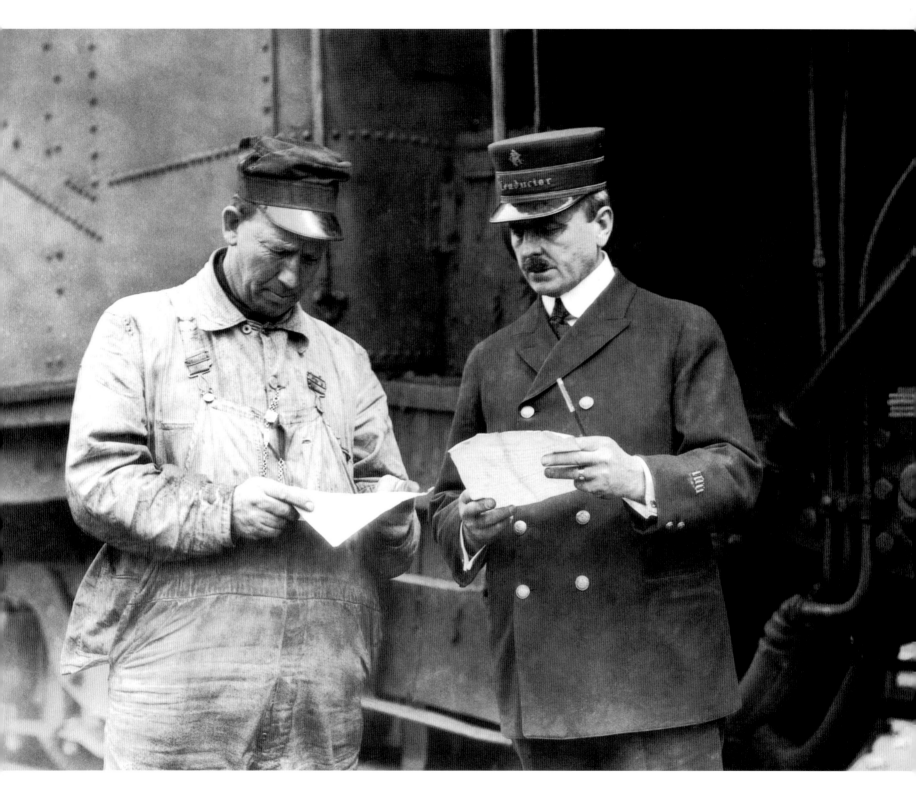

Working on the Railway

The two most important people on a steam train were the engineer and the conductor. The engineer physically ran the train, with the help of a fireman to shovel coal and help operate the levers and valves on the left-hand side of the locomotive cab. The conductor was in charge of the train and collected fares and punched tickets on passenger trains.

The train didn't move until the conductor and engineer received their train orders from a dispatcher. Dispatchers, stationed at central points along the line, usually the divisional point, gave the train orders to the crew before they left, or relayed updated train orders to them by telegraph through station agents along the line. The station agent either handed the new train orders to the crew when they stopped at the station or "hooped" them up to the crew and conductor while the train was on the fly. It saved time, fuel, and wear and tear starting and stopping fully loaded freight trains when train orders were clipped into a wooden hoop held at arm's length on the station platform for the crew to catch on the fly as the train whistled past the station without stopping. Usually, the fireman, the engineer's assistant on the head end, stuck his arm out the cab door, caught the train-order hoop, released the train order and tossed the hoop back for the station agent to fetch farther down the track. At the tail end, it was the conductor's assistant's turn to do the same. The trainman usually grabbed a similar, but shorter, train-order hoop from the station agent at the back of the train as it flew by the station.

Time was critical to all train-operating jobs. Operations, train orders, schedules, and signals all needed to be accurately timed to avoid an accident or head-on collision. Engineers and conductors carried pocket watches, which they set by the always-accurate station clock. To keep the entire railway synchronized, a daily signal was sent by telegraph from the McGill Observatory in Montreal to all three thousand station clocks on CPR's system.

An engineer and conductor with the Trans-Canada Limited in 1924.

Brigden's Studio, A.28576

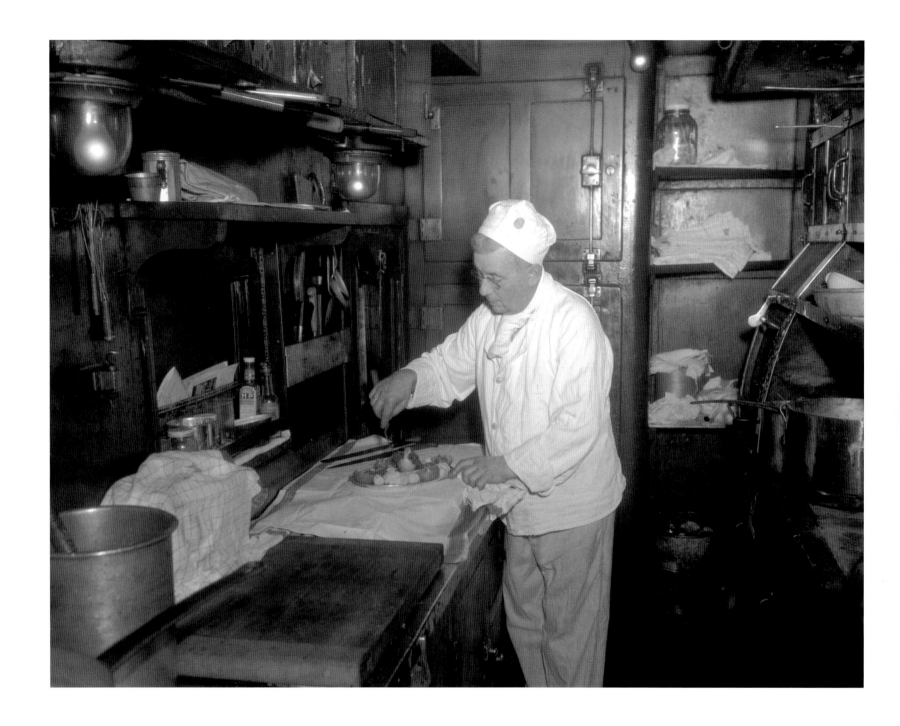

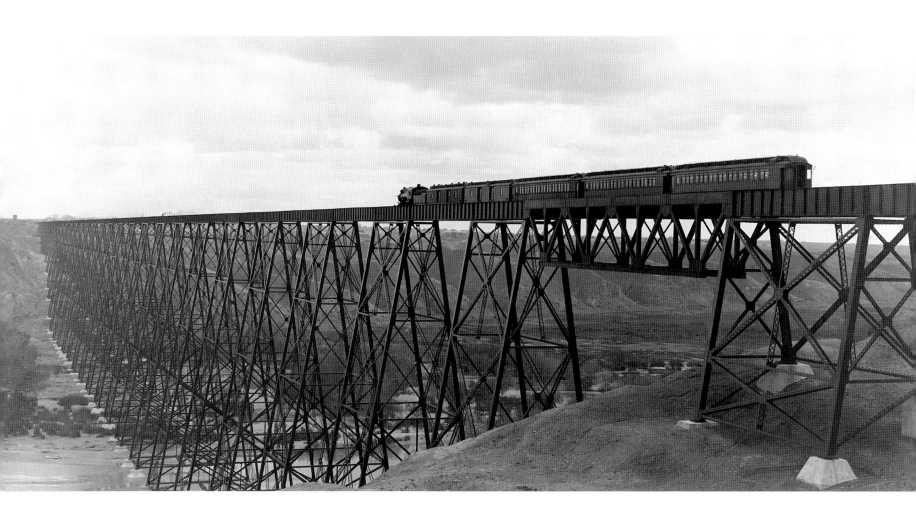

Opposite page: In this 1946 photo, veteran head dining-car chef Joseph Plante puts the finishing touches on a tempting food platter. Chef Plante earned a reputation for excellent cuisine during his many years on CPR's Montreal–Quebec City run. Passengers who frequented this run often asked for his specialty—habitant pea soup.

Phillip Delisle, NS.10926

The passengers on this mid-1920s train heading across the High Level Bridge at Lethbridge enjoyed a bird's-eye view of the Oldman River Valley in southern Alberta. The bridge, completed in 1909, was designed in-house by J. E. Schwitzer, CPR's western lines assistant chief engineer. At 95.7 metres high and 1,624 metres long, the bridge was the highest and second longest railway bridge in Canada. Today, it ranks as the twenty-fifth highest and thirty-fifth longest in the world.

Anonymous, A.15475

Just east of Field, British Columbia, in the heart of Yoho National Park, CPR's main line runs sandwiched between massive Mount Stephen, named after the company's first president, and the swift-flowing Kicking Horse River. In 1938, Nicholas Morant chose this location to photograph an eastbound CPR freight train emerging from the Mount Stephen snowshed.

Nicholas Morant, M.2740

Opposite page: On a cold winter's day the billowing steam from an early-1950s passenger train travelling through the Winnipeg yard almost obliterates the sky. At that time, Winnipeg was the location of the largest privately owned marshalling yard in the world. Canadian Pacific Railway's sprawling midtown facility covered close to 5,000 square metres of land with about 450 kilometres of track.

Anonymous, NS.7078

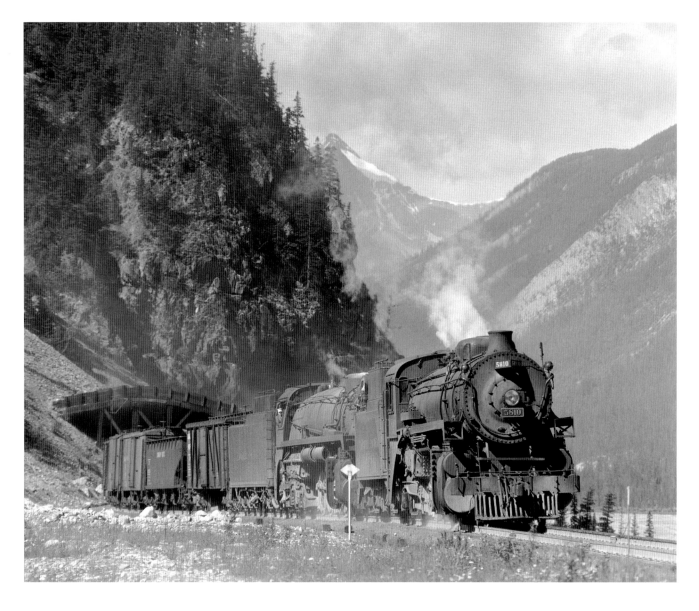

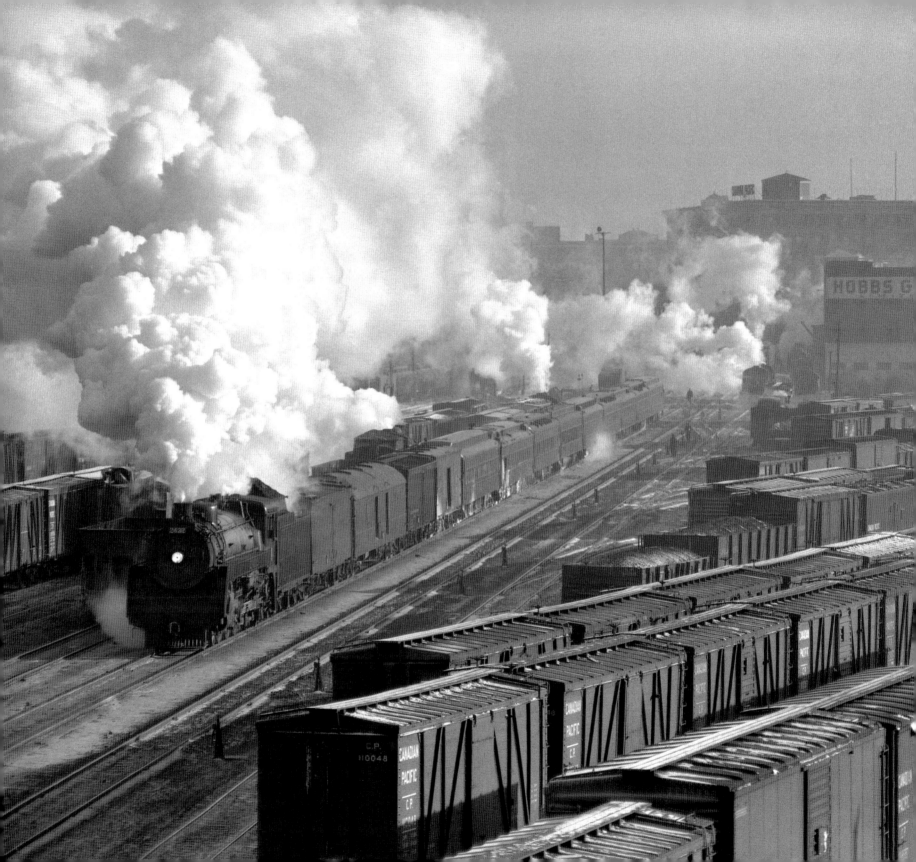

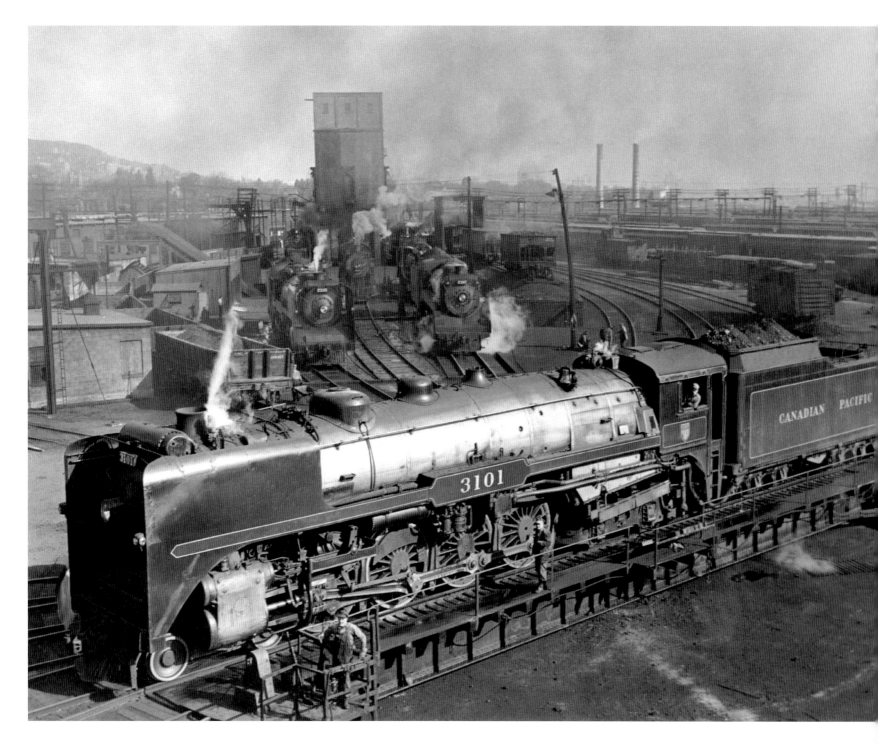

Locomotives

Things have changed a lot for CPR since the 1880s—especially on the locomotive front. In the nineteenth century and the first part of the twentieth century, steam was the order of the day. Aside from buying steam locomotives from major manufacturers or second-hand, CPR built one-third of its steam locomotives in its own shops in Montreal. Of the 3,257 steam locomotives CPR owned and operated between 1881 and 1960, 1,056 were home-grown—built in either CPR's De Lorimier Shops or, after 1904, at its Angus Shops. At first, steam locomotives were rather dainty-looking compared to the big behemoths developed between the two World Wars, when steam locomotives were at their mightiest. Ninety per cent of the 1880s CPR locomotives had a 4-4-0 wheel configuration, cost about seven thousand dollars to build, and pulled a grand total of fifteen cars. The older, second-hand locomotives burned wood for fuel. Wood was cheaper than coal, but less efficient and more prone to sparking and touching off forest fires and trestle fires along CPR's right-of-way, especially in the mountains. Because of the fire hazard, and because coal was getting cheaper and easier to find, CPR converted its last remaining wood-burners to burn coal by the early 1890s.

In March 1911, CPR introduced oil-burning locomotives. In total, CPR converted four hundred locomotives to burn oil. Oil-burners ran cleaner and were less hazardous to dry timber and were used almost exclusively in CPR's mountain operations. In the 1920s and 1930s, CPR's steam locomotives started to get bigger, better, and faster. For one glorious summer in 1931, CPR ran the fastest scheduled passenger trains in the world. The company's H1-class Hudson-type steam locomotives with a 4-6-4 wheel arrangement, pulling a full passenger train, did the 177-kilometre stretch between Smiths Falls, Ontario, and Montreal West in 104 minutes, averaging nearly 111 kilometres per hour.

The turntable at CPR's Glen Yard, a locomotive and passenger-car servicing facility, provides the setting for this handsome photograph of locomotive 3101. In 1928, CPR built two of these large, heavy, and powerful locomotives with a 4-8-4 wheel arrangement, commonly called Northern-type locomotives. They could be found for many years on the head end of the Montreal-Toronto night passenger trains.

Between the two world wars a new technology started to emerge—diesel-electric motive power. After World War II, North America, and eventually CPR, saw the efficiencies of multiple-unit diesel-electric locomotives. Diesel locomotives saved two-thirds on operations and maintenance over steam locomotives. By the end of 1960, there were no more steam locomotives running on the CPR.

Locomotive 3101 in Glen Yard in 1947.

N. Jerry, NS.9635

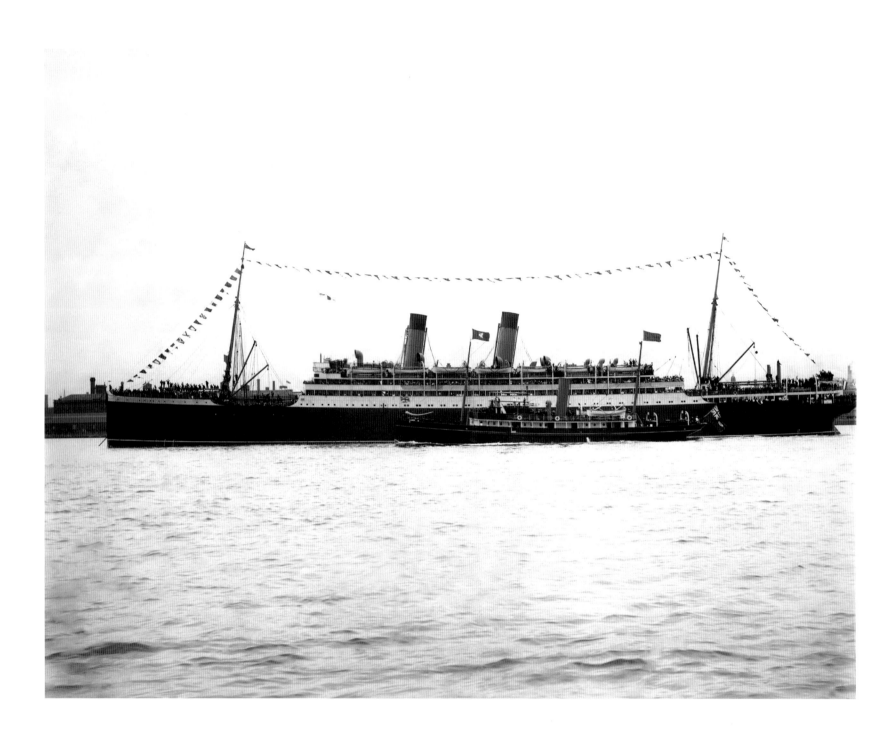

The Sinking of the *Empress of Ireland*

The most tragic quarter-hour of CPR history happened on 29 May 1914. The *Empress of Ireland*, CPR's trans-Atlantic flagship, sank just off Father Point in the sheltered waters of the St. Lawrence River near Rimouski. It happened very quickly, taking just fourteen-and-a-half minutes, at a time when most aboard were asleep. Of the 1,477 people on board, 1,015 died, even though there were lifeboats and safety belts for all.

Two years before, the *Titanic* had struck an iceberg in the North Atlantic and sank. As a result of this disaster, all ships had to have enough lifeboats for every single passenger and crewmember on board. Canadian Pacific Railway equipped its transatlantic steamships, including flagships *Empress of Britain* and *Empress of Ireland*, in accordance with the new regulations. The company even insisted its ship captains conduct rigorous boat drills before or soon after the ship set sail. Captain Kendall of the *Empress of Ireland* had done just that in Quebec City before the ship set sail. Early the next day, at 2:30 a.m., tragedy struck. There were no icebergs, but there was a heavy fog. The St. Lawrence River pilot had just disembarked at Father Point, and the captain of a Norwegian collier had changed his course. His ship, the *Storstad*, rammed Kendall's *Empress of Ireland*. The Empress capsized and sank.

Unlike the *Titanic*, the *Empress of Ireland* didn't have the wealthy and the glamorous on board that night, but it did have an undeniable link with Canada. The *Empress of Ireland* had made ninety-six trans-Atlantic round-trips, carrying 117,000 passengers over an eight-year span—mostly immigrants coming to Canada. A few celebrities had crossed the pond on the ship on previous voyages. Prince Fushimi of Japan and the Duke of Connaught, the third son of Queen Victoria, were among the celebrity passengers. The Duke of Connaught, who sailed on the *Empress of Ireland* in October 1911, was on his way to Canada to become governor general. Also on board during that very same trip was future CPR photographer Nicholas Morant, a one-year-old hellion at the time. Seventy years later, Morant wrote that, on that trip, the Duke of Connaught's personal butler had asked Morant's mother to keep a lid on her infant's early morning activities because he was disturbing "his Excellency's sleep."

The *Empress of Ireland* at Liverpool, United Kingdom, in 1913.

Anonymous, A.14746

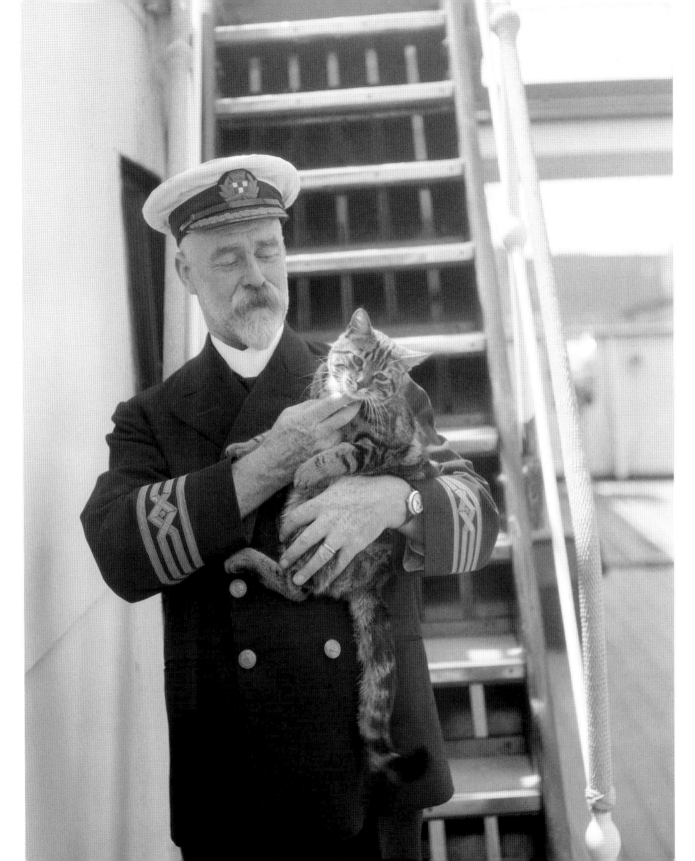

A. J. Hailey, captain of Canadian Pacific Steamship's *Empress of Canada*, poses with the shipboard cat after being recognized for his 1923 record-breaking transpacific Yokohama-Vancouver voyage. The 4,179-nautical-mile journey was completed in eight days, ten hours, and fifty-three minutes at an average speed of 20.6 knots.

Anonymous, NS.10133

Opposite page: In 1946, CPR passengers arriving at Port McNicholl could break up the 4,830-kilometre transcontinental train trip by opting to board the company's Assiniboia or Keewatin lake steamers and arrive about two days later in Fort William, now Thunder Bay. The journey, often out of sight of land, was described by CPR as "Leisurely Days on Canada's Inland Seas." The ships offered hot and cold running water, and the cost for two with deluxe bed and dining saloon meals was fifteen dollars.

Anonymous, NS.21804

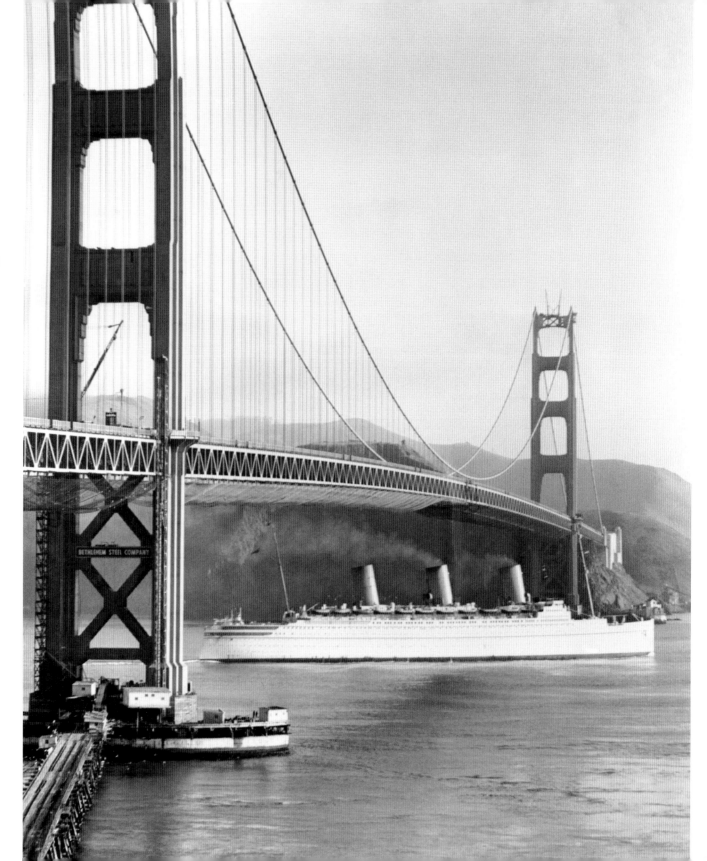

Canadian Pacific Railway was a pioneer in offering cruising as a vacation, rather than simply a way to get from one destination to another. Every winter the *Empress of Britain II* left New York on a four-month world cruise, offering its mostly American passengers the finest in service and accommodations. Cruising was an important source of revenue for the ship, especially when the Depression cut into her regular trans-Atlantic passenger trade by decreasing the number of immigrants to Canada. Unfortunately, the ship's profits as a cruise ship did not measure up to expectations. In this photo, the *Empress* is seen passing under San Francisco's Golden Gate Bridge in 1935. She completed eight world cruises before being requisitioned for war duty during World War II.

Anonymous, S.78.363

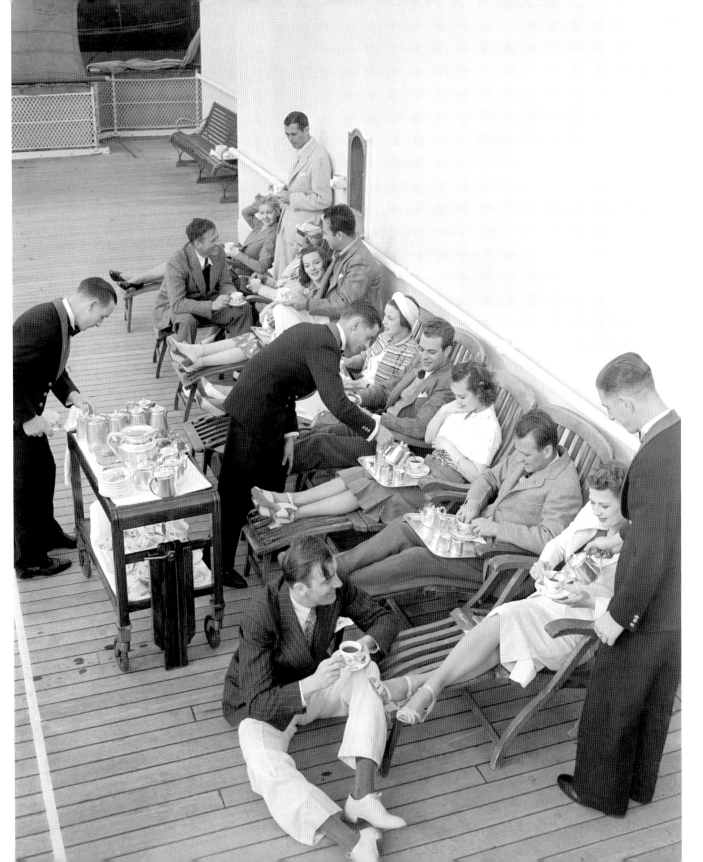

Between meals, these affluent passengers on the *Empress of Britain II* in 1935 were served tea and other beverages on the ship's specially designed line of china. Waiters and cabin stewards perfected their skills on CPR's smaller ships before being considered for service on the *Empress*. Their wages might have been low, but they often received very generous tips.

Anonymous, S.78.489

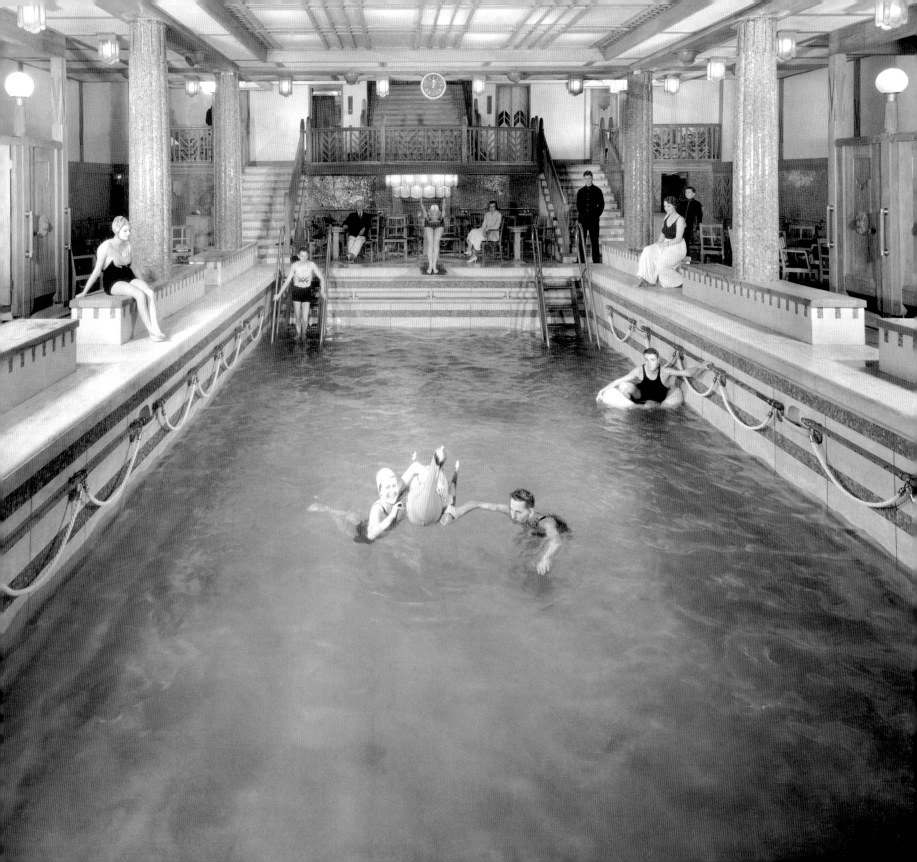

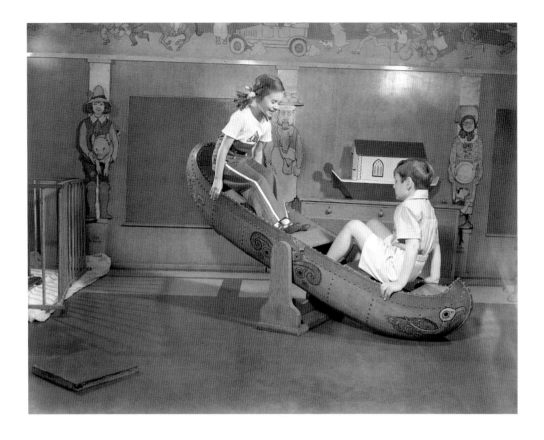

It's easy to imagine the excitement of the children in this 1935 photograph as they try out the equipment in the *Empress of Britain II*'s playroom. That year, children aged from one to ten would have paid half fare on one of the ship's Caribbean cruises. For babies, a flat rate of twenty dollars was charged.

Anonymous, S.78.407

Opposite page: An Olympic-sized indoor swimming pool was only one of the amenities offered to these passengers during a 1935 cruise aboard the *Empress of Britain II*. In fact, there was so much to do that movie star Mary Pickford, a passenger on the ship during its first season, complained that the trans-Atlantic voyage was too short to take advantage of all the ship's activities. The *Empress of Britain II* was not only luxurious, she was fast. On her maiden voyage in May 1931, she sped between Cherbourg, France (where she stopped after setting out from Southampton), and Father Point, Quebec, in four days, eighteen hours, and twenty-six minutes.

Anonymous, S.78.280

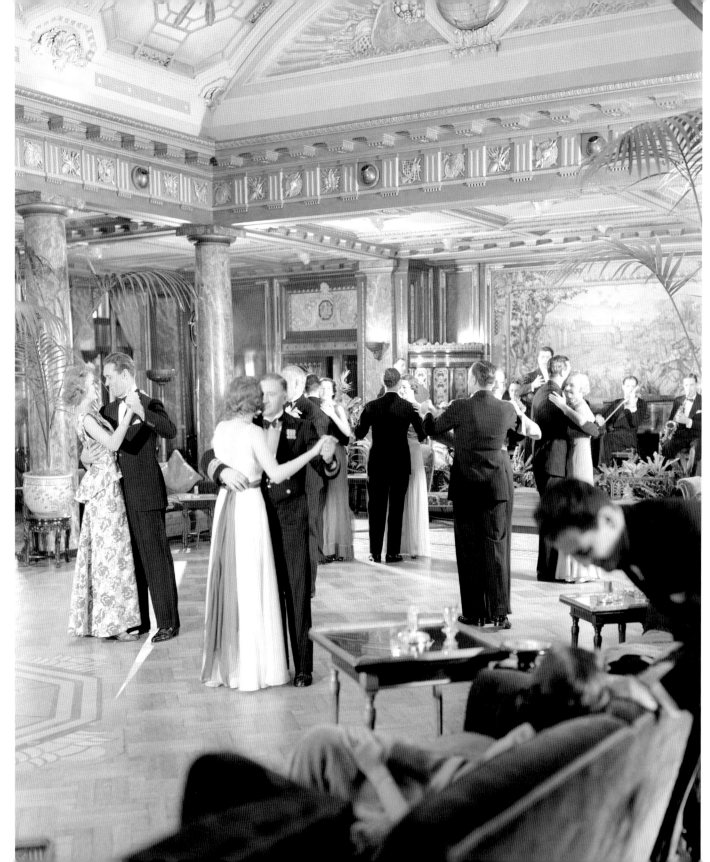

The sumptuous Mayfair Ballroom on the *Empress of Britain II*, in about 1935.

Anonymous, S.78.350

The *Empress of Britain II*

In 1931, to keep its place among the greatest shipping companies in the world, Canadian Pacific Steamships launched the luxurious *Empress of Britain II*. At 42,500 gross tons and 232 metres long, she was imposing, fast, stately, and CPR's largest ever passenger ship— almost as big as the *Titanic*. Her accommodations ranged from inside cabins to lavish suites, the largest two having their own balconies.

Some of Britain's leading artists, including W. Heath Robinson, Edmund Dulac, and Sir John Lavery, designed the ship's bars, lounges, and dining rooms. The elegant Mayfair Ballroom was panelled in walnut with silver designs. The ship boasted an Olympic-sized pool and a gym equipped with bicycling machines, electric horses, and punch balls. Other luxuries included Turkish baths, a full-sized tennis court, two theatre stages, and a cinema. She was the first to have ship-to-shore radio-telephones.

"This vessel can be considered in construction as the last word in shipbuilding, and as regards her appointments—she will have no rivals," observed Edward, Prince of Wales, at the *Empress of Britain II*'s launching. First-class passengers dined in opulent dining rooms on food prepared by the best of chefs and enjoyed thirteen different types of champagne. Nearly always, the officers and crew outnumbered the passengers.

Film stars Mary Pickford and Douglas Fairbanks were on her passenger list that first season. The ship's proudest moment probably came in June 1939, when she was chartered to bring King George VI and Queen Elizabeth back to England after their goodwill tour to North America.

The *Empress of Britain II* offered trans-Atlantic crossings in the summer and luxury world cruises in the winter. On a typical world cruise she sailed from New York, continued east through the Mediterranean and the Suez Canal to India, Java, Bali, China, Japan, then across to the American west coast, through the Panama Canal, and back to New York. The minimum fare was $2,100 and a suite could cost as much as $16,000.

With the outbreak of war in September 1939, the *Empress of Britain II* was requisitioned to transport troops. Her war duties were cut short when she was fired upon by a German reconnaissance plane on 26 October 1940. Two days later, while being towed near the Irish coast, she was torpedoed and sunk by a German U-boat.

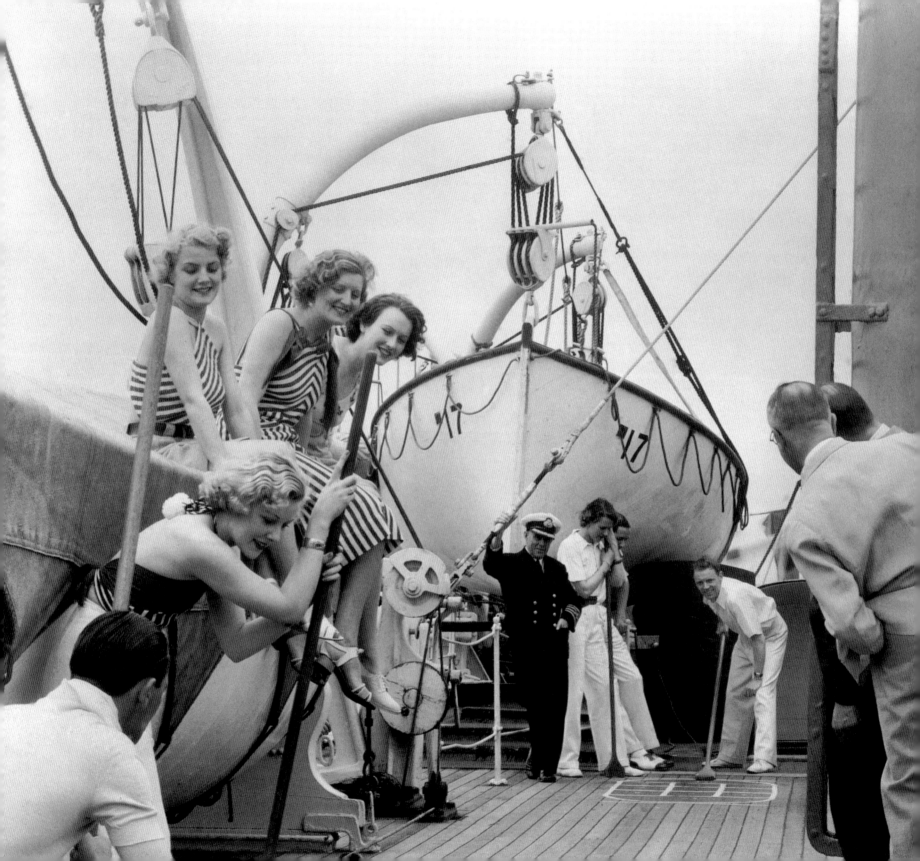

The pride of Canadian Pacific Steamships' fleet, the *Empress of Australia* was chartered in May 1939 by King George VI and Queen Elizabeth to carry them from Portsmouth, England, to Wolfe's Cove, Quebec, where they would begin a one-month, goodwill tour of Canada. To accommodate them, some of the ship's cabins were converted into royal suites, the ship's smoking room was transformed into a private dining room, and arrangements were even made to show a number of films. Presumably the crew, including these bellboys, were eager to keep fit in order to attend to Their Majesties' needs.

Anonymous, NS.18085

Opposite page: In 1939, at about the time this photograph was taken, Canadian Pacific Steamships' *Empress of Australia*'s sixteen-day spring cruise departed from Southampton with stopovers at Algiers, Catania, Naples, Monaco, and Lisbon, before returning to Southhampton. The ship boasted a gymnasium, indoor and outdoor swimming pools, a ballroom, and wide decks with plenty of room for shuffleboard. Later that same year, the *Empress of Australia* was sent to Southampton to be converted into a troop ship. She left for her first wartime voyage on 28 September 1939.

Anonymous, NS.2554

Aviation was making notable progress in Canada when this photograph was taken in 1928 of cargo transferral between a Canadian Pacific Express truck and Western Canada Airways. On 25 August 1928, Canadian Pacific Express air service inaugurated express-cargo flights between Quebec and Windsor, Ontario. Later that same year, Western Canada Airways began offering both passenger and express-cargo service between Winnipeg, Regina, Calgary, and Edmonton.

Anonymous, NS.19224

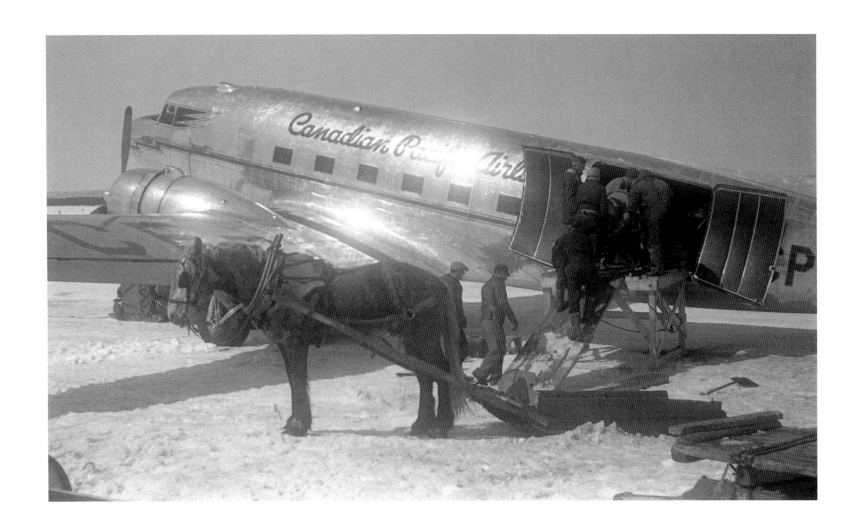

A mid-winter photograph shows Canadian Pacific Air Lines' Douglas DC-3 service to a remote airfield in Labrador in 1946, where the plane's freight was off-loaded to a horse-drawn sleigh. Four years earlier, CPR consolidated ten bush-plane companies in Quebec, Ontario, Manitoba, Saskatchewan, Alberta, British Columbia, and Yukon Territory to form Canadian Pacific Air Lines.

Anonymous, NS.8837

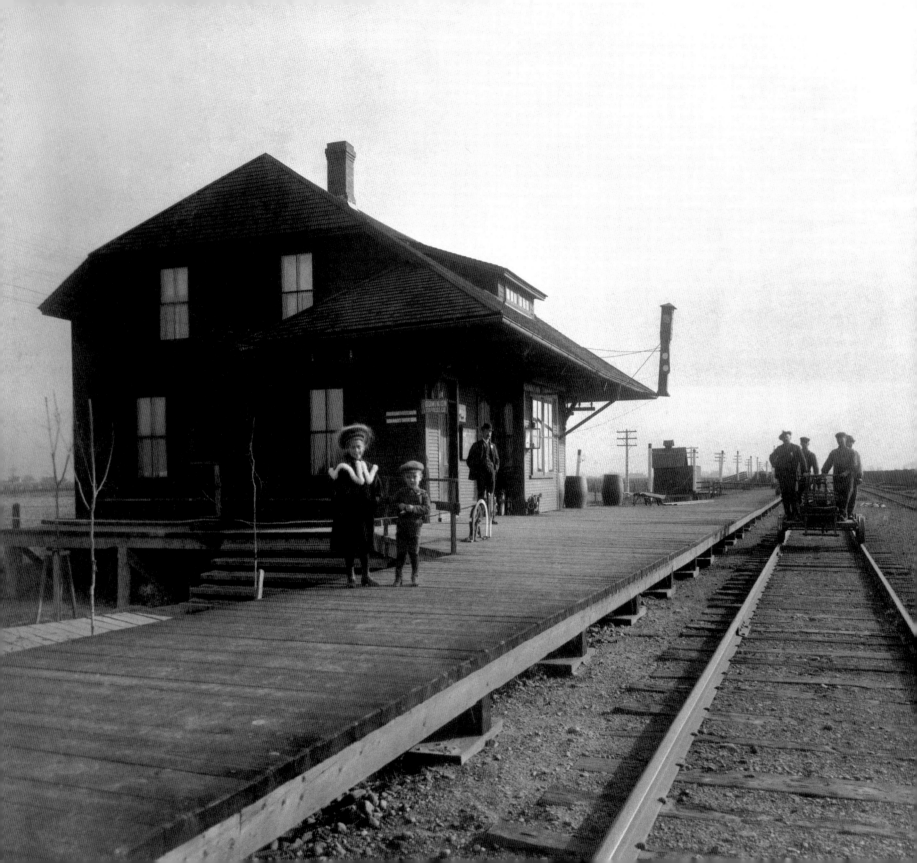

Landmarks

"They're absolutely central to our identity."

—University of Calgary history professor Donald B. Smith, referring to CPR hotels that were part of the sale of Fairmont Hotels & Resorts to Saudi Prince Alwaleed bin Talal bin Abdulaziz Alsaud, 30 January 2006

Canadian Pacific Railway was more than just trains; it was also slats and stones, glass and steel, bricks and mortar. The by-product of the CPR transcontinental railway was a coast-to-coast collection of buildings—buildings that would become Canadian icons.

Canadian Pacific Railway stations, both large and small, sprung up in cities and towns along the railway line. The small-town train station was the nerve centre of the Canadian community. Not only did passengers come and go through the station waiting rooms, but baggage, packages, catalogue orders, and personal belongings funnelled through the freight shed, too. The constant clickety-clack of the telegraph key brought sad news of casualties from far-off wars or happier tidings of births and marriages from overseas relatives.

Stations like Moose Jaw, Winnipeg, and Montreal's Windsor Station loomed even larger in the life of Canadians. For decades, these building were the gateways to their cities and the meeting places of their citizenry. Hundreds of thousands of settlers, soldiers, and sailors came and went through CPR stations. Long-distance travellers and short-hop commuters all crossed the famous Windsor Station concourse. Average citizens and the world's rich and famous trod over the very same granite floor to board their trains—after all, before automobiles and airplanes were accessible to all, trains were the only way to travel. There were many tearful goodbyes as friends and spouses sent their loved ones off to war, and just as many jubilant welcomes when royalty came to town or the hometown Canadiens brought home yet another Stanley Cup.

"Build it and they will come." This is not a famous CPR quote, but it could have been, especially when applied to CPR's historic hotels and resorts. Whether they were built to overlook the St. Lawrence River in historic Quebec City or in the middle of the wilderness on the slopes of Sulphur Mountain or the shores of Lake Louise, CPR's hotels became instant landmarks. The Château Frontenac, the Banff Springs Hotel, and the Chateau Lake Louise were among these universally recognized Canadian symbols that drew travellers and tourists from abroad. America's royalty—movie stars—and

In 1901, Joseph W. Heckman photographed the station at L'Acadie, Quebec, under the watchful eye of, most probably, the stationmaster, his two children, and the four sectionmen who brought Heckman there by hand car. L'Acadie, built in 1887 by the Atlantic and North-West Railway, a company wholly owned by CPR, was on the rail line which gave CPR direct access to the port of Saint John, New Brunswick, making the company a coast-to-coast railway in every sense of the word.

Joseph W. Heckman, A.1166

McAdam, New Brunswick, just east of the Maine border, was a railway town in the true sense of the word and an integral point on CPR's line from Montreal to the east-coast port of Saint John. Canadian Pacific Railway employed hundreds in its mechanical and operating departments at McAdam. The railway also built a distinctive combined station-hotel, along with a roundhouse, repair shops, and a freight shed, where employees (left to right) Ernie Sare, John Bennett, Jimmie Burns, Leslie Dow, Murray Carey, Frank Carey, and Tommy Golding paused for this photograph in about 1905.

Anonymous, A.1085

Opposite page: Good company and good food were to be expected at most railway lunch counters and the Luncheonette at Quebec City's Palais Station was no different. In the late 1940s, when this photograph was taken, the à la carte menu offered a complete breakfast of ham or bacon with fried egg, toast, marmalade or jam, and tea, coffee, or milk for sixty cents. Talk was free.

Anonymous, NS.5636

genuine royalty have stayed at these heritage hotels. Architectural, engineering, and construction miracles of their time, these châteaux/hotels have also claimed a place in history by hosting world events like the two World War II Quebec Conferences, the Shamrock Summit, and G-7 and G-8 Summits.

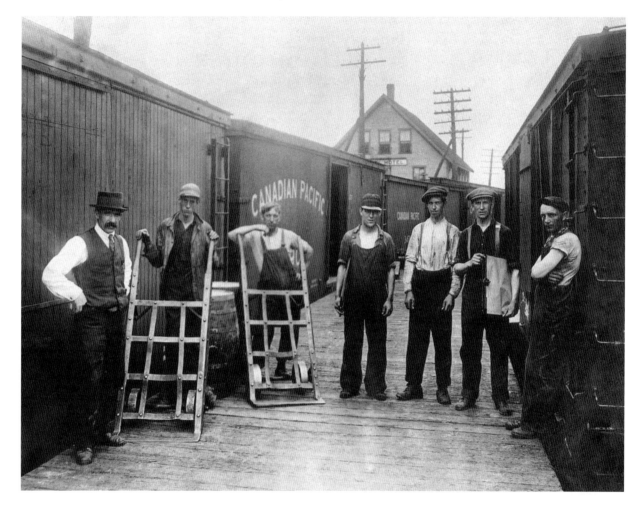

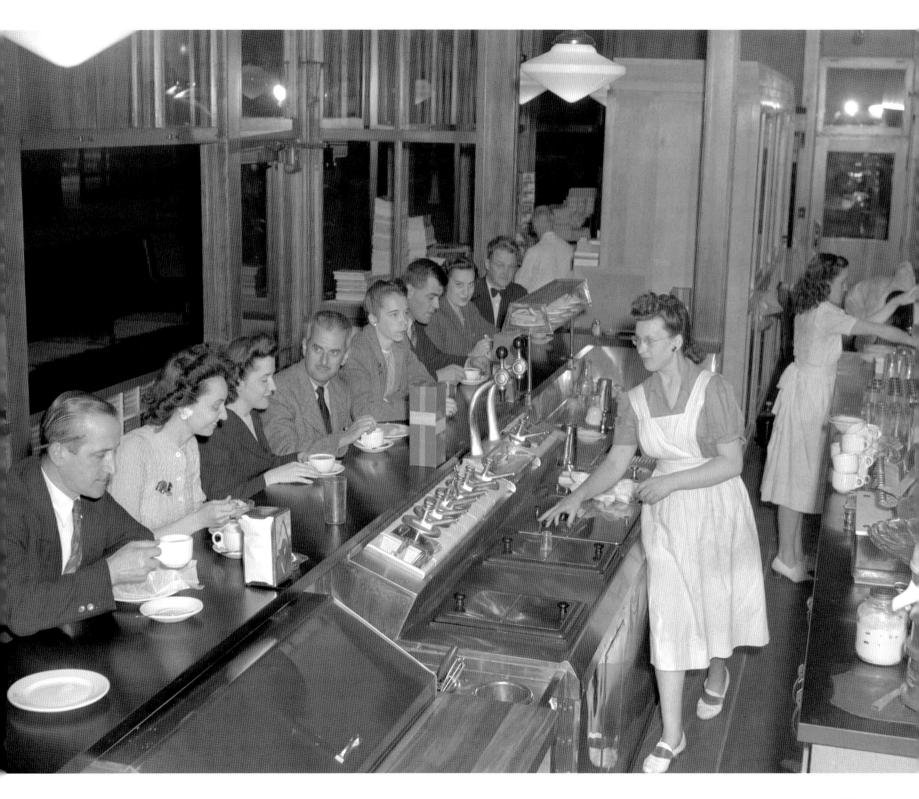

Joseph W. Heckman

In 1914, photographer Joseph W. Heckman captured not only a typical country platform scene but also the fine architectural details of the Gracefield, Quebec, station. The station was built by the Ottawa and Gatineau Valley Railway Company in 1896, which accounts for the dissimilarity to the more austere designs of CPR stations of the era. In 1902, CPR leased the line on which Gracefield stood.

Joseph W. Heckman, A.21236

From 1880 to 1884, Joseph W. Heckman worked for the Canadian government's Department of Railways and Canals as assistant engineer on railway construction between Emory's Bar and Savona's Ferry, British Columbia. At the end of this period, Heckman developed his first negative in his home, which later became the CPR station at Spence's Bridge. Between 1885 and 1888, Heckman performed survey work in Quebec and New Brunswick for the Department of Railways and Canals. In 1888, he was hired by CPR as assistant engineer, working at various locations.

Between 1898 and 1916, Heckman's interest in photography led him to undertake extensive photographic tours. During the summer months, he set out with an "all lines pass," photographing virtually every station and structure on the CPR line. His background in engineering was evident in the eleven "Photographic Survey" field books he kept. The books included, date, time, camera aperture, number of exposures, plate number, mileage, and location of each photograph. Heckman often incorporated railway sectionmen, station agents, and their families in the photographs, adding life to otherwise cold and static scenes. The photograph of his Spence's Bridge house was pasted inside the cover of one of the books. Remarkable annotated albums of contact prints, arranged by subdivisions, remain in the CPR Archives as a comprehensive photographic record of the railway's beginnings.

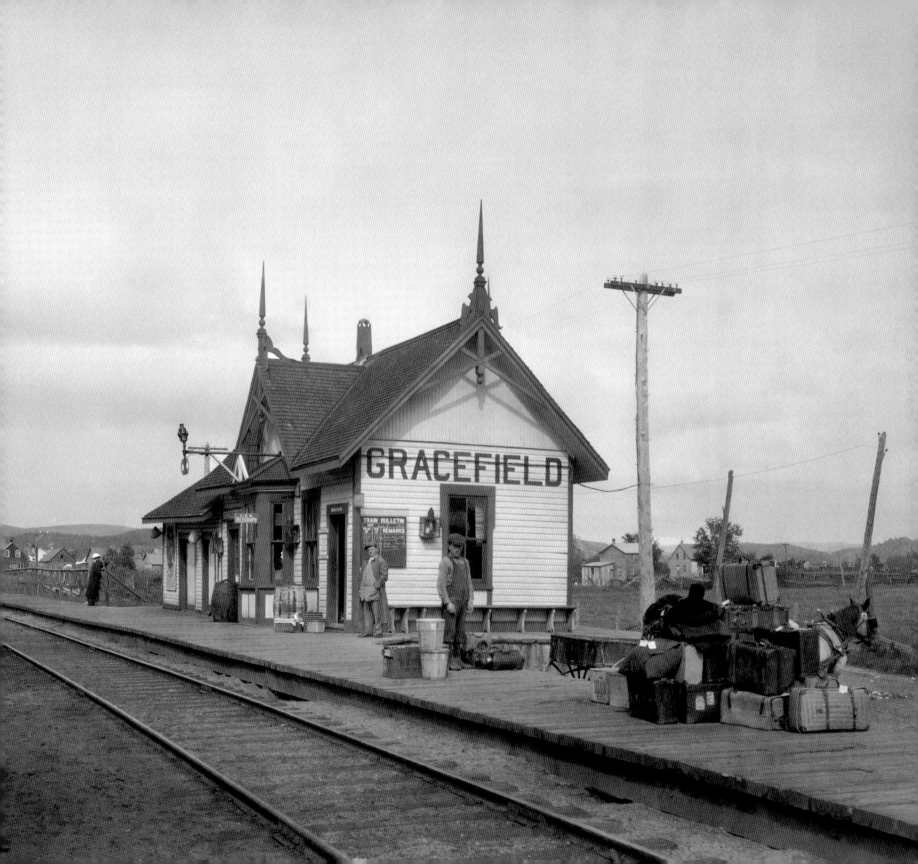

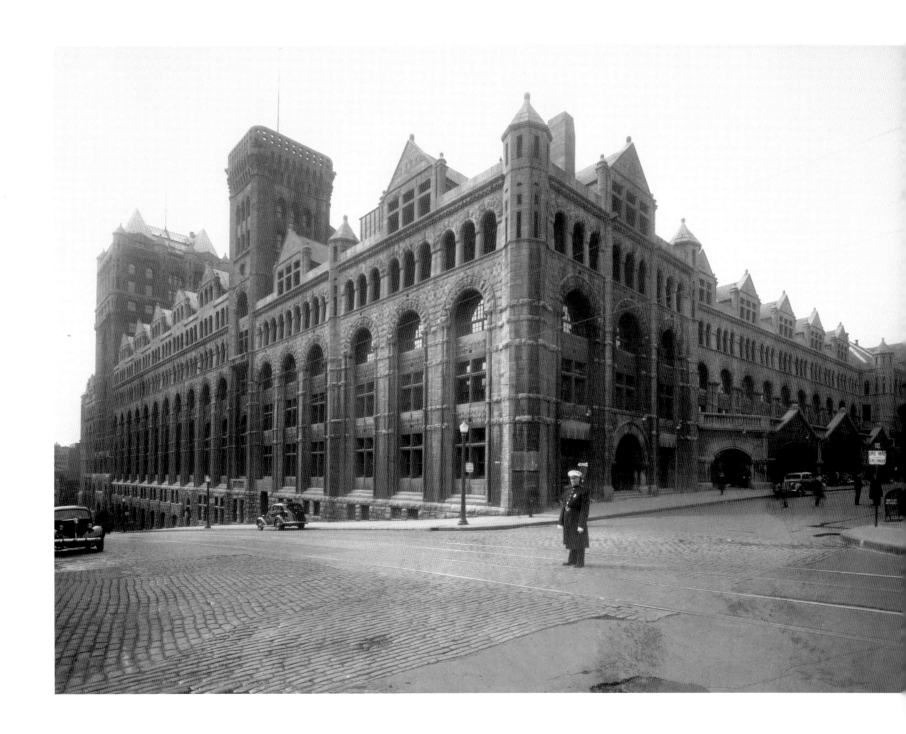

Windsor Station

"Beats all creation, the new CPR station!" proclaimed the enthusiastic president of CPR, William Van Horne. He wasn't boasting about just any old CPR station—the was talking about the company's new world headquarters. He was so proud that he had a sign made with his clever quip for the official opening, 4 February 1889, of CPR's grand new building on Windsor Street in Montreal.

Van Horne chose famed New York architect Bruce Price to design the company's new headquarters. An amateur architect himself, Van Horne nixed Price's original terracotta design, opting instead for a baronial-looking structure. In response, Bruce Price designed the grey limestone station that introduced the Romanesque Revival architectural movement to Canada.

The station was enlarged twice. Between 1910 and the 1920s, traffic increased from fifty-two trains a day to ninety, and the upper storeys of the station were now the headquarters for the "world's greatest travel system." The first new wing was built in 1899–1900, designed by architect Edward Maxwell, the second in 1910–15 by CPR's own chief designer Walter Scott Painter. These extensions were so skillfully done that the complex looked seamless—until two more extensions were added in the 1950s, one along de La Gauchetière (demolished in 1973) and another along St. Antoine Street (part of which still exists today). The main glass-roofed concourse of Windsor Station was built in 1913.

Windsor Station was almost torn down in 1929 and again in 1970. The Great Depression cancelled the first plan, and in 1970 the Friends of Windsor Station, a group of Montrealers, mobilized to save the building. In 1990, the Canadian government stepped in to protect the building, designating it as a heritage railway station.

Windsor Station, about 1935.

Anonymous, NS.7353

A 1920's slogan on a CPR poster declared: "To arrive in a fine station is to complete a fine trip." The poster portrayed a well-heeled passenger in the midst of the magnificent glass-roofed Windsor Station concourse. The station, which was the largest passenger terminus in Canada, offered men's and ladies' waiting rooms, a smoking room, nursery, newsstand, restaurant, customs office, and, as shown in this 1924 photograph, a roaming Sanitary Ice Cream cart.

Brigden's Studio, A.28943

Opposite page: A group of workers proudly pose atop Windsor Station's train shed in about 1915. The sheds were part of the station's 1910–14 major renovation which included a fifteen-storey tower, the glass-vaulted concourse, and the eleven-track train shed. They were modelled after the popular designs of A. Lincoln Bush, then the chief construction engineer for the Delaware, Lackawanna and Western Railway. Windsor Station's 120-car train shed covered an area of more than twenty thousand square metres (five acres) and featured peaked skylights to illuminate the passenger platforms as well as alternating vented roof surfaces to allow locomotive exhaust to escape.

Anonymous, A.20753

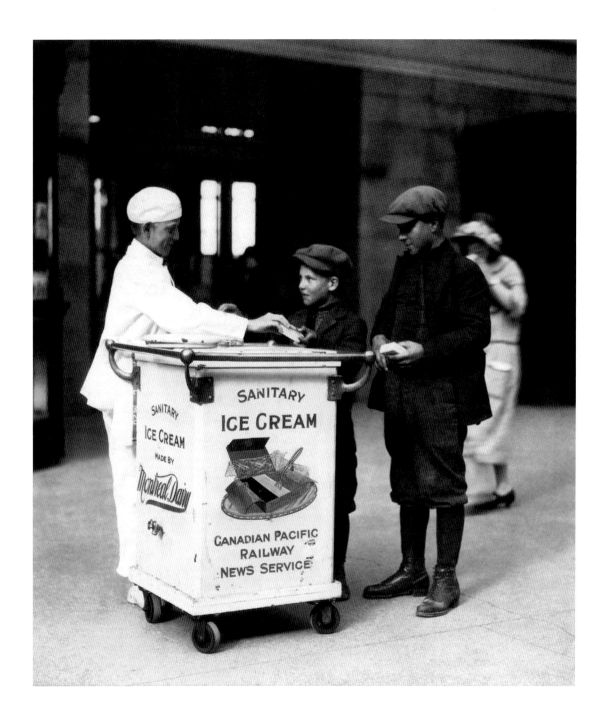

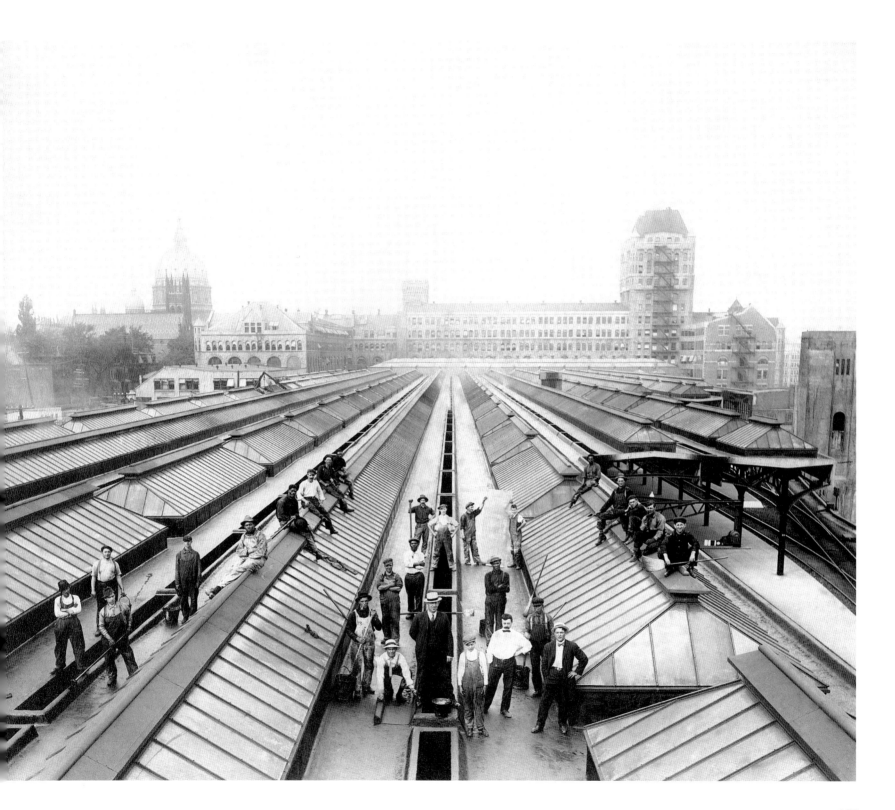

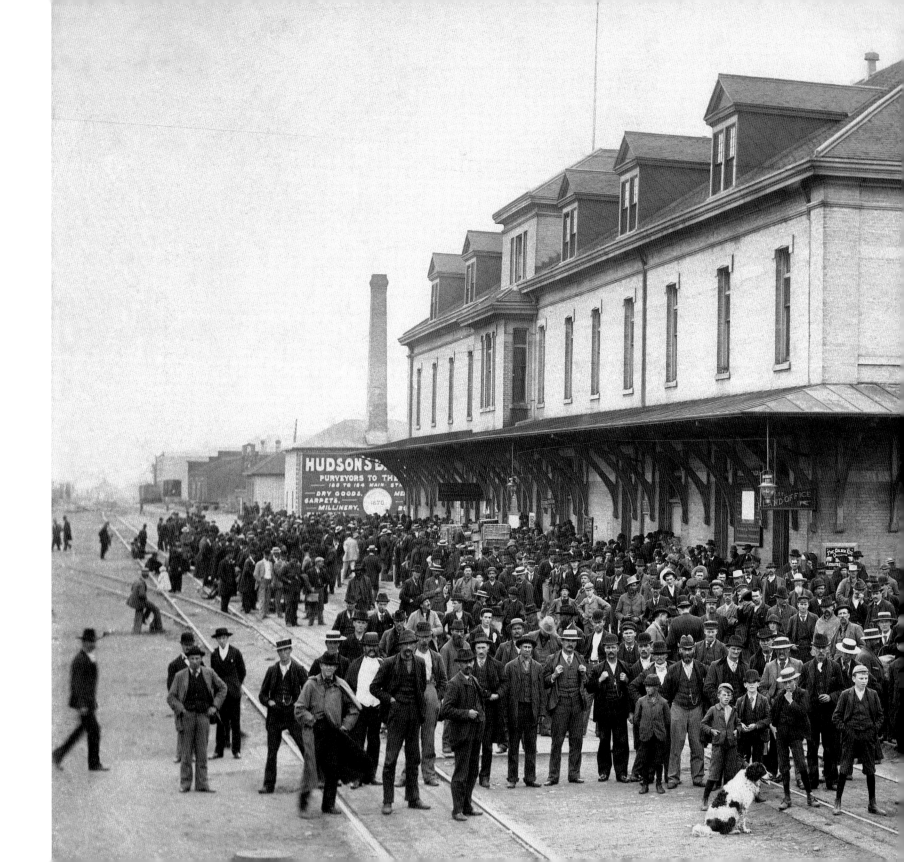

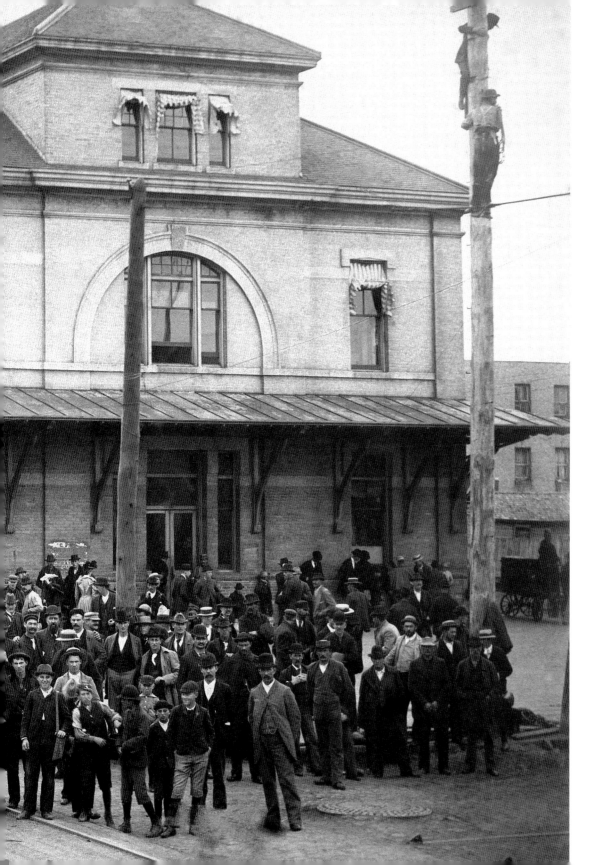

This gathering for an unknown occasion at CPR's Winnipeg station was apparently significant enough for two brave souls to climb a telegraph pole. Canadian Pacific Railway facilitated the substantial growth of Manitoba's population from 62,260 in 1881, the same year CPR's charter was granted, to 255,211 in 1901, at about the time this photograph was taken.

Steele & Co., NS.12122

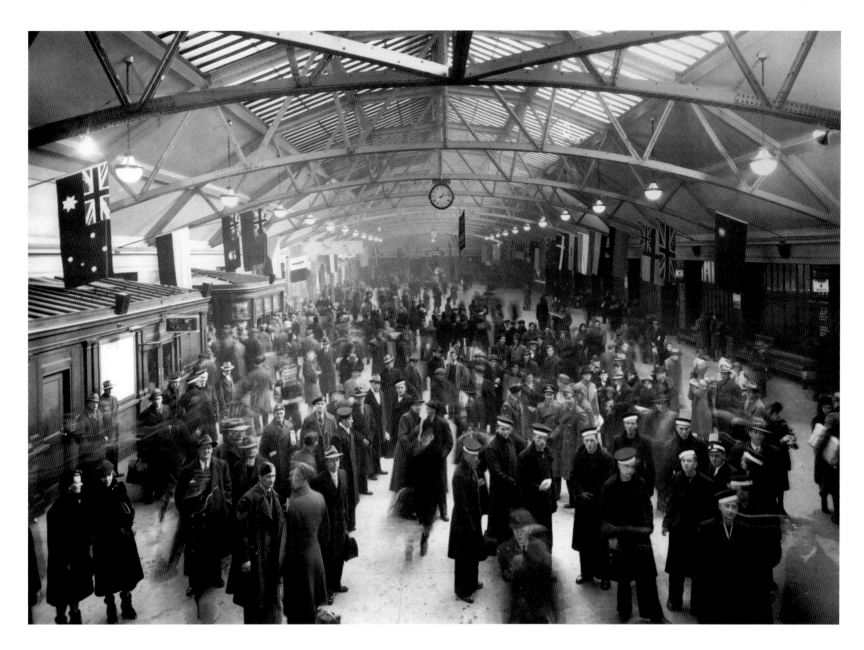

Throughout World War II, the concourse in Montreal's Windsor Station was a constant hub of activity as soldiers prepared to leave for duty on the European front. This 1945 scene, however, represents the happy occasion of returning soldiers en route to their homes and families.

Anonymous, D.201

Opposite Page: Work stopped and heads turned for the photographer who took this 1897 photo at the Toronto, Hamilton and Buffalo Railway's (TH&B) Walnut Street freight office and shed in Hamilton. In an effort to gain access to the lucrative southern Ontario markets and a gateway through Buffalo, New York, into the United States, CPR bought a 27-per-cent interest in the TH&B in 1895. Canadian Pacific Railway acquired the remaining TH&B shares in 1977 from the Consolidated Rail Corporation.

Anonymous, A.14054

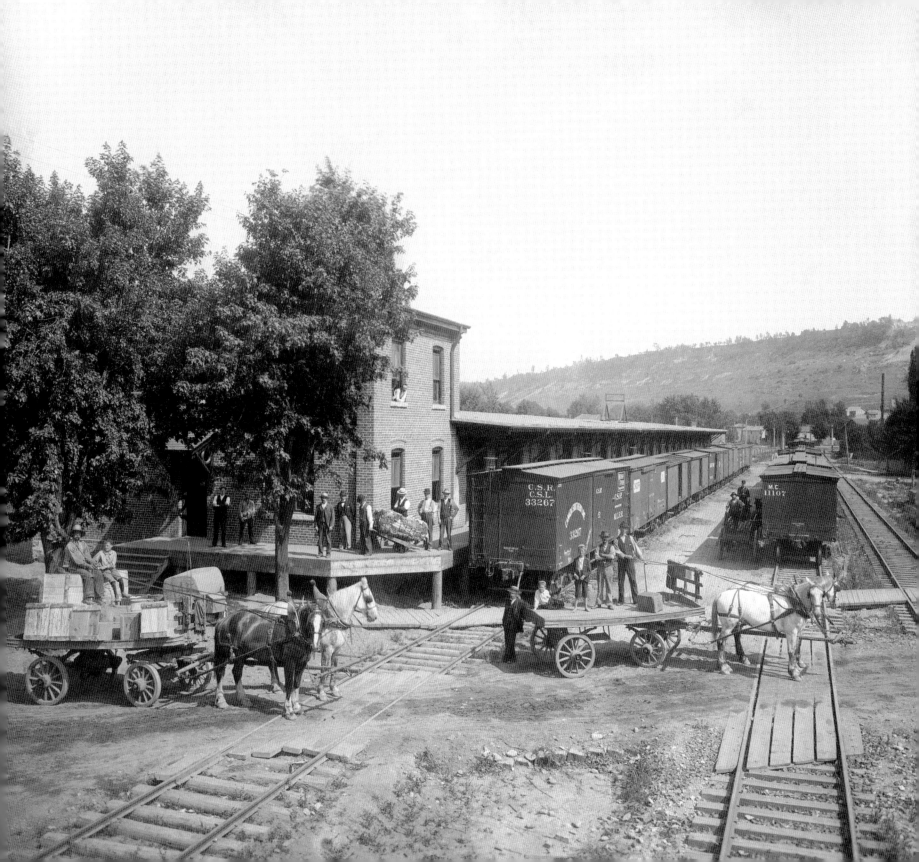

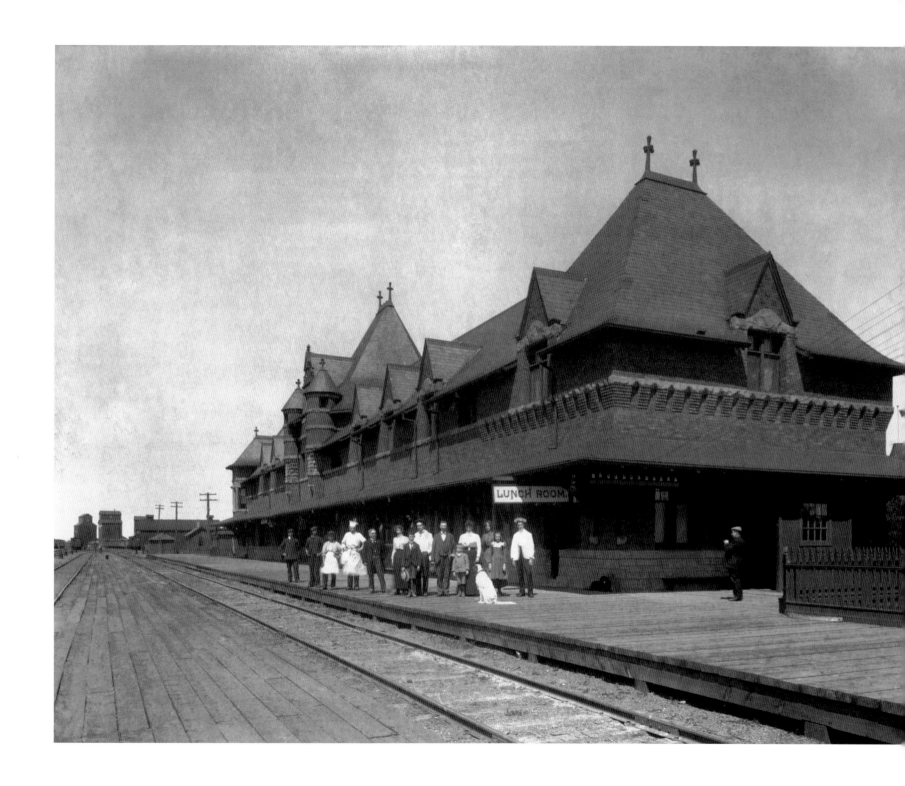

Moose Jaw: The Most Canadian of All Cities

The famous Canadian journalist Peter Gzowski called Moose Jaw "the most Canadian of all cities," yet, it was the city's important link to the United States that made it so significant to CPR.

Canadian Pacific Railway came to Moose Jaw when the company was only nine months old. On 6 September 1882, tracklaying machines and construction crews rolled into Moose Jaw—and kept on going!

Canadian Pacific Railway was formed in 1881 to build a transcontinental railway, link east with west, and settle the prairies. Prairie rail construction was off to a slow start until Van Horne took charge at the beginning of 1882. Beginning the season at Oak Lake, Manitoba, construction crews built right through Moose Jaw in September, reaching Maple Creek at season's end. The first regularly scheduled passenger train arrived in Moose Jaw on 10 December 1882. By 1883, Moose Jaw had its first station—the standard CPR two-storey wooden structure. Moose Jaw was a regular stop on CPR's transcontinental route from 1886 to 1990.

On 18 September 1893, Moose Jaw grew in importance when CPR's subsidiary, the Soo Line, linked it with a connection at Pasqua to Minneapolis and Chicago. Later passenger trains, like The Mountaineer, did the Chicago–Minneapolis–St. Paul trip to Moose Jaw in a mere thirty-three-and-a-half hours. By 1898, Moose Jaw needed a larger station, so CPR built a substantial chateau-style brick-and-stone station and hotel complex, designed by Edward Maxwell. Inside were the offices for the division superintendent, bridge inspector, conductor, and clerks. The station also included a large waiting room, baggage area, and lunchroom, as well as a dining room and hotel rooms for about thirty guests. The rare combination of station and hotel testified to the importance of the city for CPR. Between 1920 and 1922, CPR built the station and administration complex that remains there today.

There's a lot of local lore about Moose Jaw's underground tunnels near the station. Stories of hidden illegal immigrants, illicit booze dealing, gambling, corruption, and prostitution abound. Even Chicago crime boss Al Capone may have visited Moose Jaw. The Soo Line's famous named trains like the Soo-Pacific Express, The Mountaineer, and the Soo-Dominion provided direct connections to Chicago during the 1920s and 1930s —so, who knows, the stories could be true.

Moose Jaw station in 1900.

Joseph W. Heckman, A.17502

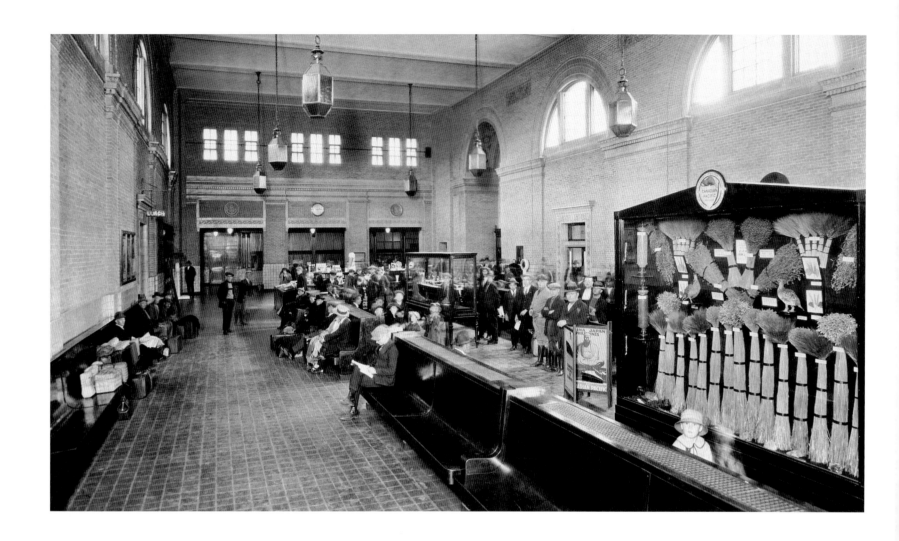

In 1924, Moose Jaw station's impressive waiting room included a display of the various types of wheat grown in Saskatchewan. That year Saskatchewan grew almost 133 million bushels of wheat—more than all the rest of Canada combined—to substantiate its reputation as "The World's Bread Basket."

Brigden's Studio, A.27548

Opposite page: Moose Jaw yard foreman William T. "Steamboat Bill" Jackson had almost four decades of service when Nicholas Morant took this photograph of him signalling his locomotive engineer. The cover photograph of CPR's July 1945 *Staff Bulletin*, it was one of several that Morant published that year, and indisputably, one of the best. He demonstrated his ingenious lighting techniques when he rewired the railway lamp to accommodate a flashbulb. Only barely visible is the wire that triggered the bulb, wrapped around the lamp's handle and hidden beneath Steamboat Bill's jacket.

Nicholas Morant, M.2759

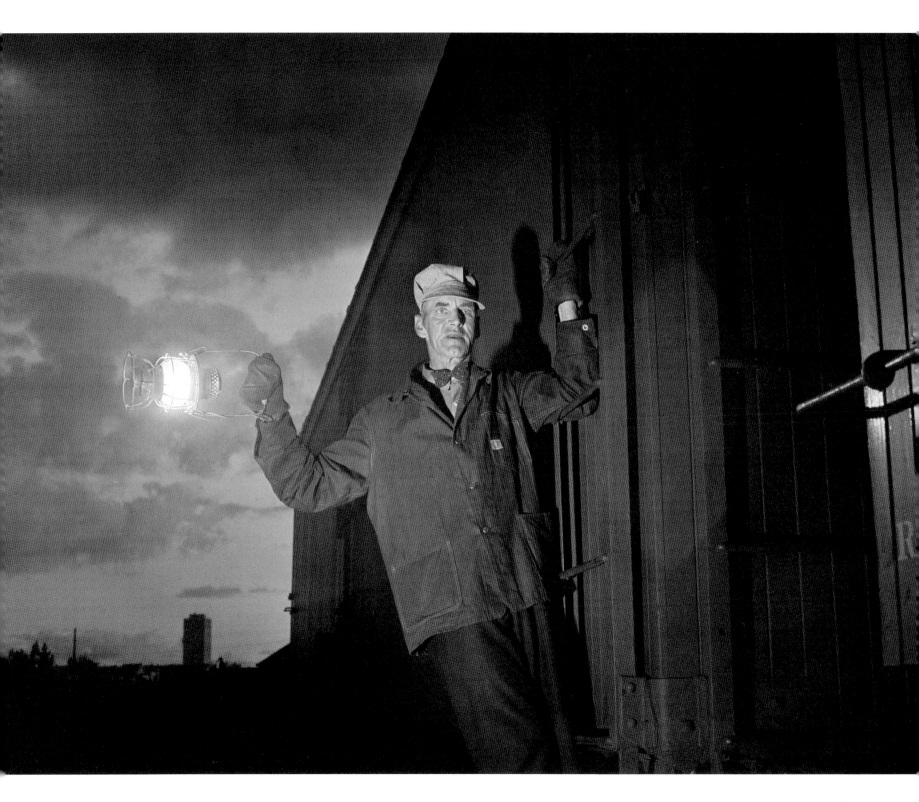

Today, one of Quebec City's most recognized winter activities is still the triple-chute toboggan slide. Thrill-seekers, who soon forget the chill of winter, walk to the slide's summit and sit astride specially built toboggans to descend the icy chutes at breathtaking speed. The slide begins from the King's Bastion of the Citadel and extends to the Château Frontenac—almost the entire length of the Dufferin Terrace. The slide had been in place long before this 1927 photo.

Anonymous, NS.24098

Opposite page: Billed as "The Empire's Greatest Hotel," CPR's Royal York Hotel opened its doors on 11 June 1929, the year this photograph was taken. The $16-million, twenty-eight-storey hotel boasted 1,048 bedrooms, each with radio, private shower, and bathtub. The walnut-panelled library contained twelve thousand books. The concert hall featured a stage and orchestra pit, as well as a mammoth Casavant Frères pipe organ. Ten high-speed elevators whisked guests to the top of what was at the time the tallest building in the Empire. On opening day the hotel employed twelve hundred people of diverse talents, including these four smartly dressed front-door attendants.

Anonymous, NS.19684

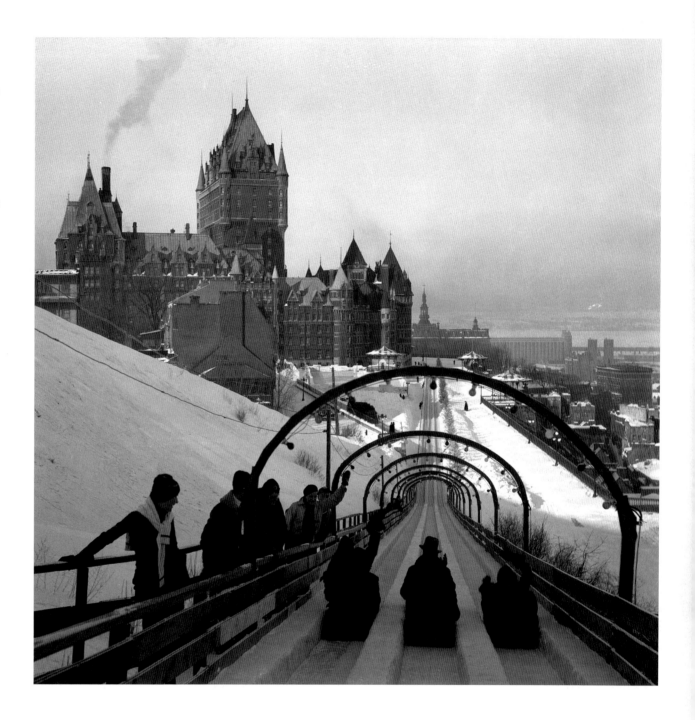

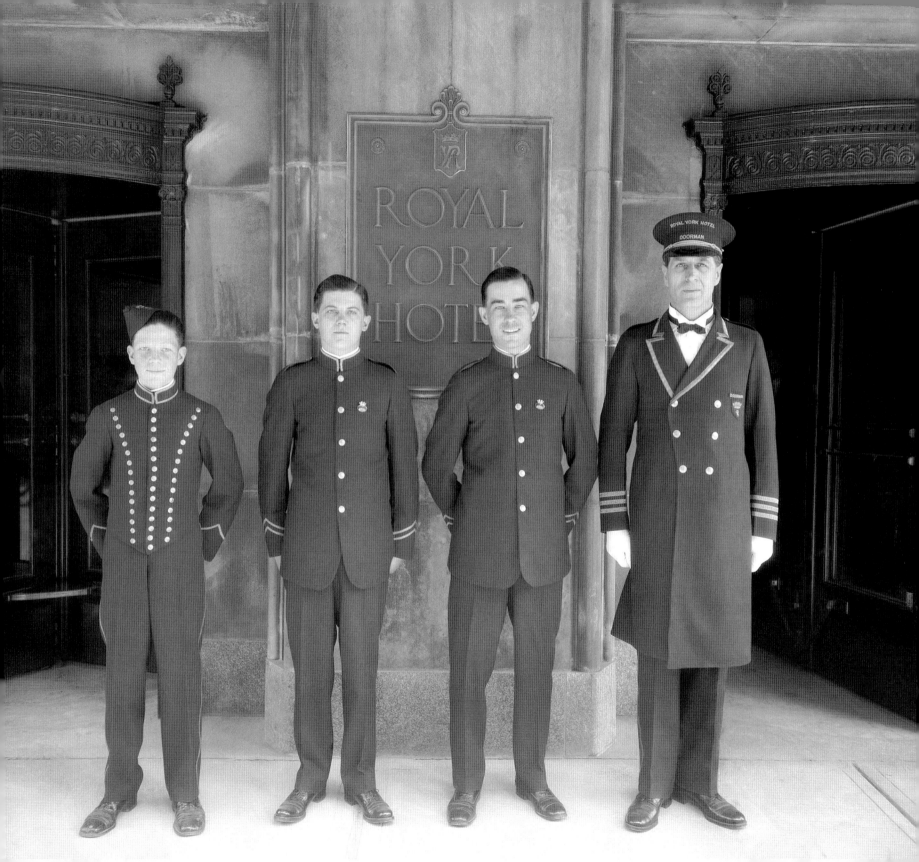

Opposite page: In the summer of 1893, the original log chalet at Lake Louise, built by CPR three years earlier, burned to the ground and was immediately replaced by the larger frame building pictured here. One of several prominent visitors to the chalet during this early period was Lady Aberdeen, wife of Canada's governor general, here seated on the steps with her sketch book in 1894. An amateur artist, writer, and camera enthusiast, Lady Aberdeen was also instrumental in the founding of both the National Council of Women and the Victorian Order of Nurses.

R. H. Trueman, NS.6856

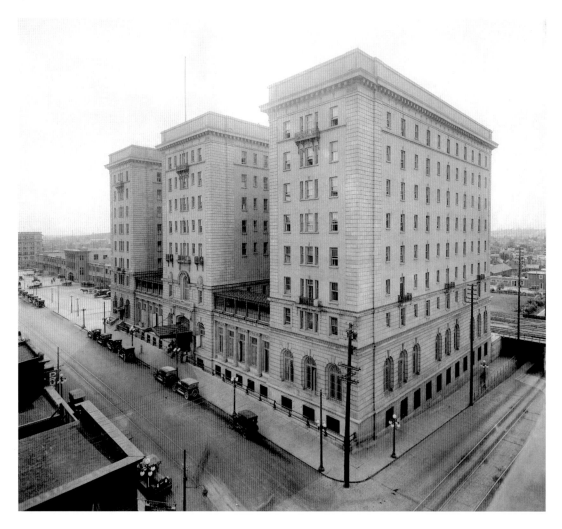

Canadian Pacific Railway's Palliser Hotel in Calgary was named in honour of Captain John Palliser, the mid-nineteenth century explorer who undertook the first comprehensive study of the agricultural potential of the Canadian prairies. Designed by Canadian architects Edward and W. S. Maxwell, the Palliser opened its doors to the public in 1914 and was soon accepted as the social centre of this rapidly growing community. Pictured here in 1920, the hotel was enlarged from eight to twelve storeys in 1929 to become Calgary's tallest building, an honour it retained until 1958.

Anonymous, A.9848

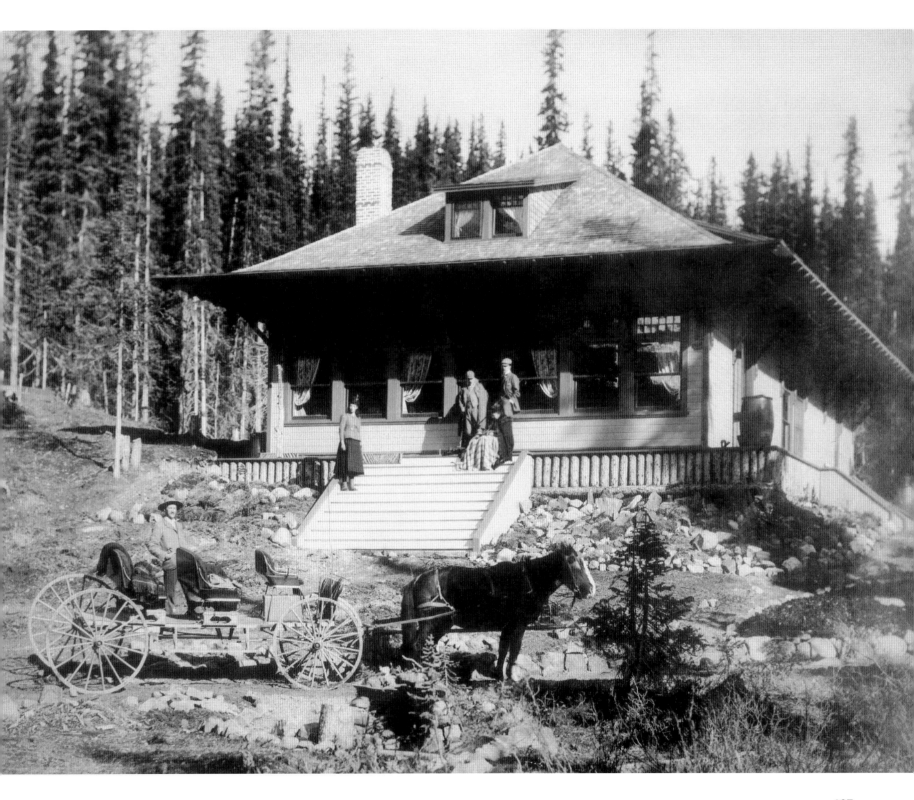

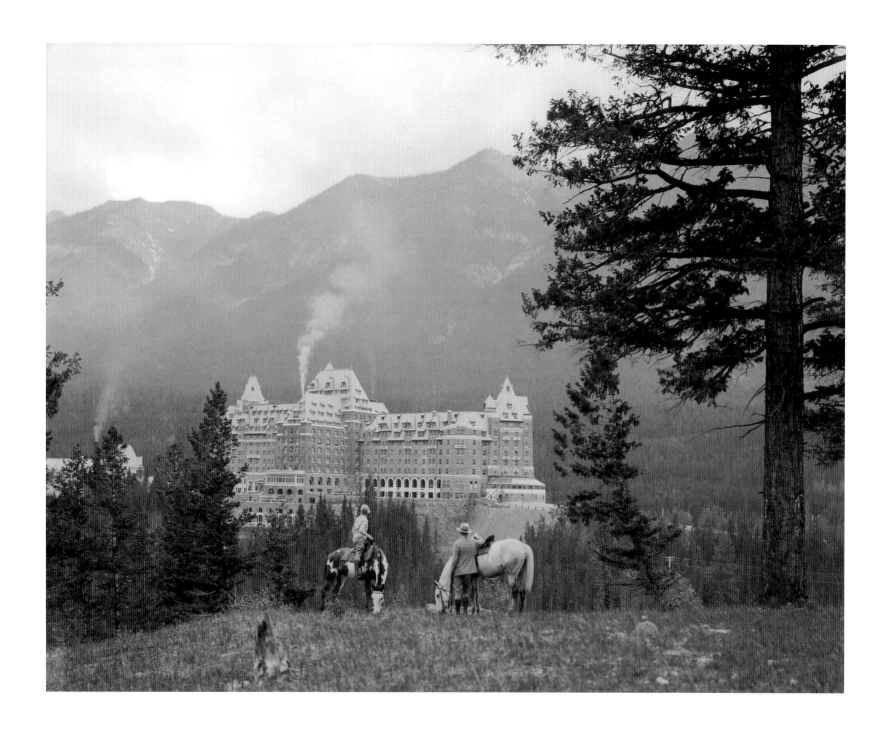

The Banff Springs Hotel

On their day off, the last Sunday of October 1883, three CPR construction workers went looking for gold at the foot of Sulphur Mountain in the Canadian Rockies. What they discovered instead were some hot springs in a cave, vaulting the area into prominence. William Cornelius Van Horne, CPR railway builder extraordinaire, was eager to capitalize on the appeal of the area and realized tourists would come in droves. On 28 November 1885, as a result of Van Horne's efforts, the federal government reserved a 26-square-kilometre area surrounding the hot springs. This created Canada's first national park, and only the third national park in the world.

Late in 1886, CPR began excavating the foundation for a new tourist hotel on a promontory overlooking the confluence of the Spray and Bow rivers. The company commissioned famed Windsor Station architect Bruce Price to design the chateau-style hotel. The following summer, Van Horne stopped by to check on the progress of Price's masterpiece. To his horror, he noted the plans were reversed—kitchen staff would have the best view, while paying tourists would only see the backside of Sulphur Mountain. Van Horne remedied the *faux pas* by designing a rotunda with a magnificent view of the rivers and the Bow Valley.

Canadian Pacific Railway opened this first Banff Springs Hotel in 1888. A combination of fires and more tourists resulted in hotel rebuilding and expansion in 1911, 1914, 1926, and 1928, with the help of architects W. S. Painter and J. W. Orrock. With the addition of some convention and staff facilities, plus a redesigned entrance at the end of the millennium, the Banff Springs Hotel became the spectacular, world-renowned, and recognizable Canadian icon that it is today.

Over the years, the hotel has welcomed its fair share of famous guests, including Marilyn Monroe, Jack Benny, Benny Goodman, and King George VI and Queen Elizabeth. A couple of less famous—and less welcome—individuals from the hotel's history perhaps still remain there. The ghost of a young bride who tragically tripped on her flowing train on the ornate staircase and fell to her death on the marble floor below is spotted every so often dancing in the ballroom. And there's Sam, the courteous and helpful bellman, who sometimes unlocks doors, turns on lights, and even helps with parcels on his ninth-floor haunt before he disappears into thin air.

Riders stop to admire the idyllic mountain location of the Banff Springs Hotel in the late 1920s.

Anonymous, NS.19709

Reinhold H. Palenske

Reinhold H. Palenske was a Chicago-born graphic artist and painter. His work is found in the Library of Congress, the New York Public Library, and the Royal Gallery of London, England. Palenske was also an avid sportsman and hunter of some renown. His love of the outdoors and mountains took him to the Canadian Rockies, where in 1923 he was part of the talented group that founded the Trail Riders of the Canadian Rockies. In the late 1920s, CPR commissioned Palenske to illustrate a number of promotional brochures and posters. Palenske also took photographs of his outdoor activities, and CPR acquired many of the negatives.

Pampered guests relax in the Banff Springs Hotel's outdoor sulphur pool in the late 1920s. The therapeutic waters that filled the pool were piped 240 metres from where they percolated out of Sulphur Mountain. When occasional plumbing problems stopped the flow of warm sulphur water, hotel staff surreptitiously filled the pool with hot water and bagfuls of sulphur. The guests were none the wiser.

Reinhold H. Palenske, NS.23238

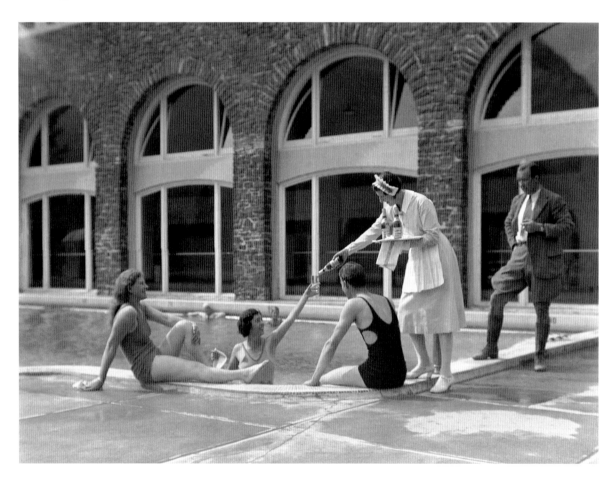

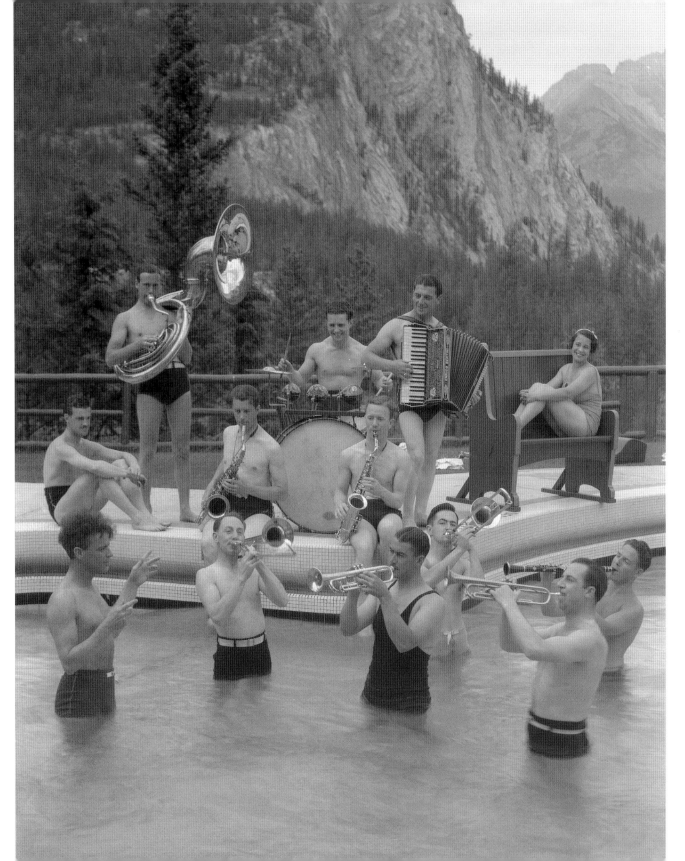

Nicholas Morant took this attention-grabbing promotional photograph of Horace Lapp's orchestra at the Banff Springs Hotel pool in 1938. Lapp's career began in the 1920s when he played the piano for silent films. In the 1930s, his orchestra was booked into such popular establishments as the Royal Muskoka Hotel and the Royal York Hotel.

Nicholas Morant, M.9

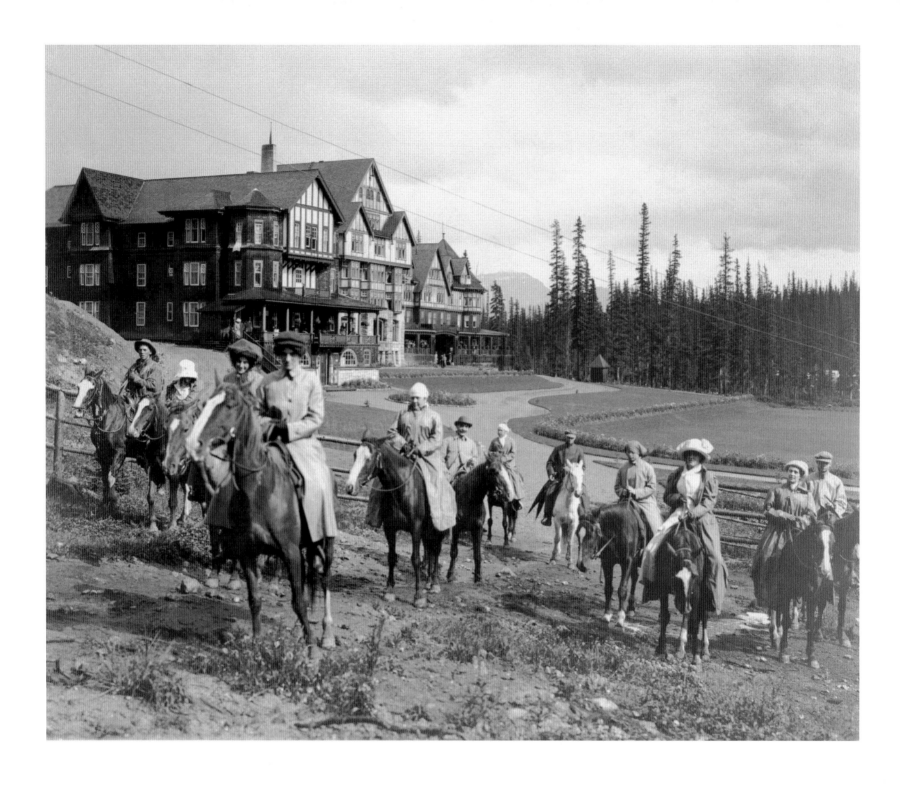

In 1887, CPR opened the first of its city hotels in Vancouver. It was a modest, sixty-room structure which soon proved inadequate for the fast-growing city. The second Hotel Vancouver (1916–1939) was an ornate structure with a sixteenth-floor rooftop garden that afforded spectacular views of the city and the Gulf of Georgia. As this 1930s-era photograph depicts, the hotel was known as the meeting place for Vancouver's tea-drinking society.

Anonymous, NS.10466

Opposite page: Architect Francis Rattenbury's Tudor-style Chateau Lake Louise forms the background for this photograph of trail riders in about 1905. At this time, the hotel was open in the summer months of June to September only and the overnight American Plan rates started at four dollars a day. Carriages, at fifty cents per person, were made available to guests for the four-kilometre ride between the hotel and the CPR station at Laggan.

Anonymous, NS.1498

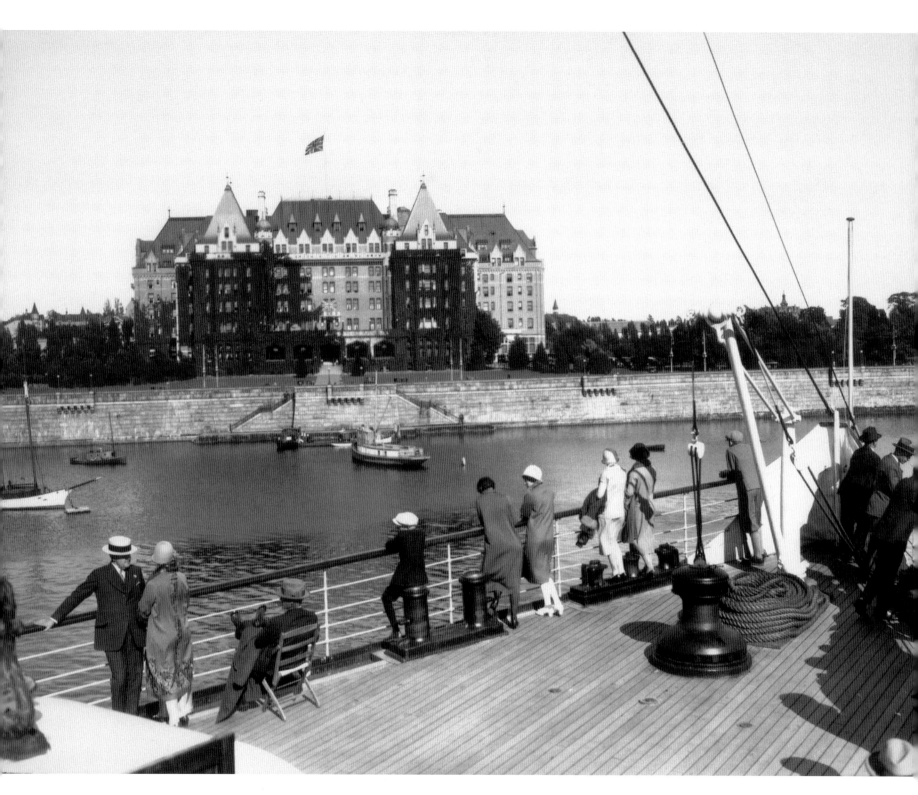

In the 1920s, pageboy Ronald Holt exemplified the Empress Hotel's formal atmosphere as he saluted the photographer. The Empress attracted a well-heeled crowd who sought to be reminded of the genteel manners of the glorious British Empire.

Associated Screen News, A.28224

Opposite page: Visitors arriving by CPR *Princess* steamer to Victoria, British Columbia's Inner Harbour in the 1920s were greeted by the ivy-clad Empress Hotel. First opened in 1908, the Empress hosted many famous people, including kings, queens, and movie stars. In 1919, Edward, Prince of Wales, danced late into the night in the hotel's Crystal Ballroom—an event considered by Victorians to be of such importance that, almost fifty years later, the obituaries of elderly ladies would appear under headlines such as "Mrs. Thornley-Hall Dies. Prince of Wales Singled Her Out."

Anonymous, *NS.14683*

Index

Acknowledgements

The authors wish to thank Paul Clark, Canadian Pacific Railway's vice-president, Communications and Public Affairs, for his support of *Portraits of Canada* and for his ongoing commitment to the CPR Archives. Thanks go also to Jo-Anne Colby, analyst, Archives, and to Gail Fraser, senior analyst, Business Information Services, for their thorough proofreading of the book. Much credit for the superb photographic reproductions goes to David Hancock, who provided his digital technology expertise. We would also like to acknowledge the Fifth House team, Charlene Dobmeier, Meaghan Craven, and Lesley Reynolds for all their encouragement and help in turning a concept into a reality.

About the Authors

Jonathan B. Hanna, born in Montreal, received a French classical education at Collège Stanislas in Outremont before graduating from Concordia University, in 1979, with a BA in history. Jonathan worked in Canadian Pacific Railway's corporate archives in the 1970s, CPR's photographic services and advertising departments in the 1980s, and in marketing communications and administration in the 1990s, before being appointed CPR corporate historian in 2000. Jonathan took early retirement from CPR at the end of 2005 and was appointed corporate historian emeritus. He continues to research and write in his favourite field of Canadian history.

Robert C. Kennell pursued his interest in photography at Toronto's Ryerson Institute of Photography. He then joined CPR's Photographic Department in 1975. Benefiting from the company's seasoned photographers and technicians, he further honed his skills, criss-crossing the country for more than twenty years photographing virtually every aspect of railway operations and contributing to many of the company's employee publications and annual reports. In 1995, Robert applied his passion for photography to the management of CPR's 800,000-image photo collection. His knowledge and expertise of CPR and its vast image collections have given him a solid basis from which to market the collection as well as to manage CPR's heritage services program.

Carol Lacourte immigrated to Canada from the United States in 1976, after having lived and taught in Finland, France, and Venezuela. After completing a masters degree in Library Science at the Université de Montréal, she worked for several companies in Montreal before joining CPR in 1989. She is in charge of CPR's business intelligence function as well as the CPR Archives. Responsible for the development of CPR's heritage programs, she has made it her goal to share CPR's archival treasures with the Canadian public.

About Fifth House

Fifth House Publishers, a Fitzhenry & Whiteside company, is a proudly western- Canadian press. Our publishing specialty is non-fiction as we believe that every community must possess a positive understanding of its worth and place if it is to remain vital and progressive. Fifth House is committed to "bringing the West to the rest" by publishing approximately twenty books a year about the land and people who make this region unique. Our books are selected for their quality and contribution to the understanding of western-Canadian (and Canadian) history, culture, and environment.

Look for the following Fifth House titles at your local bookstore:

The Face Pullers: Photographing Native Canadians, 1871–1939
 Brock V. Silversides

Famous Name Trains: Travelling in Style with the CPR
 David Lawrence Jones

From Summit to Sea: An Illustrated History of Railroads in British Columbia and Alberta
 George H. Buck

The Golden Age of the Canadian Cowboy
 Hugh H. Dempsey

Looking West: Photographing the Canadian Prairies, 1858–1957
 Brock V. Silversides

Shooting Cowboys: Photographing Canadian Cowboy Culture, 1875–1965
 Brock V. Silversides

Tales of the CPR
 David Lawrence Jones

See This World Before the Next: Cruising With CPR Steamships in the Twenties and Thirties
 David Lawrence Jones

Waiting for the Light: Early Mountain Photography in British Columbia and Alberta, 1865–1939
 Brock V. Silversides